CINEMA BETWEEN LATIN AMERICA AND LOS ANGELES

◇◇◇◇◇◇◇◇◇◇

CINEMA BETWEEN LATIN AMERICA AND LOS ANGELES

◇◇◇◇◇◇◇◇◇◇

Origins to 1960

EDITED BY COLIN GUNCKEL,
JAN-CHRISTOPHER HORAK, AND
LISA JARVINEN

RUTGERS UNIVERSITY PRESS
NEW BRUNSWICK, CAMDEN, AND NEWARK, NEW JERSEY,
AND LONDON

Library of Congress Cataloging-in-Publication Data

Names: Gunckel, Colin, 1975– editor. | Horak, Jan-Christopher, editor. | Jarvinen, Lisa, 1969– editor.
Title: Cinema between Latin America and Los Angeles : origins to 1960 / edited by Colin Gunckel, Jan-Christopher Horak, and Lisa Jarvinen.
Description: New Brunswick, New Jersey : Rutgers University Press, [2019] | Includes bibliographical references and index.
Identifiers: LCCN 2018006144 | ISBN 9781978801257 (cloth) | ISBN 9781978801240 (pbk.)
Subjects: LCSH: Motion pictures, Mexican—United States—History—20th century. | Motion picture industry—Mexico—History—20th century. | Motion picture industry—California—Los Angeles—History—20th century. | Hispanic Americans in the motion picture industry—United States—History—20th century.
Classification: LCC PN1993.5.M4 C48 2019 | DDC 791.0972—dc23
LC record available at https://lccn.loc.gov/2018006144

A British Cataloging-in-Publication record for this book is available from the British Library.

∞ The paper used in this publication meets the requirements of the American National Standard for Information Sciences—Permanence of Paper for Printed Library Materials, ANSI Z39.48-1992.

www.rutgersuniversitypress.org

Manufactured in the United States of America

CONTENTS

CINEMA BETWEEN LATIN AMERICA AND LOS ANGELES

◇◇◇◇◇◇◇◇◇◇

INTRODUCTION

Colin Gunckel, Jan-Christopher Horak, and Lisa Jarvinen

On May 20, 1932, *Santa* (1932) received its U.S. premiere at the Teatro California.[1] This first Mexican sound feature was—as documents now indicate—coproduced by José and Rafael Calderón along with Saenz de Sicilia. Directed by Antonio Moreno and starring Lupita Tovar, both of whom also had substantial careers in Hollywood, *Santa*'s premiere drew A-list Hollywood personalities, including Tovar, José Mojica, Laurel and Hardy, Ramón Pereda, Julio Peña, Juan Torena, Paul Ellis, and Carlos Villarías. The theater was decorated with huge portraits of Tovar, Morena, and Carlos Orellana, and the crowds jockeyed to see and talk to their favorite Spanish-speaking stars while critics in the next morning's papers praised the film for its realism and melodrama.[2] The Teatro California had been specifically refurbished for the *Santa* premiere and would soon become the most important screening space for Spanish-language films in Los Angeles, hosting countless premieres of films from Mexico, Argentina, Spain, and even Cuba. And while the world premiere of *Santa* had been held in Mexico City six weeks earlier, there is strong evidence that the opening in Mexico as well as the screenings in San Antonio and El Paso (at Rafael Calderón's flagship cinema, El Colón) were only organized to build up publicity for the star-studded LA premiere. Thus right from the birth of Mexican sound cinema, Los Angeles and its exhibition market were viewed as central to the international success of Mexican films, a fact that has been seldom noted in the literature. *Cinema between Latin America and Los Angeles* builds on this foundational insight to both examine the considerable, ongoing role that Los Angeles has played in the history of Spanish-language cinema and explore the implications of this transnational dynamic for the study and analysis of Latin American cinema before 1960.

This book project began as an outgrowth of an initiative at UCLA Film & Television Archive to recuperate the Spanish-language cinema culture of Los Angeles as it existed from at least the 1930s through the 1960s. In autumn 2013, the Getty Foundation announced that they would follow up their

highly successful museum initiative, "Pacific Standard Time: Art in L.A., 1945-1980" with a new initiative focused on Latin America, "Pacific Standard Time II: Latin America / Los Angeles," now simply known as LA/LA. As in the case of the first "Pacific Standard Time," during which the archive was awarded grants to stage "The L.A. Rebellion: Creating a New Black Cinema," the UCLA Film & Television Archive successfully applied for a new planning and implementation grant for their proposal, "Recuerdos de un cine en español: Latin American Cinema in Los Angeles, 1930–1960."[3] As a prequel to the Getty program, the UCLA Film & Television Archive and the Academy Film Archive staged a symposium during the 2017 congress of the Fédération Internationale des Archives du Film (FIAF) in Los Angeles on "Spanish Language Film Production in Hollywood," which was also partially funded by the Getty Foundation.

Whereas the original proposal focused exclusively on the exhibition of popular Latin American films (1930–1960) in downtown Los Angeles theaters, the curatorial committee—made up of Alejandra Espasande Bouza, María Elena de las Carreras, Colin Gunckel, and Jan-Christopher Horak—soon realized that Los Angeles was not just a site for exhibition of Latin American films but also one of the most important hubs in the Western Hemisphere for the distribution of films made in Spanish for Latin American audiences. In fact, the largest distributor of Mexican and Argentine films in North America, Azteca Films, had its headquarters in Los Angeles. Furthermore, it became clear that the city's rental studios were also sites of production for independently financed Spanish-language films, which were often distributed through the major studios. Given, therefore, that Los Angeles must be understood as a nodal point between Hollywood and Latin America for the production, distribution, and exhibition of Spanish-language films, an academic study on pre-1960 Latin American cinema through the lens of Los Angeles seemed appropriate.

Spanish-speaking people from Spain and Latin America moved back and forth between Los Angeles and their native countries, not only participating in Hollywood productions, but also professionalizing their native industries. Furthermore, the large Spanish-speaking community in Los Angeles supported an alternative and even nationalist film culture outside the media mainstream—one that survived beyond the advent of television. This book, then, aims to flesh out the generally accepted dichotomy between Hollywood and Latin America and American imperialism and Latin American nationalism in order to produce a more nuanced view of transnational cultural relations in the Western Hemisphere. As the project developed, it became apparent that it presented an exciting opportunity to rethink the historiography and geography of Latin American cinema before 1960, in keeping with emerging scholarly trends. We were soon confronted, however, with the multiple challenges inherent in conducting research

in this area, particularly when adopting a transnational framework to examine a subject more frequently understood in strictly national terms.

Precarious Objects: The Challenges of Research and Programming Latin American Cinema before 1960

For much of the twentieth century, the national cinemas of Argentina, Cuba, and Mexico remained largely invisible in Anglo-American film studies and in the general histories of cinema that steadfastly focused on American and European film production in the period prior to and after World War II. Indeed, with the exception of the Mexican films of Luis Buñuel, world cinema histories by Paul Rotha, Georges Sadoul, Jack Ellis, David Robinson, Basil Wright, Enno Patalas, Robert Sklar, and others ignored Latin American film production altogether—at least until Brazilian Cinema Novo and other New Latin American Cinema movements in the 1960s and 1970s demanded attention from a new generation of film art–oriented historians and critics. The films made in these countries prior to the rise of the Third Cinema movement in the 1960s were considered pale imitations of Hollywood fare and therefore not worthy of serious consideration because they employed narrative structures now associated with classical Hollywood narrative (as understood by Bordwell and Thompson), generic formulas, and local film stars. Typical is the statement by Paul Rotha: "It is disappointing that more has not been developed in the way of good cinema [in Latin America]. This is particularly true of Mexico. The fact remains that although Mexican producers turn out a hundred or more feature films a year, very few indeed have commanded interest."[4] Many other general film histories have simply ignored the existence of film production in Latin America. More surprisingly, historians in Latin America have treated these studio-based cinemas in a similar fashion, regarding them as bad objects, as cultural imperialism, or simply as shoddy imitations of Hollywood features, as Ana M. López has noted.[5]

Furthermore, the relationship between Los Angeles as the center of the American film industry in the classical studio era and Latin American film production has also been neglected by historians to the point that the existence of a vibrant Spanish-speaking film culture in Los Angeles had been completely forgotten by local institutions—other than an occasional Latin American screening staged by the LA Conservancy or the Latin American Cinemateca of Los Angeles. Just how close that relationship was, and not just for Hollywood to exploit Latin American film markets, can be demonstrated by the example of *Santa* along with so many other films whose production, distribution, publicity, talent, or exhibition links them to Los Angeles in some form or fashion.

Over the last twenty-five years, a number of publications have appeared in English that discuss the "Golden Age" of Mexican cinema (1939–1952) as part

of a larger project of documenting all of Mexican film history. Most prominent among them is Carl J. Mora's *Mexican Cinema: Reflections of a Society, 1896–1980,* which has gone through several updated editions.[6] Three of his chapters cover the classic Mexican cinema from 1930 to 1960, highlighting a period in Mexican cinema when it was extremely prolific. Also of value is Paulo Antonio Paranaguá's anthology *Mexican Cinema,* first published in France in 1992, which brings together the work of numerous Mexican film historians, including Aurelio de los Reyes, Gustavo García, Julia Tuñón, and Ariel Zúñiga.[7] In 1992, the UCLA Film & Television Archive curated a first major film program of Mexican cinema in Los Angeles, which was accompanied by a catalog with important essays.[8] Other significant works include Andrea Noble's *Mexican National Cinema* (2005) and the anthology *Global Mexican Cinema: Its Golden Age* (2013), perhaps the first edited volume to approach this cinema from a transnational perspective.[9] Rogelio Agrasánchez Jr.'s *Mexican Movies in the United States: A History of the Films, Theaters, and Audiences, 1920–1960* (2006), on the other hand, provides a first look at Latin American cinema in Los Angeles and the American Southwest. Agrasánchez dedicates a brief chapter to the history of Mexican cinema in Los Angeles, focusing on Spanish-language cinemas and their relationship to the Mexican film industry.[10] Lisa Jarvinen's *The Rise of Spanish-Language Filmmaking: Out from Hollywood's Shadow, 1929–1939* (2012) and Colin Gunckel's *Mexico on Main Street: Transnational Film Culture in Los Angeles before World War II* (2015) have significantly increased our knowledge of Spanish-speaking Los Angeles and its relationship to local and international film culture.[11] Finally, Charles Ramírez Berg's *The Classical Mexican Cinema: The Poetics of the Exceptional Golden Age Films* (2015) for the first time provides a book-length aesthetic analysis of classical Mexican art cinema by directors such as Emilio Fernández and Luis Buñuel.[12]

Argentine cinema has generated even less attention in scholarship produced outside of Latin America. French film historian Georges Sadoul briefly surveyed Argentine cinema before World War II, but that nation's production also remains invisible in most histories.[13] Tim Barnard's anthology *Argentine Cinema* (1986) deals mostly with independent liberation cinema in the pre- and postdictatorship period but does briefly summarize the rise of the Argentine film industry in the 1930s and its decline in the 1940s.[14] Mathew B. Karush's *Culture of Class: Radio and Cinema in the Making of a Divided Argentina, 1920–1946* (2012) is a political and social analysis that describes Argentine cinema in the classical period, particularly its relationship to radio.[15] Other than a handful of articles, no other significant work on this period of Argentine cinema has been published in English.

Finally, the history of Cuban cinema before the 1959 revolution was not only invisible in film history, but its very existence was ignored by the revolutionary government. When the FIAF congress was held in Havana in 1991, the symposium topic was archiving Latin American cinema; not one word was lost on the

previously capitalist Cuban film industry. Typical is Michael Chanan's statement in *The Cuban Image* (1985) of critical attitudes among Anglo-American film academics as well as Cuban historians working under the aegis of the communist government: "Cuba cannot be said to have had an indigenous film industry before the revolution of 1959. The melodramas, musicals, and comedies made until then reflected Hollywood's—and the United States—cultural domination of the island."[16] Such ideological blinders were happily removed recently thanks to the three-volume publication of Luciano Castillo's multi-volume *Cronología del cine cubano* (2011-2016), which has not yet been translated.

It should also be noted that other Latin American countries, especially Brazil, have had prolific film industries or, at the very least, film cultures, producing amateur, educational, and industrial films on the production side and exhibition practices, film clubs, and film criticism on the reception side. While several books dedicate space to Brazil's pre-1960 studio productions, that nation's cinema is more frequently equated with the radical aesthetic and political impulses of Cinema Novo.[17] For the most part, aside from individual essays—for example, in Manuel Alvarado, Ana M. López, and John King's *Mediating Two Worlds: Cinematic Encounters in the Americas* (1993) or Chon A. Noriega's *Visible Nations: Latin American Cinema and Video* (2000)—English-language studies on Latin American cinema in the first half of the twentieth century are woefully underdeveloped.[18]

It is a truism that the film archives of the world usually follow the lead of film historians, so it is not surprising to learn that the preservation situation for pre-1960 films in Latin America is nearly catastrophic. As the prominent head of a Latin American film archive noted in an oral history conducted for this project, "Only approximately a dozen [Mexican] films from the classic period are worth preserving, the rest being commercial."[19] Not only were many of the films from the first decades of sound cinema not considered worthy of study in their own country, but the technical infrastructures in most Latin American countries precluded any modern restoration work. This dearth of interest in all but a handful of Mexican films from the Golden Age is not, however, just a function of historical perspective; it is also a reflection of decades of neglect of the actual physical material, a situation that was endemic to almost every major film-producing nation, not just Mexico.

Exacerbating the situation in Latin America was the fact that film archives, whether national or private, were not a high priority for national agendas and therefore extremely underfunded and often lacking proper infrastructure, even for the basic care of film. In many Latin American countries, amateur cinephiles were often the first to collect films and establish archives without any government support. For example, the Museo del Cine Pablo C. Ducrós Hicken in Buenos Aires was founded by Ducrós Hicken—an essayist, researcher, academic, and collector—in 1972 to preserve Argentina's rich film heritage. It remains

without steady government funding, as does the Fundación Cinemateca Argentina in Buenos Aires.[20] Even when governments eventually created national film archives, as happened in Mexico in the 1970s, they were not funded at levels that allowed them to protect their materials. These factors ultimately lead to a nitrate film fire on March 24, 1982, under the Cineteca Nacional's cinema at the Churubusco Studios in Mexico City, which destroyed 6,506 reels—of which 3,300 were Mexican feature films and shorts made prior to 1950—and took three lives. According to Fernando Osorio, 99 percent of the Cineteca's archival holdings, constituting a substantial portion of Mexican film history, as well as the archive's library, public records, and bookshop, were irretrievably lost.[21] While the Cineteca Nacional opened its doors again in 1984, the institution placed a much greater emphasis on film screenings and is now operating as a veritable multiplex with more than twelve screens. However, in 2014, under the direction of Alejandro Pelayo, a new digital lab was created, and it has begun preserving and restoring surviving classic Mexican films digitally. Among the films that have been recently transferred to digital are a number of classic titles by famous directors from the Golden Age: ¡Ay, qué tiempos, señor don Simón! (Oh, What Times Those Were, Mr. Simón!; Julio Bracho, 1941), La otra (The Other One; Robert Gavaldón, 1946), Salón México (Emilio Fernández, 1949), and Nazarín (Luis Buñuel, 1959). Meanwhile, the other national film archive, the Filmoteca UNAM in Mexico City, has been operating an analog film laboratory for more than two decades and has constructed nitrate vaults. However, these vaults are without modern climate control. They have been preserving films in both analog and digital formats, but their budgets have been too limited to make much headway in the preservation backlog. Preserved titles include La zandunga (Fernando de Fuentes, 1938), El capitán aventurero (Arcady Boytler, 1939), Río escondido (Hidden River; Emilio Fernández, 1948), Lola Casanova (Mathilde Landeta, 1949), Víctimas del pecado (Victims of Sin; Emilio Fernández, 1950), Dos tipos de cuidado (Two Careful Fellows; Ismael Rodríguez, 1953), and El vampiro (The Vampire; Fernando Méndez, 1957).

In other Latin American film archives, the situation is equally difficult. Of twenty-four countries in Latin America, less than half have film archives associated with FIAF: Argentina, Bolivia, Brazil, Chile, Colombia, Cuba, Dominican Republic, Ecuador, Mexico, Peru, Puerto Rico, and Uruguay. Film archives in Argentina, Venezuela, and Nicaragua have been members of FIAF in the past but have since dropped out due to financial and organizational difficulties. These archives, as well as many of the archives within FIAF, have had to contend with unstable financial and political realities that have limited their ability to carry out even basic work. For example, suffering from years of budget cuts, the Cinemateca Brasileira in São Paulo experienced a catastrophic nitrate fire in February 2016, which destroyed more than one thousand reels of nitrate film. The Cinemateca de Cuba has likewise experienced significant budgetary challenges

because of the withdrawal of Russian support in the 1990s, which resulted in the loss of properly acclimatized storage space for the archive, forcing them to store all their films, even their postrevolutionary treasures, in rooms without any form of humidity and temperature control; high humidity is known to destroy acetate film in a matter of months. This reality has affected the survival of all film material in Latin America, not just pre-1960 cinema.

Researching prints from Latin America for study or programming can therefore be extremely challenging. Given that there is not a central database of such material, curators and historians must canvass every major film archive in Latin America individually in order to inquire about the existence and accessibility of specific film titles. Financial stress and fickle government policies have also resulted in constant changes in personnel and leadership at many Latin American film archives, making regular communication difficult. In order to visualize some of the difficulties facing researchers and programmers of classic Latin American cinema, the following will focus on the recent UCLA Film & Television Archive project.

For the Getty-funded film exhibition "Recuerdos de un cine en español: Latin American Cinema in Los Angeles, 1930–1960"[22] held at the UCLA Film & Television Archive in fall 2017, curators contacted the Cineteca Nacional, Mexico City; Filmoteca UNAM, Mexico City; Cinemateca Española, Madrid; Cinemateca de Cuba, Havana; the Fundación Cinemateca Argentina and the Museo del Cine Pablo C. Ducrós Hicken, both in Buenos Aires; the archives of Argentine Sono Film, Buenos Aires; the Fundación Patrimonio Fílmico Colombiano, Bogota; as well as American film archives, including the Harvard Film Archive in Boston and the Library of Congress in Washington, DC. We also contacted private television stations, like Televisa, Mexico City, which owns rights to a significant number of Mexican films. From the initial inquiry, which listed seventy titles that were documented to have played in Los Angeles cinemas between 1930 and 1960, it is clear that the survival rate of these films is extremely low. Indeed, anecdotal evidence suggests that more than 70 percent of the films made in Latin America before 1960 have been irretrievably lost. Many other films only survive in single 35mm or 16mm copies that are inaccessible until some kind of preservation or digitization is undertaken. Other films are accessible in film or electronic form, but the films are not archivally secure. For example, one the most famous classic Mexican films, *Enamorada* (Emilio Fernández, 1946), starring María Félix, was perceived to be at risk, given that the original nitrate negative was being stored in vaults without humidity and climate control, and no analog preservation masters had been made.[23] Apart from gathering information on surviving films, the UCLA Film & Television Archive also began preserving selected titles, which were found to exist in foreign archives and in their own archive. This is, of course, a very labor-intensive and expensive process, costing tens of thousands of dollars per film.

The curators also began negotiating with individual archives to help produce new preservation material and/or encourage archival partners to produce new digital masters for the production of digital cinema packages (DCPs). The biggest breakthrough came in February 2015, when the UCLA Film & Television Archive was able to bring Luciano Castillo, the newly appointed director of the Cinemateca de Cuba, to Los Angeles to announce a joint preservation project. For five decades, the Cubans had denied the existence of any Cuban films made before the 1959 revolution despite the fact that the prerevolutionary industry in Havana produced no less than seventy-five feature films between 1930 and 1958. Castillo, who is himself a historian of the prerevolutionary period of Cuban cinema, reported that virtually all Cuban films are in serious danger of being destroyed due to the loss of infrastructure brought on by the U.S. embargo. In summer 2016, Castillo hand-carried four prerevolutionary films from Havana to Los Angeles, which are being restored with the help of American funders, including *La Virgen de la Caridad* (Jaime Salvador, 1930), *Estampas habaneras* (*Chaflán en la Habana*; *Sketches of Havana*; Jaime Salvador, 1939), *La serpiente roja* (*The Red Serpent*; Ernesto Carparrós, 1937), *Casta de roble* (Manolo Alonso, 1954), and *Cuba baila* (*Cuba Dances*; Julio García Espinosa, 1961). These films are therefore now available for researchers for the first time ever.

Another breakthrough came with our discovery of the Calderón family archive, now called the Permanencia Voluntaria, in Tepoztlán, Mexico. The Calderóns—spanning multiple generations—were exhibitors, film producers, and distributors in Mexico from circa 1919 to the mid-1990s. The curatorial team was particularly interested in the surviving papers of the Calderóns because they had started as exhibitors in the border areas of Chihuahua and Texas, and their influence eventually reached as far as Los Angeles and its Mexican movie theaters on North Main Street and Broadway. Jan-Christopher Horak's chapter in the present volume is an outcome of that research. Permanencia Voluntaria was founded four years ago by Viviana García Besné, a great-granddaughter of José Calderón, the dynasty's founder, and has been collecting the hundreds of films produced by the Calderóns over six decades of production. Like almost all nongovernment archives in Latin America, it is small and struggling, reliant on donations and grants; repeated grant requests to the Ministry of Culture have failed because the film archival centers of power in Mexico have deemed the films of the Calderón brothers too lowbrow and commercial and therefore not worthy of preservation in their cathedrals of film art. Working with the Permanencia Voluntaria, the UCLA Film & Television Archive began a program in December 2016 to preserve the following Calderón titles: *El fantasma del convento* (*The Ghost of the Convent*; Fernando de Fuentes, 1934), *Don Juan Tenorio* (René Cardona, 1937), *Pescadores de perlas* (*Fishers of Pearls*; Guillermo Calles, 1938), *Sombra verde* (*Untouched*; Roberto Gavaldón, 1954), and *Yambao* (Alfred B. Crevenna, 1957).

As often happens in the world of film archiving, a third major research break-through occurred thanks to no small measure of coincidence and luck. Since the project began, the curatorial team had been looking for Argentine films from 1930 to 1960. While some titles could be found online through YouTube, the UCLA Film & Television Archive was having little luck in tracking down actual film prints with their South American colleagues. The film archive in Buenos Aires—the small, privately owned Museo del Cine Pablo C. Ducrós Hicken—is so seriously underfunded that they have not been able to preserve more than a handful of films. However, in May 2015, film archivist Todd Wiener reminded UCLA archive director Jan-Christopher Horak that in May 2009, he had approved shipping an unknown collection of nitrate films found on a loading dock in Seattle that had apparently originated in Argentina. Checking the database, curators realized that these were nitrate composite negatives from the 1930s. Given that the archive includes more than 350,000 titles, it is not surprising that these films were "lost," since no one back in 2009 knew that the archive would be preserving Latin American films for the Getty project. In fact, no fewer than ten Argentine features made between 1938 and 1940, all nitrate negatives, were discovered. Nitrate negatives of foreign titles are extremely rare and usually produce excellent material because they are only a generation from the original negative. The titles represented a cross section of some of the best Argentine directors as well as a mix of genres. Most of the films were produced by Argentina Sono Film, but two were produced by the significantly smaller Lumiton Film Company. Argentina's most famous actress (except for her deadly rival, Evita Perón), Libertad Lamarque, starred in *Caminito de gloria* (*The Little Path of Glory*; Luis César Amadori, 1939), the first title inspected. Two more Amadori films were also found: *Hay que educar a Niní* (*Niní Must Be Educated*; 1940), starring Niní Marshall, and *El haragán de familia* (*The Lazy One in the Family*; 1940), featuring Pepe Arias. Arias also starred in *El loco serenata* (*The Crazy Serenade*; Luis Saslavsky, 1939). Other titles in this collection include *La casa del recuerdo* (*The House of Memory*; Luis Saslavsky, 1940), *Y mañana serán hombres* (*And Tomorrow They Will Be Men*; Carlos F. Borcosque, 1940), *El solterón* (*The Single Man*; Francisco Múgica, 1939), *Huella* (*Footprint*; Luis Moglia Barth, 1940), and *El matrero* (*The Bandit*; Orestes Caviglia, 1939). A long-term preservation program for these films is now under way.

Then in August 2015, the UCLA archive curator María Elena de las Carreras traveled to Buenos Aires to meet with Argentine film historian and collector Fernando Peña. Peña has a comprehensive knowledge of archival matters in Argentina (in 2008, he located a print of Fritz Lang's *Metropolis* with footage that had not been seen since its international release) and readily suggested titles for preservation, including *El vampiro negro* (*The Black Vampire*; Román Viñoly Barreto, 1953) and *Los tallos amargos* (*Bitter Stems*; Fernando Ayala, 1956), both of

which were restored in conjunction with the Film Noir Foundation. Other titles that Peña sent to Los Angeles for preservation were the Argentine title *Fuera de la ley* (*Outside the Law*; Manuel Romero, 1937) and *El rey de los gitanos* (*King of the Gypsies*; Frank R. Strayer, 1933), a Spanish-language film produced by Fox and starring José Mojica.

Finally, in one of those moments of absolute archival serendipity, the curators discovered in the vaults of the UCLA Film & Television Archive a nitrate print of *Romance tropical* (1934, Juan Emilio Viguié), the first Puerto Rican feature film ever produced. Scripted by the national poet and one of the founders of Afro-Antillano poetry Luis Palé Matos with music composed by Rafael Muñoz, the island's most famous big-band leader, the film had been lost to the Puerto Rican people for more than eighty years; all that remained was a still image of the poster. A single print, shown once in New York in 1934, had been withdrawn from distribution and wandered into a Fort Lee vault facility, surviving there until 2007, when the contents of the vault were purchased sight unseen by the Packard Humanities Institute and deposited at UCLA. Given the film's generic title, it remained hidden in plain sight until September 2016, when in preparation for the upcoming exhibit, Jan-Christopher Horak again reviewed the archive's Spanish-language holdings. After a bit of research, speculation increased that it might be a lost Puerto Rican film, a fact that was confirmed by colleagues in San Juan, who sent an immediate cry of collective joy.

Both studio- and independently produced Spanish-language films had been the subject of Lisa Jarvinen's *The Rise of Spanish-Language Filmmaking*, allowing the curators to identify further films with José Mojica and other stars. In fact, the UCLA Film & Television Archive discovered several more Spanish-language Hollywood features in its own vaults and at the Library of Congress (LOC), which had previously remained unpreserved despite the fact that many of the surviving materials were unique nitrate prints. Aside from scattered holdings at archives like the Filmoteca Española in Madrid and the academy's Pickford Center for Motion Picture Study, UCLA and the LOC hold the vast majority of these films worldwide. Unfortunately, the major Hollywood studios—whether 20th Century Fox, Paramount, or Metro-Goldwyn-Mayer—had done virtually nothing to preserve their Spanish-language assets. Even more surprising, not a single Hollywood-produced Spanish-language film survived in any Latin American archive, making the finds at UCLA and LOC especially significant. As a result, the archive preserved *El rey de los gitanos* (*King of the Gypsies*; 1933), *La cruz y la espada* (*The Cross and the Sword*; Frank R. Strayer, 1934), *Granaderos del amor* (*The Grenadiers of Love*; John Reinhardt, 1934), *Angelina o el honor de un brigadier* (*Angelina or the Honor of a Brigadier*; Louis King, 1935), *La vida bohemia* (*The Bohemian Life*; Josef Berne, 1938), and *Verbena trágica* (*Tragic Festival*; Charles Lamont, 1939).[24]

The above-described difficulties in even finding films, much less preserving them for scholarly research and presentation, indicates that any kind of sustained research in pre-1960 Latin American cinema is still extremely time consuming and not easily achieved. As the UCLA project demonstrated, archives must be contacted individually with specific questions if a researcher hopes to find any material. In order to even ask such questions, researchers must first identify archives and locate their contact information. Another challenge is that Latin American film archives are understaffed and underfunded, making it difficult for them to service scholars. Another difficulty for the field as a whole is that there is no sustainable academic film culture in most Latin American countries, similar to the situation in the United States before the rise of academic film studies in the 1970s. Film scholars in Latin America are generally isolated from one another. They must make long and expensive journeys to archives that have material. Even published literature is not necessarily accessible in many countries. Without a research or academic infrastructure, developing a dialogue among scholars becomes extremely challenging.

This lack of maturity of the field brings with it additional challenges that have dogged other branches of academic film studies. As in the case of American cinema or early cinema, standards have yet to be established for replicating or documenting a historical phenomenon that is centered on cinema but also encompasses multimedia and sociopolitical conditions and remains somewhat ephemeral in nature. In other words, what do we take as our ultimate object of study? The editors and authors of the present volume, as will be explicated in the following, have opted for a multidisciplinary and multimethodological approach. This anthology also reflects the present state of the field, in which researchers from heterogeneous backgrounds—whether American-trained film academics, Latin American–based scholars, or film archivists—are working with a variety of theoretical tools, methods, and assumptions to explore the unchartered waters of this history.

RECONSIDERING THE OBJECTS: NEW QUESTIONS, NEW APPROACHES

As a response to both the dearth of cinematic texts and the historical turn within film studies, a new generation of scholars has expanded the objects and methods central to the study of Latin American cinema. In many cases, these approaches have abandoned the national frameworks and medium specificity implicit in earlier text-based analyses to examine the transnational and intermedial dimensions of these cinemas. The chapters in this volume, for instance, explore the contexts in which films were made and consumed or in which film professionals developed their craft and created networks with others. As such, they provide a snapshot of a changing field of scholarly inquiry. While they analyze some films as texts, the chapters do not engage primarily in formalist readings of films.

Formalism has much to offer, but it comes with the tendency to read films that are well known and, at a minimum, extant. This necessarily excludes a great deal of film culture, particularly that from noncanonical traditions or practices that produced films that are "too minor, too low on the cultural hierarchy to deserve sustained interest."[25] This volume also departs from the work of a previous generation of film historians who employed archival methods to examine the growth of the studio system and who largely read formal developments through a materialist lens. While Los Angeles is the nexus, our interest here is filmgoing and filmmaking outside of "Hollywood" writ large. By examining the culture of Spanish-language cinema between Los Angeles and Latin America, this volume steps outside of dominant narratives that privilege developments within the studio system as well as those that examine other industries as a part of studies of national cinemas.

In terms of method, there is much in common here with the pathbreaking work that has been done by scholars of early and precinema who have offered a new model of approaching film history through their investigations of the heterogeneity of the first years of film. Fine-grained research into primary sources frequently served as the basis for upending received understandings of how cinema first developed. Ephemera, newspapers, magazines, private collections of papers, oral history interviews—all these are available to researchers even where the films themselves too often are not.[26] In the case of the chapters in this book, the authors have used such sources to illuminate the rich intermedial milieu of Los Angeles as a key site of Spanish-language film culture. Even so, it is worth noting here that in the same way that much work needs to be done regarding the recovery and preservation of Latin American and of Spanish-language films from pre-1960, the field remains woefully underresearched in terms of textual primary sources.

Perhaps more significantly, many of these chapters radically decenter the national. The developments that the authors describe defy simple categorization even though they certainly intersect with the framework of national cinemas. They trace a trajectory in which Spanish-language filmmaking and filmgoing cultures connect with the centrality of Los Angeles as home to the world's dominant film industry and yet do not remain tied to it. In an odd reversal of fortune, a Spanish-language filmmaking tradition that was born in Los Angeles remained, as it has been said, in the shadows, due in part to the city's social exclusion of the largely Mexican and Mexican American minority that made up the local Spanish-speaking audience. Ultimately, in the period of time covered by this book, Mexico emerged as the most significant producer of Spanish-language media, whether cinema or television, but this position was tenuous and existed within an extensive, interconnected firmament of producers and consumers in Latin America, Spain, and areas in the United States with significant Latino populations.

The chapters in this book also call into question the periodization that has characterized the history of cinema by dividing it into stages that correspond to the development of the industries in the United States (i.e., Hollywood) and Europe. As some of these chapters intimate, although do not make explicit, these eras do not fully apply to the development of cinemas in Spanish. This was an era of cinema born twice, again. As André Gaudreault and Philippe Marion have argued, in the beginning, cinema was born first as a technical innovation (the ability to record and project moving images) and a second time as a system of signification and a social, cultural, and economic institution.[27] One might well ask whether this double birth also applies to cinema as a global practice. Did some cultures come sooner, or later, to it? The history of Spanish-language film-making and filmgoing suggests that film cultures that developed outside of Hollywood and the major European producers were not simply derivative, as they have been portrayed for too long.[28]

The transition to sound was key to the rise of Spanish-language filmmaking. This may seem to be a truism because language, particularly spoken language, did not become fundamental to the cinema until the technical innovation of synchronized dialogue became widely used, but it is not. The history of the transition to sound has yet to give the centrality of spoken language its full due. In this case, synchronized film sound was a new technology, or first birth, while Spanish-language filmmaking in all its cultural variants was a second birth. It was the protective effect of language differentiation that provided the basis for robust filmmaking to arise in Spanish-speaking countries or diasporic communities. While standard histories of the transition to sound have argued that Hollywood easily weathered the challenge of maintaining its hold on foreign-language audiences, this claim overlooks the fact that while a few Spanish-speaking countries had modest silent film production, none had a substantial film industry until after sound came in. Hollywood may have remained the world's dominant industry, but without question, its English-language films lost market share in the Spanish-speaking world that has never been regained. It was as *social, cultural,* and *economic institutions* that Spanish-language sound film developed, not merely as the use of the technological innovation of synchronized sound systems—not all of which, it might be noted, were developed by Hollywood studios. This framework, then, is significant because it drives the choices that researchers make as they seek, identify, and select primary sources. We can see this dynamic in action in this book, as the authors have incorporated a wide and intriguing range of previously untapped sources to illuminate the many ways in which Spanish-language cinema(s) grew and expanded between Los Angeles and Latin America.

A number of chapters in this volume revise (again implicitly) notions of pre- and early cinema that are normative. Urban Spanish-speaking audiences continued to frequent popular theatrical performances for much longer than did

their English-speaking counterparts in the United States. These theatrical tradi-
tions provided the inspiration for narrative genres, stock-character types, and a
vast network of actors, writers, musicians, and so on for early Spanish-language
filmmaking. Filmic modes that were established within Spanish-language film
cultures certainly drew from the formal and narrative conventions of Holly-
wood, but the theatrical traditions that had informed silent film in the United
States were not Spanish, Latino, or Latin American. Spanish-speaking audi-
ences were indeed familiar with the conventions of silent cinema, but they had
become accustomed to seeing these films even as they continued to enjoy popu-
lar theater—sometimes interleaved with silent film showings in the same ven-
ues. While this also was the case with very early cinema showings in the United
States and Europe, feature-length silent films soon replaced live entertainment
at most popular theaters. Likewise, while the influence of theatrical practices,
both serious and popular, on early silent filmmaking is well known, this waned
by the 1910s. In the Spanish-language cinemas that arose once sound came in,
theatrical antecedents had a similarly formative impact on films, but these were
incorporated into cinematic practices that were formally much more complex
than in the early silent period, and most significantly, they allowed for the use
of highly sophisticated verbal and musical material. As a number of chapters in
this volume show, the impact of Latin American and Spanish popular theater on
Spanish-language sound film was profound. Beyond these, one might think of
examples such as the phenomenal success of a performer like Cantinflas—whose
persona as a *pelado* and whose deft wordplay derived from the *carpa* (tent) the-
atrical tradition—or of the *ranchera* films kicked off by the 1936 hit *Allá en el
Rancho Grande* (*Over on the Big Ranch*; Fernando de Fuentes, 1936) that mixed
local musical styles and narrative genres with U.S. American forms such as the
singing cowboy films.

It is striking how dismissive many film histories are of popular cinema
produced outside of Hollywood. As noted earlier, in the case of the Spanish-
speaking cinemas of Latin America, until quite recently, even histories that con-
centrated on the region or were produced within it tended to regard the popular
films and genres before the 1960s with some disdain. Only with the rise of New
Latin American Cinema did film critics and historians begin to take seriously
the region's filmic contributions. What is at stake here is the popular: popular
cinema outside of that produced by Hollywood has had a problematic place in
film history. Unlike art or explicitly political films, both of which have long been
used to define national cinemas, popular films fit uneasily into the neat dichot-
omy between Hollywood and the rest of the world. Such films, which may have
been very successful with their target audiences (outside of Hollywood and Bol-
lywood, very little popular filmmaking aims to have global appeal), frequently
do not lend themselves to formalist analysis or auteur approaches. They both
require and reward analysis that is rooted in a strong understanding of local

political contexts and industrial conditions and a deep knowledge of relevant cultural referents.[29] These are not minor corrections to dominant narratives of the history of world cinema. Expectations about where groups of films or stages of development fit into these narratives powerfully shape research agendas.[30] Reexamining the periodization of national and regional film histories, employing new types of sources, and emphasizing local contexts as a way to read films or genre conventions are all aspects of the methodologies that authors have used in this volume to come to new insights and fresh conclusions about not just the nature of the region and time period covered but how the films contribute to a larger reimagining of global cinema.

In the case of Los Angeles's Spanish-speaking theaters, it was the arrival of sound film combined with the effects of the Great Depression that finally curtailed the staging of live entertainment for popular audiences and gave way to movie theaters. Even so, in the crucial first few years of film sound when the large majority of Spanish-language sound films were being made in Los Angeles, live entertainment theaters were able to stay afloat longer than they might have otherwise by showing films. These showings were sometimes star-studded premieres where audiences could enjoy having the film introduced by its director or lead actor.[31] However socially marginalized the Mexican and Latino community was in LA, through these theaters people were connected to a much larger cultural community that encompassed Latin America and Spain. Indeed, like audiences in those countries, Spanish-speaking Angelenos saw offerings from multiple countries in their native language—something that would have been an uncommon experience for most Americans. As Horak's chapter details, movies shown at Spanish-language theaters in downtown Los Angeles included films produced not just in Los Angeles and Mexico but also in Argentina, Spain, and Cuba. Thus audiences had the opportunity to become familiar with stars from a number of countries and whom they frequently saw appear in films produced in more than just the actor's country of origin. In this sense, audiences in Los Angeles, like their counterparts elsewhere in the Spanish-speaking world, had access to another star system. This was more modest in scope than that of Hollywood, but it was nonetheless significant.[32] This Spanish-speaking talent also freely crossed national borders, often working in multiple countries during their careers. Audiences could also access a range of films that employed different genres and narrative conventions than those produced by Hollywood right in the city where they lived, films that spoke to other experiences and cultural traditions.

PLACE MATTERS: LATIN AMERICAN CINEMA IN LOS ANGELES

If these observations hold true and the experiences discussed in this book point in the direction of fluidity rather than fixedness, why then should we emphasize Los Angeles? To begin with, cultural geographers have considered why

categories such as identity should be looked at through place-based models, arguing that while identity might not be fixed, it is nevertheless "situated."[33] Here we are using this notion as a means to consider how the concentration in Los Angeles of a major film industry, a diasporic group of film professionals, and an emerging ethnic community became dynamically and reciprocally linked to filmmaking and filmgoing in Latin America. As the following chapters will demonstrate, a place-based study resonates with the new approaches and questions outlined previously, just as it forces us to revise the analytical frameworks and geographical boundaries by which Latin American film history has typically been understood. If the nature of Los Angeles's Spanish-speaking audiences raises questions about nationalism and identity, for instance, the circulation of Spanish-speaking film professionals among multiple industries raises them about nationalism and cultural production. This was particularly the case during the time period covered by this book, when Latin American nations were often fiercely nationalist in terms of economic policy and cultural politics. In such a scenario, the reality that film professionals faced—in which nascent industries often could not support steady employment and moving around to follow opportunities was common—meant that the vision of or appeals to the national through film were often undergirded by surprisingly multinational film casts and crews.[34]

As one scholar of industrial organization has noted, film production "rests upon intricate and informal social relations between people who know each other through previous projects, and who often re-use previously built trust for future projects."[35] It is easy to see how this observation holds true for Hollywood, with its tight-knit, often even familial bonds that characterized the development and consolidation of the studio system. In the case of professionals who worked in Spanish-language filmmaking, it can be considerably less obvious yet crucial to understanding the dramatic growth of sound industries in Mexico, Argentina, and Spain (and, to a lesser extent, other countries in Latin America). Ana M. López has traced the circulation of a number of key figures in Latin American cinemas during the 1940s and 1950s and has emphasized the significance of "cross-fertilization" in the development of distinctive and highly popular film genres in the region.[36] In this volume, authors such as Gunckel and Avila continue to work in the direction of the transnational development of genres. The authors also do much to illuminate the cultural and economic geography that not only link a vaguely defined experience in "Hollywood" with later developments in Latin America but articulate the specific connections in terms of production, distribution, and exhibition that grew out of networks that were often born in Los Angeles during the formative years of Spanish-language filmmaking. As chapters like those of García Besné and Tremps, Hoechtl, and Horak show, these relationships led to fruitful partnerships and novel ways to develop markets for sound films in Spanish. It is often the specific ties to a Spanish-speaking community

of film professionals, along with connections to the English-dominant culture of the Hollywood studio system, that explain the complicated relationship of cinema between Los Angeles and Latin America.

From another perspective, the chapters in this volume compel us to reevaluate Los Angeles's position within film historical narratives, reframing it as a crucial site of interface between multiple film industries and audiences and as a global "media capital" for Latin American (particularly Mexican) cinema. Michael Curtin, writing primarily about contemporary broadcasting, has proposed this concept as a way of accounting for multidirectional media flows facilitated by globalization. As such, cities are characterized by "interactions among a range of flows (economic, demographic, technological, cultural and ideological) that operate at a variety of levels (local, national, regional and global)."[37] From the perspective of Latin American cinema, this lens allows for analyses that transcend yet encompass the nation while undermining the notion of unidirectional media flows. Whereas this framework is most frequently applied to the intensification of such dynamics in the contemporary moment, it is an equally useful way of revisiting transnational media exchanges of the past, which often resemble globalization avant la lettre. Considering Los Angeles as a *Latin American* media capital—distinct from yet intersecting with Hollywood—challenges the idea of Los Angeles as only the unidirectional exporter of cinema to the rest of globe, situating it instead as a vibrant site of interface and intersection.

It almost goes without saying, however, that in the field of cinema and media studies, Los Angeles has most frequently been equated with Hollywood. While historical studies of exhibition in the United States have moved beyond an initial focus on New York to examine rural exhibition, small towns, and other major cities like Chicago, cinema scholarship has overwhelmingly approached Los Angeles as a site of production rather than consumption.[38] And while a handful of works have examined the relationship of the city to its cinematic representation, few have addressed the rich fabric of film or entertainment cultures that flourished as the city grew into a major metropolis.[39] By the late 1920s, there emerged a vibrant theatrical culture in Los Angeles, and as the city expanded into a constellation of neighborhoods, it witnessed a constant proliferation of movie theaters coincident with the consolidation of Hollywood as a vertically integrated industry. As the expansion of film production, film exhibition, and the city's population marched hand in hand, multiple venues sprung up in different parts of the city to serve its black and Jewish residents—along with communities of Chinese, Japanese, Filipino, and Mexican descent. As multiple scholars working primarily from the vantage point of ethnic studies have demonstrated, these vibrant film cultures provided ethnically or linguistically specific entertainment, fulfilled important social functions, and served as sites from which conceptions of community and identity were both formulated and contested.[40]

The city's Spanish-language, Latino-oriented film culture in particular provides new ways of considering the intersections among the history of entertainment in urban Los Angeles, the historical operation of Hollywood, and the relationship of both of these to other international film industries. To be certain, the chapters in this volume aspire to rethink the film historical frameworks, including questions of periodization and technology, which are derived from the study of Hollywood. Nonetheless, this vibrant film culture at times operated as a key interface between Hollywood and a population that variously functioned for the industry as labor or talent, as an audience, and as source material from which Hollywood elaborated its imaginary of Latin America. It is also an ideal vantage point from which to understand Hollywood as a fundamentally transnational industry, one that relied on and cultivated connections to other industries. Latino Los Angeles offered a multilayered set of linkages with and exchanges between Latin America as a market while indirectly shaping Hollywood's representation of Latinos and Latin Americans onscreen.

In terms of urban history, we might begin with a brute fact: between the 1920s and 1960s, there were more than fifty Spanish-language theatrical venues or movie theaters in Los Angeles. These were spread around the city, located in both neighborhoods and the city's bustling downtown. As our research for the Getty project revealed, it was in such theaters that more than 1,000 individual Spanish-language films were shown before 1960—many of them repeatedly. While most of these were from Mexico, this figure includes Spanish-language films produced in the United States, approximately 150 Argentine features, and a significant number from both Spain and Cuba (including Mexican coproductions). Although these theaters and their offerings were undeniably part of the urban fabric during the period in question, their existence has largely been forgotten, and their historical documentation, until recently, has been relatively sporadic. What these figures do suggest, however, is that any history of film culture and exhibition in Los Angeles is incomplete without an acknowledgment of this history. In fact, almost every remaining theater in downtown Los Angeles was at one point a Spanish-language venue; this is as much a part of a theater's historical significance as the architect who designed it or the studio-owned chain that once operated it.

But what might we make of the presence of these theaters aside from the undeniable fact of their widespread and ongoing existence? Their role within the city's Spanish-language (and primarily Mexican) film culture, tied to particularities of exhibition practice, allow us to understand exactly how they functioned as a crucial nexus between multiple industries and their audiences. From their earliest inception in the early 1910s, these theaters integrated film screenings into vaudeville-like entertainment or alternated between cinema and theatrical programming. By the mid-1930s, with the consolidation of Mexican cinema, the inauguration of Frank Fouce's chain of downtown theaters, and the opening

of a branch of the Azteca Films distribution company in Los Angeles (1935), the synergy and cross-pollination between multiple media became fundamental to the logic of their operation. Film screenings would be proceeded by musical revues or star appearances, theaters hosted variety shows that featured film stars or popular musicians (who also often appeared in films), Spanish-language radio programs broadcasted from theaters, and variety shows would be based on radio shows, well-known songs, or popular films. Records and radio shows would feature songs made popular by films, and conversely, the films themselves would often be based on such songs—or at least integrate them into their titles. All these connections were in turn manifest and explicitly emphasized in the Spanish-language press and in publicity for the theaters.

If the success of these theaters and their popularity with audiences can at least partially be attributed to this mutually reinforcing synergy among media, the same might be said of the popularity of Latin American cinema within the United States. In other words, both Mexican and Argentine cinemas were intermedial phenomena from the inception of sound onward. The understanding of them as such is fundamental to gauging the significance of these theaters in Los Angeles as a nexus that linked multiple film industries. As should be apparent from the aforementioned range of entertainment these theaters offered, they became crucial sites through which a substantial amount of Latin American talent circulated. From the mid-1920s through the 1970s, actors and musicians traveled throughout California, Texas, and the U.S. Southwest, performing at the extensive circuit of Spanish-language theaters that at one point reportedly numbered over five hundred.

Major cities like San Antonio and Los Angeles, however, offered these individuals unique opportunities to capitalize on their respective talents. As the importation of records from Mexico was almost nonexistent before 1955, musicians produced recordings in the United States for the benefit of their audiences on this side of the border. An older brother of Mexican film producer José Calderón, Mauricio, operated a music store on North Main Street with a music publishing business, which probably functioned as a catalyst for the Calderóns' extensive use of popular music in their productions once sound arrived. Live performances served as de facto advertisements for these recordings, as would appearances on local radio stations. In Los Angeles, artists would grant interviews and conduct publicity with the Spanish-language newspaper *La Opinión* and, after 1947, with the magazine *La Novela Cine-Gráfica*, both of which circulated throughout the Spanish-speaking United States and beyond. Latin American trade magazines like Mexico's *Cinema Reporter* also had correspondents stationed in Los Angeles to cover both Hollywood and the activities of Mexican stars on tour.

The proximity of these theaters to Hollywood and the frequent travels of Latin American talent to Los Angeles meant that the studios presented them with another opportunity. Of course, the most extensive presence of Spanish-speaking

talent in Hollywood was during the short-lived production—by studios and independents alike—of Spanish-language film in the years following the transition to sound. As multiple scholars have demonstrated, the eventual suspension of this practice (or at least, its increasingly sporadic nature) prompted the return of talent to their countries of origin, where many would participate in the birth of sound film industries. For many, however, this "return" was far from unidirectional or fixed; instead, it may have been more circular and recurring. Major stars like Dolores Del Rio and Pedro Armendáriz, for instance, worked in both Hollywood and Mexico from the 1940s to the 1960s. Mexican actress Lupita Tovar began her career in Hollywood, performed in Spanish-language versions at Universal (including *Drácula*), returned to Mexico to star in that country's first sound feature (*Santa*), and would continue acting between both industries. In the late 1930s, for example, she appeared in several Spanish-language versions of George Hirliman's B-movie productions. As Hollywood definitively abandoned Spanish-language versions by the 1940s, Spanish-speaking talent was recruited into the preferred practice of dubbing for the purposes of international distribution. While this labor remained largely invisible, it was nonetheless extensive; it provided such a significant financial incentive for Mexican talent that the Mexican industry had to negotiate some accommodation with Hollywood studios during the 1940s.

Adding another layer to this dynamic interface among industries, Hollywood's onscreen versions of Latin Americans and Latinos during the studio era were never only aimed at U.S. audiences. Rather, as the cycle of Pan-American films of World War II makes patently apparent, these images were representational strategies that also aspired to appeal to audiences in Latin America. This is evident not only in the recruitment of Latin American talent but also in the studios' adaptation of the generic formulas and cross-media synergy so central to Latin American cinema of the period. That is, as Hollywood sought to strengthen its foothold in the Latin American market in the early years of World War II and then to recapture it in the postwar era, they borrowed inspiration and actors from the *comedia ranchera* genre, the ascendancy of which was cemented by the immensely popular *Allá en el Rancho Grande*. The success of these efforts was decidedly mixed, as Latin American audiences and critics often voiced their distaste for Hollywood's cinematic representations of them. It was precisely for this reason that Hollywood agreed to offer support and technology to the Mexican industry during the war, providing the infrastructure that would sustain the Golden Age. Nonetheless, Mexican cinema as a multimedia phenomenon—and its stars who shuttled among screen, stage, radio, and record—offered a model for Hollywood to reach out to audiences in this market. Again, it was through the Spanish-language theaters and their exhibition practices that these media most forcefully interacted and converged, where the nature of Mexican cinema

was consistently made most visible and audible while drawing its major talent to Los Angeles.

The ongoing presence of talent and the success of Mexican cinema thus arguably influenced Hollywood's representational practices and visions of Latin America. As Ana M. López has argued in relation to Hollywood's cycle of Pan-American films, Hollywood studios approached the representation of Latin America in a way that resonated with ethnography, actively generating its own interpretations of the continent and its peoples rather than representing any preexisting reality.[41] This tendency is nowhere more apparent than in Disney's short *South of the Border with Disney* (1942), a documentary that chronicles the research animators did in South America, a gathering of images and material that magically transforms onscreen into the characters that would be featured in *Saludos Amigos* (1942). While such imagery is usually associated with tropes of a tourist or ethnographic gaze directed at exotic lands, there was also a "foreign" element readily available to studios due at least in part to talent drawn to Los Angeles and its Spanish-language film culture. While there is some scattered evidence to suggest that studios used Mexican-oriented theaters as testing grounds for material or as a way to gauge audience taste, these venues and their exhibition practices were part and parcel of Hollywood's relationship to and representation of Latin America. This prompts a revision of the imagined geography of Hollywood as an international enterprise that sent films abroad and gathered feedback from critics, distributor agents, and audiences about regional preferences. Rather, Latin American film culture in Los Angeles functioned as a multidirectional, transnational nexus among Hollywood, film audiences foreign and domestic (and "foreign" domestic audiences), international talent, and Latin American cinema.

As one of the Mexican industry's most lucrative markets—and one whose criticism and coverage circulated throughout the Spanish-speaking world—the city also exerted a substantial influence on a cinema so frequently understood in national terms. Whether Mexican producers considered it a metropolis within "greater Mexico" (and one that returned revenue in dollars) or as a facet of their broader international market, Los Angeles as a nodal point played a crucial role in the ongoing development of Mexican cinema. As García Besné and Tremps demonstrate in their chapter in this volume, the Mexican industry's ability to gauge the preferences of Los Angeles audiences extended beyond the box office draw of certain stars or genres. Pedro and Guillermo Calderón, the owners of Producciones Calderón, for instance, relied on their uncle Mauricio Calderón, owner of the popular downtown music store Repertorio Musical Mexicano, to rank the records and artists that were most popular with his clientele. This information, in turn, greatly influenced the stars, songs, and properties that would shape the Calderóns' production priorities.

It is this kind of insight, derived from archival sources, that is fundamentally altering the way scholars approach Latin American cinema. The aforementioned methodologies represented in this book, aside from registering the historical turn in film studies, take as their point of departure the inability to conceptualize national cinemas in strictly national terms. That is, it is increasingly apparent that the long-standing method adopted by Latin American film studies—the close textual analysis of films as allegories or interrogations of the nation—does not adequately capture the multidirectional, intermedial, and transnational exchanges that defined Mexican cinema and the various audiences it sought to address.

If music and stardom were central to the success and transnational circulation of both Argentine and Mexican cinema, these elements were also at the heart of their appeal to local audiences in Los Angeles. So while we might ascribe to these theaters a particular position within the industrial logic of both U.S. and Latin American film industries, these very elements also held important cultural significance to audiences (which also explains why industries would attempt to harness this appeal). While direct audience response and ethnographic data, given historical distance, are either scant or nonexistent, the consistent popularity of the theaters, the publicity they generated, and the accounts in the Spanish-language press offer insight into the diverse and pervasive appeals of Latin American film culture in Los Angeles. As both Laura Isabel Serna and Colin Gunckel have elsewhere demonstrated, Latino audiences often identified with stars like Dolores Del Rio and Ramón Novarro, as Spanish-language publicity in both Latin America and the United States used them as mechanisms to create a unique, culturally specific relationship to silent-era Hollywood.[42] The ongoing recruitment of Latin American talent endeavored to reproduce this successful dynamic throughout the studio era—with mixed results. As Desirée J. Garcia has argued, the musical dimension of films like *Allá en el Rancho Grande* also successfully capitalized on the nostalgia of immigrants unable to return to Mexico.[43] Indeed, publicity for the theaters not only emphasized the musical dimension of these films—often reprinting the lyrics to the songs they featured—but also directly appealed to both a sense of nostalgia and evocations of national pride and identity. As the abundant Spanish-language film criticism published in the United States attests, this film culture also provided a forum in which the terms of nationality, language use, belonging, collective identity, and politics of media representation were contested and adjudicated. These issues became particularly salient as prolonged presence in the United States and successive generations challenged strictly national terms of identity to explore hyphenated or negotiated conceptions of self and community, a process explored most fully by George Sánchez in his influential book *Becoming Mexican American: Ethnicity, Culture, and Identity in Chicano Los Angeles, 1900–1945* (1993).[44]

The very notion of a collective category—along the lines of Hispanic or Latino—was under construction during the time period covered by this book; it was only beginning to be clearly articulated by those who would have been included within it. Still, film offerings, advertisements, fan culture, and the like increasingly spoke to an identity that had roots in Latin America and was expressed partly through language (to enjoy this film culture, one needed to be a fluent Spanish speaker) but to which the experience of living in Los Angeles and, by extension, the United States, was integral. This culture of filmgoing constituted a mode of public address that defined a new social situation.[45] It is difficult to overstate how deeply paradoxical this situation was. Latinos in Los Angeles were at the very heart of the world's leading film industry, but they were simultaneously forming and being formed by a filmmaking and filmgoing culture that was not *of* Hollywood or of Latin America or one of its nations—except in a diasporic sense. If, during the decades covered by this book, this experience of being connected but not fully belonging to a national or regional identity as expressed by Spanish-language filmgoing culture in Los Angeles was in some ways troubling, it was also characteristic of certain trends in Spanish-language film production. In this sense, Los Angeles audiences were at the crux of an experience of modernity in which older notions of identity were being revised and of globalization in which cultural production ceased to be fixed.

LOS ANGELES AS TRANSNATIONAL NODAL POINT FOR LATIN AMERICAN CINEMA

The importance of Los Angeles as a center of Latin American film culture, specifically Mexican film and theater activity, has been underrepresented in the literature. Until the publication of Lisa Jarvinen's *The Rise of Spanish-Language Filmmaking* and Colin Gunckel's *Mexico on Main Street*, Los Angeles as a site for the production, distribution, and exhibition of Spanish-language cinema was virtually invisible in any historical narrative, even those focused on Hollywood. In point of fact, as mentioned previously, attempting a geographical focus when discussing the history of classic Latin American cinema can be extremely productive, not only in terms of filling in some of the historical gaps that presently exist in that narrative, but also in terms of explicating Hollywood's relationship to other national cinemas. Los Angeles must be seen as a transnational nodal point between the American film industry and its Spanish-speaking neighbors to the south.

Highlighting the question of audiences and reception also allows authors in this volume to break out of some of the historiographic issues discussed previously. While reception is notoriously difficult to study, a number of the chapters engage with the "rhetoric of reception" insofar as they examine the cultural context of LA's Mexican theater and film world. How were films pitched to

imagined audiences and how were audiences' responses in turn portrayed and interpreted?[46] This work is significant in the context of Los Angeles in relation to Latin America because it leads us to interrogate the notion of *Latino* as constructed through audiovisual media.[47] Certainly within LA, Spanish-speaking audiences largely consisted of Mexican immigrants and Mexican Americans, and thus previous studies have often emphasized the experiences of these groups in relation to films that frequently came from Mexico.[48] Yet larger issues of diasporic identity were also at stake. One of the most vexing aspects for critics at the time and for film historians since about the Spanish-language films produced in Hollywood has been how to understand them in relation to the national.

In chapter 1, Jacqueline Avila makes a key contribution to understanding Mexican film culture in Los Angeles by analyzing the influence of a widespread theatrical practice in Mexico at the beginning of the twentieth century—namely, the *teatro de revistas*. Avila theorizes that the revistas were a symbol of cultural nationalism that perpetuated national archetypes with specific sound and musical associations and also engaged in social and political commentary. Not only were examples of this theatrical genre precursors to Mexican sound films; many were indeed adapted as sound films. As revista companies traveled to Los Angeles, the local Mexican-inflected theatrical culture reterritorialized and absorbed local musical and theatrical culture to create a distinctive cosmopolitan practice that reshaped interpretations of Mexican nationalism.

Desirée J. Garcia looks at a particular film and film star in chapter 2. Taking the production of *Ramona* (Edwin Carewe, 1928) as the starting point, Garcia positions Mexican actress Dolores Del Rio as one of the most important figures for identification in the growing Los Angeles Mexican American community in the early 1930s. The reception of the film, on the other hand, reveals fissures in the social fabric of the city, if only by delivering a message of tolerance while reminding Spanish-speaking Angelenos of the ethnic stereotyping and discrimination they were still subject to because of their skin color, culture, and nationality. Garcia aptly demonstrates that a single film, directed toward and exhibited to very different audiences, can produce a disparate range of meanings, affects, and associations.

In chapter 3, Viviana García Besné and Alistair Tremps look at the founding years of one of the Mexican industry's family dynasties—the Calderón family, who ran a major film business with exhibition, distribution, and production branches. García Besné is a descendant of the Calderóns and, along with Tremps, made the highly regarded documentary *Perdida* (2009), which examines the controversial history of the films that her family ultimately produced—ones that she had been told were the "worst" of all of Mexican cinema—and the ways in which the rise and fall of the dynasty often paralleled that of the industry itself. An important theme of that film and, to an extent, the chapter in this volume, is that popular tastes were often at odds with ideas about what the national imaginary

should be. Here García Besné and Tremps take us back to an earlier era to recount how the family business was founded during the years of the Mexican Revolution in towns and cities of the U.S.-Mexico borderlands. Due to their unique access to the family archives, the authors are able to document some of the family's key business decisions and practices. For instance, they deal with the question of translation for Spanish-speaking audiences during the silent era, when intertitles in American films posed a problem not just of language but also of literacy—an important precursor for how issues of translation would play out during the sound period. Of most interest for this volume, they show the significance of audiences for Mexican films who were living in the United States to the production choices of the family business once it had been established as one of the most important brokers in the Mexican film industry. Strikingly, we see that the tastes of Los Angeles audiences drove choices that were products of an often deeply nationalist industry, again demonstrating the fruitfulness of looking through a Los Angeles lens.

Next, Lisa Jarvinen's chapter expands on her remarkable book *The Rise of Spanish-Language Filmmaking*, the definitive historical account of Spanish-language Hollywood. In the present volume, she reconsiders Hollywood's production of Spanish-language films in the 1930s by arguing that the industry's response to the language barrier was greatly shaped by the city's proximity to Mexico and its relationship with Latin America, including a substantial population of Spanish-speaking immigrants. More than only explaining Hollywood's response to the challenges presented by the transition to sound, these factors also briefly allowed it to become the epicenter for Spanish-language cinema produced outside of studios. Independent filmmakers from various nations of origins, for instance, took full advantage of the city's congregation of Latin American talent while catering to audiences eager to see cinema in their own language. Quite provocatively, Jarvinen also argues that this combination of factors facilitated a nascent "Latino audiovisual culture" that predates what we typically understand as the birth of Latino media. It was the city's intertwined position as an internationally oriented production center and the transnational convergence of both talent and audiences that facilitated early articulations of now familiar collective identities like Hispanic or Latino.

After Jarvinen's focus on LA Spanish-language film production, Jan-Christopher Horak in chapter 5 uncovers the lost history of an independent Mexican American film production company that produced two films in the late 1930s in Los Angeles, demonstrating that LA was a center for the production, distribution, and exhibition of Spanish-language cinema in the classical era. It is an astonishing fact that a minority-controlled film system existed under the noses of the Hollywood studios, despite their alleged monopoly on all American film, yet has remained invisible in American film historiography. As the director of the UCLA Film & Television Archive, Horak became aware of the fact

that the archive held surviving materials on a number of Spanish-language films produced in Los Angeles. In discussing Cantabria and other independent Mexican American producers in Los Angeles, Horak demonstrates that the ability to succeed was dependent on a matrix of factors but that the distribution politics of the major film studios that often picked up these films was a major cause of their ultimate failure. Furthermore, in presenting a quantitative analysis of all Spanish-language films screened in LA's downtown theaters in the late 1930s, Horak theorizes that the city sustained a vibrant oppositional cinema despite being in Hollywood's back yard.

In chapter 6, Colin Gunckel examines case studies of films produced, adapted, remade, or repurposed between the United States and Mexico, arguing that hybrid films and cinematic anomalies reveal the ways that both industries functioned transnationally. As a scholar of both U.S. Latino popular culture and Mexican cinema, Gunckel brings these fields into a productive conversation. On the one hand, he suggests that Mexican cinema's attempt to attract English-speaking audiences in the United States has been overlooked and underestimated in historical accounts of this industry. The case studies in question suggest that producers and distributors navigated a peculiar territory between exploitation and art markets as a way of distinguishing these films from Hollywood fare in the competitive U.S. market. On the other hand, Gunckel also argues that Hollywood's own attempt to garner Latin American markets relied on lessons learned from Mexican cinema—from its star system to the synergy between cinema and music. On both counts, he traces previously unexamined connections between Mexican film history and the history of Latino representation in U.S. cinema, arguing that scholarship in both areas has failed to take their historical interdependency into account.

Finally, Nina Hoechtl in chapter 7 reminds us that Los Angeles is now again a majority Latino city and that elements of its Mexican culture have survived from the early twentieth century to the present day. Hoechtl's work as an artist and researcher is highly interdisciplinary, so it is not surprising that her chapter intersects with architecture, Latin American cultural studies, and audience reception studies. Focusing on the Mayan Theater, which opened in Los Angeles in 1927 and became a prominent space for both Mexican films and live performance, Hoechtl theorizes that the theater's Mesoamerican-infused architecture and decoration not only supported the nationalist aspirations of the films screened and theatrical presentations performed but also encouraged the memories of those audiences who had participated in such events. This is also true for recent performances of the Lucha VaVoom spectacle. The Mayan Theater can therefore be viewed as a Los Angeles–specific site that negotiated and/or contested race/ethnicity, gender, sexuality, and class for its audiences.

As these chapters suggest, the rich and multifaceted nature of Latino-oriented film culture in Los Angeles during the classical period resonates in a number of ways with the Getty Research Institute's LA/LA initiative. This cultural environment alone suggests multiple intertwined senses by which we might interpret this organizing concept: as the distribution and exhibition of Latin American cinema in Los Angeles, as the presence and circulation of Latin American talent in and through Los Angeles, as an undeniable affirmation of the transnational nature of U.S. and Latin American film industries, as a cultural milieu in which audiences deliberated the changing terms of what it meant to be Latin American in Los Angeles, and as a general confirmation that from a cinematic perspective (and otherwise), there has always been and will always be a Latin America in Los Angeles and vice versa. At the same time, this volume proposes that we understand Los Angeles during this period from multiple interrelated historical perspectives: as the global capital of film production, as a multiethnic urban environment with a myriad of overlapping entertainment cultures, as a major market for Latin American (and particularly Mexican) cinema, as a way for Mexican producers to gauge the preferences of U.S. Latinos, as an employment opportunity for Latin American talent, as a site of interface between Hollywood and multiple film industries, and as a de facto Latin American metropolis. More than only asserting that the histories of Hollywood and Latin American cinema are inextricably intertwined, the chapters in this anthology propose a productive reconceptualization of both while prompting a reconsideration of Los Angeles and the role that both cinema and the city's Latino population had in shaping it.

Notes

1. Theater names vary based on the year and how the venue was being operated. For instance, the California Theater was first open with this name in 1918 but was known as the Teatro California in Spanish-language newspapers once it began featuring Spanish-language entertainment.

2. See Rogelio Agrasánchez Jr., *Mexican Movies in the United States: A History of the Films, Theatres, and Audiences, 1920–1960* (Jefferson, N.C.: McFarland, 2006). Photos of the premiere, an advertising truck for *Santa* in Los Angeles, and the California marquee survive at Permanencia Voluntaria. See also the chapter by Viviana García Besné and Alistair Tremps in the present volume, who argue that the event was staged by Mexicans with connections to Los Angeles.

3. See Allyson Nadia Field, Jan-Christopher Horak, and Jacqueline Najuma Stewart, eds., *L.A. Rebellion: Creating a New Black Cinema* (Berkeley: University of California Press, 2015).

4. Paul Rotha, *The Film till Now: The Film since Then* (London: Spring Books, 1970), 769.

5. Ana M. López, "Tears and Desire: Women and Melodrama in the 'Old' Mexican Cinema," in *Mediating Two Worlds: Cinematic Encounters in the Americas*, ed. John King, Ana M. López, and Manuel Alvarado (London: British Film Institute, 1993), 147–149.

6. Carl J. Mora, *Mexican Cinema: Reflections of a Society, 1896–1980*, 3rd ed. (Jefferson, N.C.: McFarland, 2012).

7. Paulo Antonio Paranaguá, ed., *Mexican Cinema* (London: British Film Institute, 1995).

8. See Chon A. Noriega and Steven Ricci, eds., *The Mexican Cinema Project* (Los Angeles: UCLA Film & Television Archive, 1994).

9. Andrea Noble, *Mexican National Cinema* (New York: Routledge, 2005); and Robert Irwin and Maricruz Ricalde, eds., *Global Mexican Cinema: Its Golden Age* (London: British Film Institute, 2013).

10. Agrasánchez, *Mexican Movies.*

11. Lisa Jarvinen, *The Rise of Spanish-Language Filmmaking: Out from Hollywood's Shadow, 1929–1939* (New Brunswick, N.J.: Rutgers University Press, 2012); and Colin Gunckel, *Mexico on Main Street: Transnational Film Culture in Los Angeles before World War II* (New Brunswick, N.J.: Rutgers University Press, 2015).

12. Charles Ramírez Berg, *The Classical Mexican Cinema: The Poetics of the Exceptional Golden Age Films* (Austin: University of Texas Press, 2015).

13. George Sadoul, *Histoire d'un art: Le cinéma des origines à nos jours* (Paris: Flammarion, 1964), 508ff.

14. Tim Barnard, ed., *Argentine Cinema* (Toronto: Nightwood Editions, 1986).

15. Matthew B. Karush, *Culture of Class: Radio and Cinema in the Making of a Divided Argentina, 1920–1946* (Durham, N.C.: Duke University Press, 2012).

16. Michael Chanan, *The Cuban Image* (London: British Film Institute, 1985), 5.

17. See, in particular, Stephanie Dennison and Lisa Shaw, *Popular Cinema in Brazil, 1930–2001* (New York: Manchester University Press, 2004); Randal Johnson and Robert Stam, *Brazilian Cinema* (New York: Columbia University Press, 1995); and Lisa Shaw and Stephanie Dennison, *Brazilian National Cinema* (New York: Routledge, 2007).

18. Manuel Alvarado, Ana M. López, and John King, eds., *Mediating Two Worlds: Cinematic Encounters in the Americas* (London: British Film Institute, 1993); Chon A. Noriega, ed., *Visible Nations: Latin American Cinema and Video* (Minneapolis: University of Minnesota Press, 2000).

19. Interview with Alejandro Pelayo, director of the Cineteca Nacional, August 2015, UCLA / LA Oral History Project.

20. In May 2009, Professor Dan Streible of New York University's Moving Image Archives Preservation Program led a cohort of twelve students to Buenos Aires to help the museum begin basic preservation of orphan films. See "NYU Professor Leads Team of Film Archivists on a Mission to Save Orphan Films at the Museo Del Cine, Buenos Aires," NYU news release, May 14, 2009, http://www.nyu.edu/about/news-publications/news/2009/may/nyu_professor _leads_team_of.html.

21. See Fernando Osorio, "The Case of the Cineteca Nacional Fire: Notes and Facts in Perspective," in *This Film Is Dangerous: A Celebration of Nitrate Film*, ed. Roger Smither (Brussels: FIAF, 2002), 142; Anthony Slide, *Nitrate Won't Wait: A History of Film Preservation in the United States* (Metuchen, N.J.: Scarecrow Press, 1992).

22. Under the rubric "Pacific Standard Time 2: LA / LA," the Getty Foundation funded more than seventy-five exhibitions in Southern California on the topic of Latin America in Los Angeles.

23. The original nitrate camera negatives are now stored at UCLA Film & Television Archive and are being preserved in analog and digital formats.

24. No other films from Fox or independent producers in Hollywood are known to survive.

25. Rob King, "Introduction: Early Hollywood and the Archive," *Film History* 26, no. 2 (2014): xii.

26. Richard Abel, "History Can Work for You, If You Know How to Use It," *Cinema Journal* 44, no. 1 (2004): 107–112.

27. André Gaudreault and Philippe Marion, *The End of Cinema? A Medium in Crisis in the Digital Age*, trans. Timothy Barnard (New York: Columbia University Press, 2015), 104–126.

28. This point has also been made about African cinemas. See, for example, Matthias De Groof, "Intriguing African Storytelling: On *Aristotle's Plot* by Jean-Pierre Bekolo," in

Storytelling in World Cinemas, vol. 1, *Forms*, ed. Lina Khatib (London: Wallflower Press, 2012), 126. Aaron Gerow has also made similar observations about silent Japanese film culture in *Visions of Japanese Modernity: Articulations of Cinema, Nation, and Spectatorship, 1895–1925* (Berkeley: University of California Press, 2010).

29. Dmitris Eleftheriotis, *Popular Cinemas of Europe: Texts, Contexts and Frameworks* (New York: Continuum, 2001), 68–80; Tim Bergfelder, *International Adventures: German Popular Cinema and European Co-productions in the 1960s* (New York: Berghahn, 2004), 3.

30. Bergfelder, *International Adventures*, 6.

31. Gunckel, *Mexico on Main Street*.

32. Ana M. López, "A Cinema for the Continent," in *The Mexican Cinema Project*, ed. Chon A. Noriega and Steven Ricci (Los Angeles: UCLA Film & Television Archive, 1994), 7–12.

33. Barney Warf, "Introduction: Fusing Economic and Cultural Geography," in *Encounters and Engagements between Economic and Cultural Geography*, ed. Barney Warf (Berlin: Springer, 2012), 2.

34. Ana M. López, "Crossing Nations and Genres: Traveling Filmmakers," in *Visible Nations: Latin American Cinema and Video*, ed. Chon A. Noriega (Minneapolis: University of Minnesota Press, 2000), 33–50.

35. Mark Lorenzen, "Creativity at Work: On the Globalization of the Film Industry" (Creative Encounters Working Papers, Copenhagen Business School, February 2008), 8, http://www.cbs.dk/creativeencounters.

36. López, "Crossing Nations and Genres"; and "Before Exploitation: Three Men of the Cinema in Mexico," in *Latsploitation: Exploitation and Latin American Cinemas*, ed. Victoria Ruétalo and Dolores Tierney (New York: Routledge, 2009), 13–36.

37. Michael Curtin, "Media Capital: Towards the Study of Spatial Flows," *International Journal of Cultural Studies* 6, no. 2 (June 2003): 222.

38. See, for instance, Kathryn H. Fuller, *At the Movie Show: Small-Town Audiences and the Creation of Movie Fan Culture* (Washington, D.C.: Smithsonian Institution Press, 2001); Kathryn H. Fuller-Seeley, ed., *Hollywood in the Neighborhood: Historical Case Studies of Local Moviegoing* (Berkeley: University of California Press, 2008); Richard Maltby, Melvyn Stokes, and Robert C. Allen, eds., *Going to the Movies: Hollywood and the Social Experience of Cinema* (Exeter: University of Exeter Press, 2007); Jacqueline Najuma Stewart, *Migrating to the Movies: Cinema and Black Urban Modernity* (Berkeley: University of California Press, 2005).

39. See Mark Shiel, *Hollywood Cinema and the Real Los Angeles* (London: Reaktion, 2012); and Celestino Deleyto, *From Tinseltown to Bordertown: Los Angeles on Film* (Detroit, Mich.: Wayne State University Press, 2017). Although the book covers the period before classical Hollywood, the exception to this tendency is the work of Jan Olsson, *Los Angeles before Hollywood: Journalism and American Culture, 1905–1915* (Stockholm: National Library of Sweden, 2008).

40. See José M. Alamillo, *Making Lemonade out of Lemons: Mexican American Labor and Leisure in a California Town, 1880–1960* (Urbana: University of Illinois Press, 2006); Linda España-Maram, *Creating Masculinity in Los Angeles's Little Manila: Working-Class Filipinos and Popular Culture, 1920s–1950s* (New York: Columbia University Press, 2006); Denise Khor, "Asian Americans at the Movies: Race, Labor, and Migration in the Transpacific West, 1900–1945" (PhD diss., University of California, San Diego, 2008); Laura Isabel Serna, *Making Cinelandia: American Films and Mexican Film Culture before the Golden Age* (Durham, N.C.: Duke University Press, 2014), 180–214.

41. Ana M. López, "Are All Latins from Manhattan? Hollywood, Ethnography, and Cultural Colonialism," in *Unspeakable Images: Ethnicity and the American Cinema*, ed. Lester D. Friedberg (Urbana: University of Illinois Press, 1991), 404–424.

42. Serna, *Making Cinelandia*, 123–153; Colin Gunckel, "Ambivalent Si(gh)tings: Stardom and Silent Film in Mexican America," *Film History* 27, no. 1 (Spring 2017): 110–139.

43. Desirée J. Garcia, "'The Soul of a People': Mexican Spectatorship and the Transnational *Comedia Ranchera," Journal of American Ethnic History*, 30, no. 1 (Fall 2010): 72–98.

44. George J. Sánchez, *Becoming Mexican American: Ethnicity, Culture, and Identity in Chicano Los Angeles, 1900–1945* (New York: Oxford University Press, 1993). See also Douglas Monroy, *Rebirth: Mexican Los Angeles from the Great Migration to the Great Depression* (Berkeley: University of California Press, 1999); and Vicki L. Ruiz, "'Star Struck': Acculturation, Adolescence, and the Mexican American Woman, 1920–1950," in *Building with Our Hands: New Directions in Chicana Studies*, ed. Adela de la Torre and Beatríz M. Pesquera (Berkeley: University of California Press, 1993), 109–129.

45. Marta Braun et al., *Beyond the Screen: Institutions, Networks, and Publics of Early Cinemas* (Bloomington: Indiana University Press, 2016), 4–5.

46. Eric Smoodin, "'Compulsory' Viewing for Every Citizen: 'Mr. Smith' and the Rhetoric of Reception," *Cinema Journal* 35, no. 2 (1996): 4–5.

47. Latinos are not, of course, only Spanish speakers, nor is this group primarily defined by language abilities. Nonetheless, over the course of twentieth (and into the twenty-first) century, the Spanish language became a frequently used marker to define media addressed to Latinos. See, for example, Arlene Dávila's discussion of the language question in *Latinos, Inc.: The Making and Marketing of a People and a Culture* (Berkeley: University of California Press, 2001), 151–180.

48. See, for example, Chon A. Noriega, *Chicanos and Film: Representation and Resistance* (Minneapolis: University of Minnesota Press, 1992); Rosa Linda Fregoso, *The Bronze Screen: Chicano and Chicana Film Culture* (Minneapolis: University of Minnesota Press, 1993); and Brian O'Neil, "Yankee Invasion of Mexico, or Mexican Invasion of Hollywood? Hollywood's Renewed Spanish-Language Production of 1938–1939," *Studies in Latin American Popular Culture* 17 (1998): 79–105.

CHAPTER 1

EL ESPECTÁCULO

THE CULTURE OF THE *REVISTAS* IN MEXICO CITY AND LOS ANGELES, 1900–1940

Jacqueline Avila

En el teatro de revista, todo es posible.
(In the theater of revues, everything is possible.)

—Armando de María y Campos,
El teatro de género chico en la revolución mexicana

The so-called *epoca de oro*, or Golden Age, of Mexican cinema (roughly 1936–1952) is composed of several film genres that are considered significant in the exhibition of *mexicanidad* (Mexicanness)—the cultural identity of Mexican people.[1] Genres such as the *comedia ranchera* (ranch comedy) and the prostitute melodrama, among others, offered varying interpretations of mexicanidad that often contradicted each other but maintained a wide public following. A major source of influence for these films was Mexico's *teatro de revistas* (theater of revues), also called *revistas* or *teatro de género chico*.[2] The revistas began as a popular theatrical practice at the turn of the twentieth century that was geared toward social and political commentary. Their popularity with the public and their malleable structure were instrumental to the success of Mexico's national film industry.

The revistas and early sound film shared several characteristics, including narratives, stock characters, and backdrops. Another significant element was the soundscape that included music, sound, and dialogue.[3] As revista companies traveled to Los Angeles during and after the years of the armed struggle of the revolution (1910–1920), the theatrical practice reterritorialized, absorbing local musical and theatrical culture and becoming a crucial space where the Mexican revista flourished. The result created a hybridized cosmopolitan practice that

31

perpetuated national archetypes with specific sound and music associations, developing soundscape models that were later used in Mexican synchronized sound films. This chapter examines those elements of cultural hybridization that shaped the teatro de revistas as it traveled from Mexico City to Los Angeles and how it may have contributed to and influenced Mexican cinema. The sound-scape shaped by the revistas in their eclectic theatrical structure transferred over into Mexican cinematic practice beginning in the 1930s, constructing a cultural and aesthetic bridge between popular theater and sound cinema. The influence of revistas on sound cinema in turn shaped exhibition practices in Los Ange-les, where film screenings were frequently combined with live performances that drew from this theatrical tradition.

TEATRO DE REVISTAS: CULTURAL HYBRIDIZATION

The Porfiriato—the thirty-five-year dictatorship of Porfirio Díaz (1876–1911)—is marked as a period of economic growth and modernization and one of oppres-sion and greed. One of the cornerstones of the Díaz dictatorship was the attrac-tion of foreign investors to help stimulate the economy.[4] This tactic centralized power within Mexico City, taking away employment from the local population and opening the economy to foreigners. As commerce and industry flourished, new consumer cultures developed in which cosmopolitanism became the embodi-ment of the elite class. Porfirian high culture embraced everything that was foreign, shaping Mexico City into a thriving modern and cultural center. At the core of this growing cosmopolitanism was a process of cultural hybridization that intersected the local and the global, creating new representations of mexicanidad.

Nestor García Canclini defines *hybridization* as the "socio-cultural processes in which discrete structures or practices, previously existing in separate form, are combined to generate new structures, objects, and practices."[5] The process of hybridization impacts popular culture and conceptions of national identity construction. García Canclini argues that "hybridization occurs under specific social and historical conditions, amid systems of production and consumption that at times operate coercively. . . . Another of the social entities that both foster and condition hybridization is the city."[6] The fin de siècle in Mexico City exhib-its several cases of cultural hybridization, and the teatro de revistas is one such example.

The revista fused several popular entertainments, including the French revue, the Spanish zarzuela, vaudeville, burlesque, and satire.[7] During the Porfiri-ato, Mexico City experienced an invasion of Spanish zarzuelas and Italian operas, sculpting an eclectic soundscape.[8] Zarzuelas held the most popular following as "the great capital became 'zarzuela-ized'" because the public flocked to the-aters to be entertained by narratives of romantic misunderstandings and musi-cal performances.[9] Although several Spanish zarzuelas have proven to be highly

influential in the revistà's development, *El año pasado por agua* (*Last Year for Water*; 1899) by Ricardo de la Vega and Federico Chueca served as an important model. Alejandro Ortiz Bullé Goyri asserts that various dramatic elements and musical numbers were taken from this zarzuela and reinterpreted, or "Mexicanized," for the Mexican stage. One such example is "Cuplé de la bombilla y la electricidad," which welcomes the modern invention of the telephone with grace and charm. The 1904 revista *Chin Chun Chan* by José F. Elizondo with music by Luis G. Jordá features a similar comical and flirty number entitled "El teléfono sin hilos" ("The Wireless Telephone").[10]

The revista is typically structured into one act that is divided into *cuadros*, or scenes, beginning with a prologue and containing various comical skits and musical performances.[11] Revista narratives centered on socially relevant topics and were geared toward the working class. According to Nicolás Kanellos, the revista "represented the birth of a truly Mexican national theater" that was revered for its piquant political and social commentary.[12] With librettos written by Mexico City journalists such as José F. Elizondo and Antonio Guzmán Aguilera (more popularly known as Guz Águila), the revistas at times provided biting criticisms on political and social issues and contemporary gender roles.[13] They focused on the everyday of Mexican society, emphasizing "the character, music, dialect, and folklore of various Mexican regions."[14]

The revistas were utilitarian, directed toward representing the pulse of the nation at politically unstable moments.[15] Armando de María y Campos posits that the Spanish zarzuela exemplified how to include political commentary on stage, but the Mexican revistas surpassed what the Spaniards offered: "The Mexican authors of political theater outperformed their teachers, the Spanish, in which they received . . . the first inspirations and discoveries of the formulas, 'machotes' (models) actually, for addressing political issues, extracting from the scenes the characters, or relating to them to suit their own purposes."[16] It was, however, not just contemporary politics that made its way onto the stage; the popular press and popular culture did as well. The revista *La cuatra plana* (*The Fourth Page*), written by Luis Fernández Frías, premiered at the Teatro Principal on October 28, 1899.[17] Its major source of inspiration was the fourth page of the popular periodical *El Imparcial* that featured advertisement inserts.[18] *La cuatra plana* highlights how theatrical entertainment and the press became inextricably intertwined to form an aesthetically significant part of popular culture.

THE SOUNDSCAPE OF THE *REVISTAS*

The revista soundscape refers to the variety of musical genres, sounds, and dialogues articulated on stage. References to the soundscape are discussed in historical studies of popular Mexican theater, providing a conception of what type of music and sounds were used and how they influenced various national symbols

and archetypes. As the revistas surged in popularity during the revolution, librettists used comedy and satire to criticize contemporary politics. Actors impersonated revolutionary leaders, among others, to appeal to the public.[19] The librettists often reinterpreted crucial events of the revolution with a comedic and ironic slant. One of the most popular *revistas políticas* (political revistas) was *El país de la metralla* (*The Country of Shrapnel*), written by José F. Elizondo with music by Rafael Gascón. According to de María y Campos, *El país de la metralla*, which premiered May 25, 1913, was a revista that conveyed "the traditional elements of the genre" and was set during "La Decena Trágica."[20] John Koegel states that this revista was both scandalous and successful, depicting the characters "Vespaciano Garbanza" and "Patata," satirical references to Venustiano Carranza and Emiliano Zapata. The revista also satirized the United States through its famous chorus line of singing Uncle Sams and featured "a French cancan danced to the rhythm of machine guns."[21] Intriguingly, the revista also introduced a character representing "the unknown economic and social phenomenon in Mexico," labeled "Mademoiselle Crisis." In a scene resembling "La maquinista del amor" ("The Machinist of Love") from the Spanish zarzuela *Las bribonas* (*The Impostors*; 1908), Mlle. Crisis enters in a gold suit, holding a whip and a golden bag. Men from several nationalities closely follow her, carrying an object that produces the sound of jingling change.[22] At the time of its premiere, Mexico had undergone severe political transformations due to a regime change that eventually led to Elizondo's exile and Gascón's suicide.[23]

El país de la metralla represents one of the first revistas políticas and showcases the eclectic structure of the cuadros with elements performed in the name of satire. Other revistas about or set during the revolution followed suit but utilized other types of music, including the *corrido*, the narrative musical genre that became a musical archetype of the revolution. Several corridos were performed in the revistas políticas, which included already composed examples such as "La Adelita" used in the revista *1914* by Alberto Michel and those composed especially for the revista such as "El income tax" from the 1924 revista *El income tax* by Juan Díaz del Moral.

The countryside represented another significant backdrop and became the revista's utopian space, untouched by the armed struggle as thousands moved toward Mexico City or the north. Villatic life with the presence of *charros* (Mexican horsemen) and the *china poblanas* (female counterparts to the charros)—depicted in the zarzuela *En la hacienda* (*At the Hacienda*; 1907) and the revistas *Las cuatro milpas* (*The Four Cornfields*; 1927), *El país de la ilusión* (*The Country of Illusion*; 1925), and *Tierra brava* (*Brave Land*; 1933)—offered audiences semblances of their lost rural home: "The cultural urban shock, the discrimination of the employers and the repression of acculturation allowed them to momentarily forget their troubles when the tandas presented an idealized version of rural life."[24] Musically speaking, these revistas featured performances of *canciones mexicanas*, *canciones campiranas*, and ballads.[25]

Figure 1.1. Libretto cover *El país de la metralla,* Mexico City, Talleres de Imprenta y Fotograbado "Novedades," 1913.

The cuadros of revistas typically featured a series of sketches and skits that consisted of rapid repartee among characters, often on nonsensical topics, articulated between musical interludes. These sketches and skits introduced a variety of characters that *sometimes* related to the narrative.[26] Since the revistas varied from week to week, actors may or may not have learned the lines thoroughly, relying heavily on improvisation. Luis Sandi states, "The actors have to

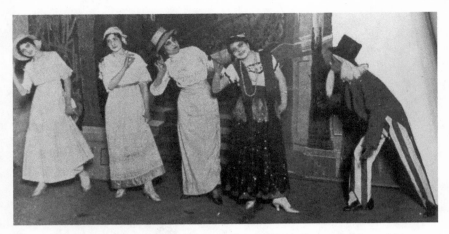

Figure 1.2. Photo still from *El país de la metralla* with Uncle Sam and china poblana, "Teatrales y sociales," *La Semana Ilustrada,* no. 191 (June 24, 1913).

learn, in a few rehearsals, the lines written by the authors in a few days. Those who will submit to this routine of uninterrupted treason to art are naturally not the finest."[27]

Often, these dialogues featured an important revista archetype: the *pelado*, a disheveled man who represented the urban underclass. Cultural critic Carlos Monsiváis defines the pelado as "the dangerous shadow of poverty in the expanding city, the nameless and almost naked threat, the figure of riot, robbery, assault."[28] The pelado represented one of the more scandalous revista characters because he was perceived as a negative stereotype of Mexicans, yet he remained popular with audiences. While the pelado at times sings songs, his dialogue defines him. Samuel Ramos explains, "The slightest friction causes him to blow up. His explosions are verbal and reiterate his theme of self-affirmation in crude and suggestive language. He has created a dialectic of his own, a diction which abounds in ordinary words, but he gives those words a new meaning."[29] Ramos, according to Jeffrey Pilcher, attributed this definition to Mario Moreno "Cantinflas," who was Mexican sound cinema's leading pelado. His manner of speaking, labeled as *cantinflando*, was a rapid verbal assault that utilized the vernacular: he says something without saying anything. Cantinflas, who began his career in the revistas and carpas, was one of several comics to take up the pelado character, which also included Anastaio Otero Tacho, who performed as a pelado as early as 1910.[30]

Musical borrowing was an essential component of the genre. Revista librettists and composers took dead aim at the theatrical origins, featuring Mexicanizations of the once revered Spanish zarzuela. Musical selections were often recycled from the zarzuelas because of the popular appeal: audiences enjoyed the songs, and their repetition in the revistas prompted the audiences to return. One

such example is the revista política *La tierra de los volcanes* (*The Land of the Volcanoes*; 1918), a libretto by Carlos Ortega and Pablo Prida with music composed by Manuel Castro Padilla. This revista contains a combination of original music, such as the bouncy song "Viva México" that provides nationalistic descriptions of Mexico's volcanic lands, and recycled music taken from the Spanish zarzuela *Panorama nacional* (*National Panorama*; 1889). One significant musical number in the zarzuela mirrored an exchange between grocery products. Placing this scene within a Mexican context, two actors dressed as "Pulque" and "Tequila" sing about indigenous populations in various parts of Mexico.[31] The borrowing or recycling of Spanish zarzuela melodies and narratives exemplifies the process of Mexicanization, in which theatrical material is reinterpreted for the local context.

Also crucial to the revistas were the *tiples*, the female singer-actresses, and the *vice tiples*, the female chorus line.[32] The tiples and vice tiples offered most of the musical performances during the interludes between cuadros. Some of the better-known tiples from the 1910s and 1920s include Mimí Derba, Lupe Rivas Cacho, Celia Montalván, Lupe Vélez, and the most famous, María Conesa. Conesa, popularly known as "la Gatita de Oro," had an already established zarzuela career in Spain and Cuba before her Teatro Principal premiere in 1907.[33] She was described as petite and thin, but during her performances, she transformed into a coquettish and erotic singer, bordering on the point of obscenity. Her talent came in her delivery of lines, which contained double entendres and an emphasis on words that drove the audience crazy. Some examples include "Cuplets de los curados" from *Verde, blanco y colorado* (*Green, White, and Red*; 1921) and "Que chulos ojos" from *Mexicanerias* (*Mexicaneries*; 1921).[34]

The tiples and the vice tiples played a significant role in the revistas during the 1920s with the French revue *Bataclán*. Laura Guitérrez asserts that *Bataclán* "came to signify the practice among female performers of exposing their skin while onstage."[35] *Bataclán*, led by Madame Berthe Rasimi, premiered at the Teatro Iris in the early 1920s, depicting scantily clad female performers.[36] The revue was a great success, not just for challenging what was deemed permissible on the Mexican stage, but also for exposing government officials in the guise of satire: "The success of the Paris *Bataclán* coined the term for those who wanted to 'make naked' those people of significance: Bataclán meant to leave something in raw flesh, nude."[37] Inspired by the spectacle, Guillermo Ross and Juan Díaz del Moral wrote a libretto containing "sketches of local customs" entitled *Mexican Rataplán*. The revista, with music by Federico Ruiz and Emilio D. Uranga, premiered in 1925 at the Teatro Lírico, advertised by the following line: "Ni una vieja ni una fea" (Not one old lady, not one ugly lady).[38] Revistas políticas suffered a bit of setback during the 1920s as "Bataclán" became the spectacle du jour, featured in *La república del Bataclán* (*The Republic of Bataclán*), a revista by Carlos Ortega and Pablo Prida with music by Federico Ruiz, which utilized

"Bataclán" to represent a minister of fine arts, a minister of public relations, and
other leaders and deputies.[39]

REVISTAS IN LOS ANGELES

Between 1900 and 1930, theatrical activity in Mexico increased and spread into
border states—in particular, California—through the advent of modern trans-
portation, which included the railroad and the automobile.[40] As previously men-
tioned, the armed struggle of the revolution prompted thousands to relocate to
the United States and aided in the diffusion of theatrical activities. Los Angeles
stands as one metropolis that benefitted from this artistic influx; it was a city with a
large population of Mexican immigrants and a lively theater culture. While many
sought new lives in the United States, the revolution and its impact on Mexi-
can culture were still felt, particularly during the reconstruction period of the
1920s and 1930s. During these decades, the definition of mexicanidad spread
throughout the nation and impacted those diasporic communities that were still
struggling with their transnational status.

The revistas in Los Angeles maintained many of the same qualities as those in
Mexico City, exhibiting ample use of satire, political commentary, and musical
performance—but not on a grand scale. Several popular Mexico City revistas
such as El país de los cartones (The Country of Cartons) and La ciudad de los
volcanes (The City of Volcanoes) and the zarzuela En la hacienda received public
and critical praise. In his work on the revistas and Spanish-language theater in
Los Angeles, John Koegel notes that the revistas políticas were especially favored,
in particular El país de la metralla, which premiered in Los Angeles at the Teatro
Capitol in 1924. He further notes that the revista received numerous perfor-
mances and was popular with the Los Angeles audience, who had kept the revo-
lution fresh in their minds.[41]

While several Mexico City revistas received repeated performances in Los
Angeles, new revistas were composed that related specifically to the local cul-
ture and environment. The Mexico City journalists and playwrights who had
joined the mass migration to the Southwest due to the revolution authored
many of these new works. Of the most notable are Romualdo Tirado, an
impresario and revista librettist—who, according to John Koegel, brought the
Mexican and Spanish forms of the revista to Los Angeles during the 1910s
and 1920s—and Guz Águila, one of the more prominent revista librettists.[42] A
revered journalist in Mexico City and popular playwright, Guz Águila established
himself as the leading political revista librettist with La huerta de don Adolfo (The
Orchard of Don Adolfo; 1919), a work inspired by the interim president Adolfo
de la Huerta, who, after being exiled in 1924, settled in Los Angeles and "gave
voice lessons to Hollywood stars and to performers from the local Mexican
stage."[43] At its premiere, this revista was advertised as "a revista that is political

from pure fruit, in no more than four scenes . . . which has committed the sin of being original."[44] The revista received numerous performances in Mexico and the U.S. Southwest for nearly two decades.[45]

Guz Águila maintained an important position in Mexican political circles, especially with President Adolfo de la Huerta during his administration. Once Álvaro Obregón attained the presidency, Águila was arrested. After his release from prison, Águila went into exile in Los Angeles and remained there for much of the 1920s. Several of his revistas were performed in Los Angeles, including the aforementioned *La huerta de don Adolfo* and *Exploración presidencial* (*Presidential Exploration*), but he also wrote revistas that accompanied the new setting: *Los Angeles vacilador* (*Hesitant Los Angeles*), *Evite peligro* (*Avoid Danger*), and *El eco de México* (*The Echo of Mexico*). During his lifetime, he wrote hundreds of revistas, several of which were reworked and renamed to accommodate different current events, locations, and audiences.[46]

Although depicting the essence of the traditional revistas, the Los Angeles revistas conveyed other characteristics unique to contemporary times. Kanellos states, "With their low humor and popular musical scores, the revistas in Los Angeles articulated grievances and poked fun at both the U.S. and Mexican governments. The Mexican Revolution was satirically reconsidered in Los Angeles from the perspectives of the expatriates, and Mexican American culture was contrasted with the 'purer' Mexican version."[47] Politics played a prominent role in this process, but the revistas placed the archetypes and narratives of the nation on the stage for the local audience to experience with nostalgia. Colin Gunckel elucidates, "In the broadest sense, Mexican theatrical culture became a staging ground for grappling with the impact and influence of mass culture among an immigrant population."[48] The performances in Los Angeles, whether they were established revistas from Mexico City or newly composed, conveyed the cultural shock that immigrants felt while acclimating to life in the United States.[49] Within this context, the popular character of the pelado functioned as a provocative figure, serving now as a hybridization of the Mexican and Mexican American diasporic communities.

The pelado functioned as a flexible character who conformed to his social surroundings. As previously mentioned, the pelado's position in the revistas was a representation of the working and lower classes, the disenfranchised, whose rapid-fire articulation of the vernacular provided another important aural and comedic code in Mexican popular entertainment. Although adored by the public, the pelado received considerable scrutiny, particularly in Los Angeles, as exemplifying "the worst Mexican stereotypes generated by Hollywood. To this extent, it threatened [cultural authorities'] ongoing efforts to elevate the cultural and racial status of Mexican immigrants in Los Angeles."[50] Gunckel notes that the pelado achieved popularity in newspaper dailies such as Daniel Venegas's novel *Las aventuras de Don Chipote, o cuando los pericos mamen* (*The Adventures of Don*

Chipote, or When Parrots Breastfeed), which was serialized in the newspaper *El Heraldo de México*.[51] The pelado within the revista was perceived as the symbol of lowbrow culture that constructed a negative representation of Mexicans in the United States.

Revista music continued to experience cultural hybridization in Los Angeles. Tomás Ybarra-Fausto states, "Although some libretto writers in urban centers like San Antonio and Los Angeles wrote revistas based on the prototypical Mexican, the most well know form in Mexican American theater was a toned down sketch-like version, which were embellished with music and dance interludes."[52] The music performed in these revistas was indeed diverse, consisting of not only genres and styles popular in Mexico, such as the *canción mexicana*, corrido, and the *canción ranchera*; other forms of popular music were used as well. The music genres performed in the revistas were hybrid forms, such as waltzes, *danzones*, polkas, the Charleston, the shimmy, and fox-trots—all genres that have been shaped by cultural hybridity coming from Western Europe, Latin America, and the United States.[53] Dancing was featured prominently, particularly showcasing the talents of the tiples and vice tiples. Ybarra-Fausto notes, "The dance was the most democratic component of the artistic mix that formed the variety tandas. Chorus lines, tap dancers, exotic and folkloric dancers participated alongside the typical billings. The ultimate social fad in dance in Mexico and the United States (the fox trot, cha-cha-cha, boogie-woogie) were immediately incorporated in the tandas."[54] *Mexican Rataplán*, the hit sensation of Mexico City, inspired Guz Águila to write two revistas in 1925: *Los efectos de Bataclán* (*The Effects of Bataclán*) and *El Bataclán oriental* (*The Oriental Bataclán*), which continued to feature the seminaked and dancing tiples but with local influences, becoming a "transnational Bataclán." Koegel states, "Los Angeles thus followed the fashion established earlier on the Parisian and Mexico City stages." He also specifies that the *Bataclán-Rataplán* vogue was performed at the Teatro Hidalgo in February 1925, a few months after its introduction in Mexico City.[55]

EL ESPECTÁCULO: FROM STAGE TO CELLULOID

Los Angeles revistas maintained their popularity, but scant information exists indicating whether they ever made it to Mexico City. By the 1930s, revista performance in both Los Angeles and Mexico City fell into decline when such theatrical entertainment lost much of its audience to sound cinema. Laura Isabel Serna argues that moviegoing and film culture nurtured a sense of what it might mean to be Mexican on both sides of the border.[56] The ritual of moviegoing had a profound impact on national consciousness and cultural identity formation, and the Mexican film industry played a significant role in this process. In fact, due to their popularity, several sound films were later recycled or readapted as revistas for the Los Angeles stage that highlighted the significance of the films' musical numbers,

including *La mujer del puerto* (*The Woman of the Port*; Arcady Boytler, 1933) and *Allá en el Rancho Grande* (*Over on the Big Ranch*; Fernando de Fuentes, 1936). Soon, live performances were integrated with film screenings in Los Angeles, offering another hybrid entertainment practice that fused the stage and the screen. While Hollywood features were screened widely in Mexico City, Mexican films offered close examinations of new conceptions of mexicanidad that relied on several transnational and cosmopolitan factors. Attending movie theaters and screening spaces was one impact, but what about the actual films?

The direct influence of the Los Angeles revistas on Mexican film culture is still an underresearched area, but there is no question that many popular players of the revistas in Los Angeles were among the first to penetrate Mexican sound cinema, particularly during the advent of the epoca de oro. Colin Gunckel points out that critics were ambivalent about Mexican-produced films, commenting that "these films presented a version of transnational mexicanidad that combined elements of modernization (through the mastery of Hollywood technology) with cultural specificity (through the evocation of a folkloric past)."[57] It wasn't just the audience that favored the screen; it is here that I argue that the revistas became a key source of cultural borrowing, as many of the major players transferred their talents from the stage to the screen. But it was not just the actors, librettists, and composers who crossed over—the narratives, characters, backdrops, and soundscapes did as well, initiating a transition from popular culture (the revistas) to a mass cultural mediation (the cinema) and another level of hybridization. The recycling of the revistas into Mexican cinema took on many guises—sometimes obvious, sometimes hidden—but the revista structure and soundscape became essentially integrated into several film genres.

Mexico's first synchronized sound film and box office success was *Santa* (Antonio Moreno, 1932). Based on the controversial 1903 novel by Federico Gamboa, *Santa* renewed the fallen woman narrative, beginning Mexico's prostitute melodrama genre. After several stage adaptations and a silent film version produced in 1918, the synchronized sound version featured recently returned Hollywood players, including actress Lupita Tovar, director Antonio Moreno, and the sound production team José and Roberto Rodríguez.[58] *Santa* premiered at the Palacio Theater in Mexico City on March 30, 1932, and at the Teatro California in Los Angeles on May 20, 1932, and both premieres were deemed successful. While a Hollywood-trained actress and a Hollywood-trained director graced the film, *Santa* featured music by revista composers Miguel Lerdo de Tejada and Agustín Lara. Lara, who had spent ample time playing piano in brothels and cabarets and composed music for revistas in Mexico City, composed the bolero "Santa," a *danzón*, and a fox-trot, both of which mirrored contemporary musical currents in dance halls, cabarets, and the revista stage. Not coincidentally, both Lerdo de Tejada and Lara appeared in Spanish-language theaters in Los Angeles, either performing live before film screenings or in a variety format that evoked the revista

tradition. Mexican cinema not only borrowed conventions from the stage; music, theater, and cinema were integrated into hybrid programming practices in the more prestigious theaters catering to the city's Mexican population.

Following in the footsteps of the prostitute melodrama are the *cabareteras* (cabaret-set films) from the 1940s and early 1950s. The cabareteras featured the *rumbera*, a female dancer who performed stylized rumbas and other dances for audiences as part of a cabaret show. As I have stated elsewhere, the revista tiples served as precursors to Mexican cinema's highly popular rumbera.[59] Much like the tiples, the rumberas performed in scant attire and featured provocative choreography, performing a variety of genres that included mambos, sambas, and danzones. Film examples include *La reina del trópico* (*The Queen of the Tropics*; Raúl de Anda, 1946), *Aventurera* (Alberto Gout, 1950), and *Sensualidad* (*Sensuality*; Alberto Gout, 1951).

Perhaps the most significant influence on Mexican cinema from Los Angeles was the return of Guz Águila to Mexico City in 1927. Although he went back to the stage, he did not regain his past success. With his writing abilities and his knowledge of both the Mexico City and Los Angeles theatrical and musical landscapes, he transferred his talents to the silver screen, particularly during the 1930s and 1940s. His first sound film was the prostitute melodrama *La mujer del puerto*, but his later films, *Allá en el Rancho Grande* and *¡Águila o sol!* (*Heads or Tails*; Arcady Boytler, 1938), feature many folkloric themes borrowed from the revistas.[60] While these films received screening time in both Mexico City and Los Angeles, *Allá en el Rancho Grande* functioned as a transitional turning point in Spanish-language cinema.

Allá en el Rancho Grande became the first official comedia ranchera that successfully consolidated materials from the *revistas costumbristas* (revistas of customs), Mexican folkloric culture, and the singing cowboy westerns of Hollywood. The film mirrors the revista's use of the countryside—particularly the zarzuela *En la hacienda*, on which the plot is loosely based. The film features several of the revista stock characters including charros and china poblanas, who are the sources of musical diffusion. Musically speaking, the film follows in the structure of the revista, containing musical numbers that function as interludes, such as "Canción mixteca" by José López Alavez and performed in the film by Ester Fernández and the title song "Allá en el Rancho Grande" sung by international radio sensation Tito Guízar. The effect provided an interpretation of Mexican rural life that synthesized nostalgia with folkloric representations to mass appeal.[61] As Colin Gunckel notes, *Allá en el Rancho Grande* was so popular in Los Angeles that a revista based on the film, featuring key musical numbers and re-creations of certain scenes and labeled as "la más mexicana de la revistas" (the most Mexican of revistas), took place at the Teatro California in 1937.[62] Scholarship on Mexican cinema has interpreted the film to be a response to conservative politics of the period, specifically the land reforms initiated by President Lázaro

Cárdenas during his *sexenio*, "six-year term" (1934–1940). The narrative capitalizes on nostalgia for the idyllic countryside and the prerevolutionary social hierarchies that were exploited on the haciendas. Regardless of the politics, the film was well received in both Mexico City and Los Angeles, serving as a positive (and, argued by many, "authentic") representation of Mexico and Mexican culture and initiating the production of more comedias rancheras.

As a backdrop for the revistas, the revolution served as a popular setting to publicly criticize and satirize government officials and other men of rank. In cinema, this pointed criticism was recycled for dramatic effect in the revolutionary melodrama, perhaps the industry's darkest and most violent cinematic genre. Humor and satire were removed and replaced by realistic brutality influenced by portrayals from the revolutionary novel.[63] This was best exemplified during the 1930s in director Fernando de Fuentes's highly critical revolution trilogy *El prisionero trece* (*Prisoner 13*; 1933), *El compadre Mendoza* (*Godfather Mendoza*; 1934), and *¡Vámonos con Pancho Villa!* (*Let's Go with Pancho Villa!*; 1935). However, because of the popularity of the revistas and its reinterpretation in the comedia ranchera, the revolution became a popular setting for films with a comedia ranchera spin. One such example is Russian director Arcady Boytler's folkloric film *Así es mi tierra* (*Such Is My Country*; 1937), starring Cantinflas in his first onscreen role. Set in a small town during the revolution, the film combines revolutionary rhetoric with comedy, romance, and folkloric representations of china poblanas, tequila, *jaripeos* (rodeos), rebozos, and other revista stock characters. While the film includes several musical numbers, including the title song "Así es mi tierra" by Ignacio "Tata Nacho" Fernández, the real focus was on the rapid-fire dialogue between Cantinflas and Manuel Mendel against the backdrop of the revolution and the film's love triangle. Another example is a lesser-known film entitled *La Adelita* (Guillermo Hernández Gómez, 1937), which builds on the violent interpretations of the revolutionary melodrama and is synthesized with several elements of the comedia ranchera. This included musical sequences that function similarly to the revista structure. Interwoven into a dramatic love triangle taking place during the armed struggle are musical performances featuring popular songs from the revistas including "Mi querido capitán" ("My Dear Captain"), "Soy una flor" ("I am a Flower"), and the famous corrido-canción "La Adelita"—all of which were published as sheet music in Mexico City.[64]

¡Águila o sol! presented another folkloric interpretation of mexicanidad that directly references the revistas starring Cantinflas and Mendel.[65] Moving away from the countryside, this film projected an urban environment with picaresque characteristics. Emilio García Riera states that director Boytler and Guz Águila wanted to create a "modern musical comedy" with "choreographic numbers worthy enough for the major North American productions."[66] With music written by revista composer Manuel Castro Padilla, *¡Águila o sol!* became a popular

and detailed cinematic production that included extensive revista and carpa the-
ater performances from two of the leading stage comedians of the period.

As previously mentioned, the revistas were known for their musical and nar-
rative recycling from Spanish zarzuelas. While this practice is featured in sev-
eral film genres, at the end of the 1930s, it was made explicit in the successful
but short-lived *cine de añoranza porfiriana* (films of Porfirian longing), based
on the 1930s revista genre *revistas de evocación* (evocative revistas). The genre
began with *En tiempos de don Porfirio* (*In the Times of Don Porfirio*; 1938), a polit-
ical revista that utilized zarzuela melodies popular during the Porfiriato. The
film adaptation, directed by Juan Bustillo Oro, borrowed the title from the revista
and the quick banter starring revista actors Joaquín Pardavé and Fernando Soler
but avoided the politics. Instead, the goal of the film was to depict the musical
atmosphere of the Porfiriato.[67] In the film, Pardavé comically performs "El galán
incógnito" from the 1892 zarzuela of the same name by Ricardo de la Vega and
Cristóbal Oudrid. Following *En tiempos de don Porfirio*, the second feature in
the cine de añoranza porfiriana, *¡Ay, qué tiempos, señor don Simón!* (*Oh, What
Times Those Were, Mr. Simón!*; Julio Bracho, 1941), was also based on a revista
by the same name. Rather than merely satirizing Spanish zarzuelas, the film fea-
tures cancan dancers performing the popular couplets from 1907 entitled "Y algo
más también" ("And Something Else"), also featured in the revista *En tiempos de
don Porfirio*.[68] Every example from cine de añoranza porfiriana includes excerpts
from zarzuelas and revistas that are utilized to create the appropriate musical
atmosphere, but in later films such as *México de mis recuerdos* (*My Memories of
Mexico*; Juan Bustillo Oro, 1944), the musical sequences are integrated to reflect
specific parts of the narrative. This film features an evocative excerpt from the
1904 Mexican revista *Chin Chun Chan* and, much like *El país de la metralla*,
showcases the scene "La maquinista del amor" from the Spanish zarzuela
Las bribonas.[69]

The musical comedies of the 1950s starring Germán Valdés "Tin Tan" also
incorporate several references and borrowings from revistas and contemporary
Spanish zarzuelas. Valdés is most famously known for his characterization of a
pachuco, a transnational product of migration that emerged in the Southwest
who dressed in zoot suits and spoke a rapid-fire Spanish dialect. For Valdés,
his interpretation of his pachuco character developed during his theatrical tours
Los Angeles and through his involvement in the theater scene.[70] The pachuco has
been defined as a provocation of Mexican national identity and a consequence of
diasporic culture—a synthesis of Mexican and American cultures that was often
frowned upon by audiences, much like the pelado.[71] Also like the pelado, the
pachuco became a fixture in Los Angeles revistas, showcased in, for example,
El carnival de los pachucos (*Carnival of Pachucos*), written by Gabriel Navarro,
Adalberto Elías González, and Rafael Ibarra, which premiered at the Teatro
Mason in 1943.[72] Valdés brought the pachuco into the national limelight in films

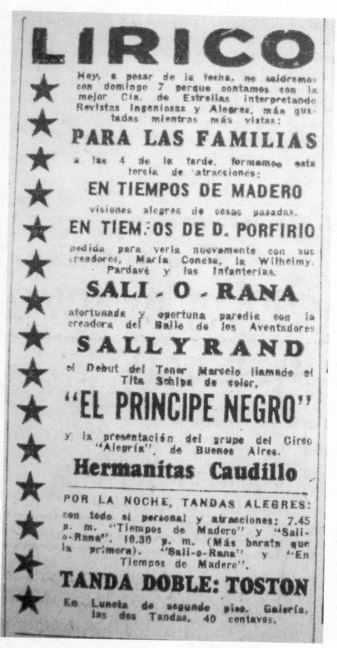

Figure 1.3. Advertisement for *En tiempos de don Porfirio, El Universal,* April 7, 1940, 13.

such as *El hijo desobediente* (*The Disobedient Son*; Humberto Gómez Landero, 1945) and *El rey del barrio* (*The King of the Neighborhood*; Gilberto Martínez Solares, 1949). He received his start in carpas and popular theater, showcasing his diverse musical and dance talents through the performance of a rich variety of genres from North and South America. Indeed, before entering the film industry, he performed at the Teatro Mason in Los Angeles in 1944 and 1947, when he shared the stage with the magician Paco Miller and the Trio Hispano-Americano.[73] Many of the songs he performed onscreen were initially intended for the revista and zarzuela stage, and they maintained the same function

Figure 1.4. Advertisement for "Pachuco's Review" at the Mason Theater. *La Opinión*, December 14, 1943.

in film: they often had nothing to do with the narratives. Several of Valdés's films feature these musical sequences, particularly those that satirize classics of Western literature such as *Los tres mosqueteros y medio* (*Three and a Half Musketeers*; Gilberto Martínez Solares, 1957) and *El fantasma de la opereta* (*The Phantom of the Operetta*; Fernando Cortés, 1959).

CONCLUSION

The revistas exhibited a hybrid and cosmopolitan identity through their synthesis of popular entertainments and national symbols in both Mexico City and Los Angeles. While many historians remark that the end of the revistas came with the rise of sound cinema, I would argue that cinema continued the revista tradition by utilizing its soundscape, characters, and narratives in new cultural climates and with new technology. Although material from the turn of the twentieth century is scarce, more research and work is needed to understand and analyze the effect the revistas and other forms of lyric theater had on the Mexican film industry and on the construction of mexicanidad and the impact the cinema had on revistas. Luis Sandi states, "The revue is the only form that has given the theatre a glimpse of wealth of Mexican popular art, the only form that has produced actors who can really be described as belonging to a Mexican school, that is to say, who speak, act and live on the stage as Mexicans speak, act and live."[74] The revistas predate the cinema, but these hybrid practices synthesize to form new and conflicting conceptions of the nation and its cultural identity at home and abroad.

NOTES

1. For a discussion on Mexicanness, see Samuel Ramos, *Profile of Man and Culture in Mexico* (Austin: University of Texas Press, 1962); Octavio Paz, *The Labyrinth of Solitude* (1961; repr., New York: Grove Press, 1985).

2. Also known as revistas or tandas. According to John Nomland, *género chico* is the generic name that refers to works that are written to be one act. He states, "People generally believe that 'género chico' is exclusively a zarzuela written in one act. We do not understand it like that. We consider 'género chico' to be the total theatrical work, with or without music, in one act, that stands alone, and 'functions for hours.'" See *Teatro mexicano contemporáneo 1900–1950* (Mexico City: Ediciones del Instituto Nacional de Bellas Artes, Departamento de Literatura, 1967), 133.

3. Borrowing from R. Murray Schaffer's concept of the soundscape, I use the term here to discuss the general acoustic environment on the revista stage, which includes music, sound, and dialogue. For more information, see R. Murray Schaffer, *The Soundscape: Our Sonic Environment and the Tuning of the World* (Rochester, N.Y.: Destiny Books, 1994).

4. For more information on the cultural climate during the Porfiriato, see William H. Beezley, *Judas at the Jockey Club and Other Episodes of Porfirian Mexico* (Lincoln: University of Nebraska Press, 2004); Steve Bunker, *Creating Mexican Consumer Culture in the Age of Porfirio Díaz* (Albuquerque: University of New Mexico Press, 2012); Michael

Johns, *The City of Mexico in the Age of Díaz* (Austin: University of Texas Press, 1997); Mauricio Tenorio Trillo, *Historia y celebración: México y sus centenarios* (Mexico City: Tusquets Editores México, 2009); Rafael Tovar y de Teresa, *El último brindis de Don Porfirio 1910: Los festejos del centenario* (Mexico City: Santillana Ediciones Generales, 2012).

5. Néstor García Canclini, *Hybrid Cultures: Strategies for Entering and Leaving Modernity* (Minneapolis: University of Minnesota Press, 1995), xxv.

6. García Canclini, xxxiv.

7. The zarzuela is a form of Spanish lyric theater in which music is combined with spoken dialogue, generally structured into one act. Narratives tend to be romantic and comic in nature. For more information on the zarzuela, see Clinton Young, *Music Theater and Popular Nationalism in Spain 1880–1930* (Baton Rouge: Louisiana State University Press, 2016); Susan Thomas, *Cuban Zarzuela: Performing Race and Gender on Havana's Lyric Stage* (Chicago: University of Illinois Press, 2008); Janet L. Sturman, *Zarzuela: Spanish Operetta, American Stage* (Chicago: University of Illinois Press, 2000).

8. For more information on the musical culture of the Porfiriato, see Jacqueline Avila, "Los sonidos del cine: Cinematic Music in Mexican Film, 1930–1950" (PhD diss., University of California, Riverside, 2011), 142–196; Yolanda Moreno Rivas, *Historia de la música popular mexicana* (Mexico City: Océano, 2008).

9. Gabriela Pulido Llano, "Empresarias y tandas," *Bicentenario: El ayer y hoy de México* 2, no. 6 (2009): 16.

10. Alejandro Ortiz Bullé Goyri, "Orígenes y desarollo del teatro de revista en México (1869–1953)," in *Un siglo de teatro en México*, ed. David Olguín (Mexico City: Consejo Nacional para la Cultura y las Artes, 2011), 43–44.

11. Leonora Saavedra, "Urban Music in the Mexican Revolution" (paper read at the national meeting for the Society for Ethnomusicology, Columbus, Ohio, 2007).

12. Nicolás Kanellos, *A History of Hispanic Theatre in the United States: Origins to 1940* (Austin: University of Texas Press, 1990), 60.

13. See Saavedra, "Urban Music"; Laura G. Gutiérrez, *Performing Mexicanidad: Vendidas and Cabareteras on the Transnational Stage* (Austin: University of Texas Press, 2010); and Jacqueline Avila, "Juxtaposing *teatro de revista* and *cine*: Music in the 1930s *comedia ranchera*," *Journal of Film Music* 5, no. 1–2 (2012): 119–124.

14. Kanellos, *History of Hispanic Theatre*, 59.

15. Saavedra, "Urban Music."

16. Armando de María y Campos, *El teatro de género chico en la revolución mexicana* (Mexico City: Biblioteca del Instituto Nacional de Estudios Históricos de la Revolución Mexicana, 1956), 20.

17. Mexico City boasted a variety of theaters that became hot spots for the revistas. The largest theaters included the Lírico, Arbeu, Virginia Fábregas, Esperanza Iris, and Renacimiento. Other venues catered to a variety of audiences, such as the Riva Palacio, María Guerrero, Hidalgo, Colón, and Circo Orrin. The hot spot for revista performance was the Teatro Principal, nicknamed "la Catedral de las Tandas." De María y Campos, 37.

18. De María y Campos, 34.

19. Saavedra notes that these public officials often frequented the performances of the revistas. Reactions toward their impersonations varied. See Saavedra, "Urban Music."

20. "La Decena Trágica," or the "Tragic Ten Days," refers to a series of events in February 1913 in Mexico City that led to a coup d'état and the assassination of President Francisco Madero.

21. John Koegel, "Mexican Immigrant Musical Theater in Los Angeles, circa 1910–1940" (paper read at the national meeting for the American Musicological Society, Louisville, Ky., 2015).

22. De María y Campos, *Teatro de género chico*, 139.

23. John Koegel, "Mexican Immigrant Musical Theater."

24. Tomás Ybarra-Fausto, "Aún se oye el aplauso, la farándula chicana: Carpas y tandas de variedad," *Revista de Humanidades* 1, no. 2 (1989): 12.

25. For more information on these musical genres, see Moreno Rivas, *Historia de la música popular.*

26. Tomás Ybarra-Fausto includes descriptions of revista archetypes that resonated in both Mexico and the United States. Ybarra-Fausto, "Aún se oye el aplauso," 13–19.

27. Luis Sandi, "The Story Retold: Chronicle of the Theater in Mexico," *Theater Arts Monthly* 21, no. 8 (1938): 619.

28. Carlos Monsiváis, *Mexican Postcards* (London: Verso, 1997), 98.

29. Jeffrey M. Pilcher, *Cantinflas and the Chaos of Mexican Modernity* (Wilmington, Del.: Scholarly Resources, 2001), 40.

30. De María y Campos, *Teatro de género chico*, 71. Carpas were tent theaters that specialized in vaudeville and variety performances, frequented generally by the working class. They traveled throughout Mexico and the Southwest United States.

31. De María y Campos, 210.

32. Saavedra, "Urban Music."

33. For María Conesa's biography, see Enrique Alonso, *María Conesa* (Mexico City: Océano, 1987).

34. Jorge Miranda, ed., *Del rancho al Bataclán: Cancionero de teatro de revista 1900–1940* (Mexico City: Museo Nacional de Culturas Populares, 1984), 28–29.

35. Gutiérrez, *Performing Mexicanidad*, 211.

36. One such revue was entitled *¡Voilá le Ba-ta-clán!* and featured seminude tiples adorned with "exotic feathers; white, tall, and thin covered with artificial stones." *El país de las tandas: Teatro de revistas 1900–1940* (Mexico City: Museo Nacional de Culturas Populares, 2005), 63.

37. De María y Campos, *Teatro de género chico*, 297.

38. Pablo Dueñas, *Las divas en el teatro de revista mexicano* (Mexico City: Asociación mexicana de estudios fonográficos, 1994), 25.

39. De María y Campos, *Teatro de género chico*, 297.

40. Kanellos, *History of Hispanic Theatre*, 17.

41. Koegel, "Mexican Immigrant Musical Theater."

42. John Koegel, "Mexican Musical Theater and Movie Palaces in Downtown Los Angeles before 1950," in *The Tide Was Always High: The Music of Latin American in Los Angeles*, ed. Josh Kun (Berkeley: University of California Press, 2017), 53.

43. Koegel, "Mexican Musical Theater," 58.

44. De María y Campos, *Teatro de género chico*, 236.

45. Kanellos, *History of Hispanic Theatre*, 64.

46. Kanellos, 64.

47. Kanellos, 59–60.

48. Colin Gunckel, *Mexico on Main Street: Transnational Film Culture in Los Angeles before World War II* (New Brunswick, N.J.: Rutgers University Press, 2015), 69.

49. Kanellos, *History of Hispanic Theatre*, 61.

50. Gunckel, *Mexico on Main Street*, 69.

51. Gunckel, 73. For more information on this serial, see Laura Isabel Serna, *Making Cinelandia: American Films and Mexican Film Culture before the Golden Age* (Durham, N.C.: Duke University Press, 2014), 180–181.

52. Ybarra-Fausto, "Aún se oye el aplauso," 10.

53. Saavedra, "Urban Music."

54. Ybarra-Fausto, "Aún se oye el aplauso," 17.

55. Koegel, "Mexican Musical Theater," 58.

56. Serna, *Making Cinelandia*, 11.

57. Gunckel, *Mexico on Main Street*, 125.

58. Lupita Tovar developed a career in Hollywood's Spanish-speaking industry during the 1920s and 1930s, starring in Universal's *Drácula* (1931). Antonio Moreno became a Hollywood actor in the 1910s, appearing in several melodramatic and comedic productions, particularly as the love interest to Clara Bow in *It* (1927).

59. See Avila, "Los sonidos del cine"; and Gutiérrez, *Performing Mexicanidad*.

60. *La mujer del puerto* actress Andrea Palma received her start as an extra in Hollywood and later became a hatmaker for actress Marlene Dietrich. When she accepted the role in *La mujer del puerto,* she modeled much of her character on Dietrich and her acting methodologies. For more information on her role in the film, see Jacqueline Avila, "Arcady Boytler: *La mujer del puerto* (1933)," in *Clásicos del cine mexicano,* ed. Christian Wehr (Frankfurt: Editorial Vervuert Verlag, 2015), 57–70.

61. For more information on the influence of the revistas on *Allá en el Rancho Grande,* see Avila, "Juxtaposing *teatro de revista,*" 119–124. For an in-depth analysis of the production and exhibition of the film in Los Angeles, see Gunckel, *Mexico on Main Street,* 122–158.

62. Gunckel, *Mexico on Main Street,* 144.

63. Some examples include *Los de abajo* (*The Underdogs*; 1915) by Mariano Azuela and *¡Vámonos con Pancho Villa!* (*Let's Go with Pancho Villa!*; 1931) by Rafael F. Muñoz.

64. John Koegel notes that these sheet music examples included illustrated covers featuring the performers who made these songs popular. See Koegel, "Mexican Musical Theater," 53.

65. De María y Campos notes that there is a cuadro entitled "Águila o sol." In his brief description, this cuadro starred the most famous comedians of the period—Roberto Soto, Joaquín Pardavé, and Delia Magaña—and was political in nature. Boytler's film removes the politics, borrowing only the revista's title. See de María y Campos, *Teatro de género chico,* 355.

66. Emilio García Riera, *Historia documental del cine mexicano,* vol. 1, *1929–1937* (Mexico City: Consejo Nacional para la Cultura y las Artes, 1969), 163.

67. Juan Bustillo Oro, *Vida Cinematográfica* (Mexico City: Cineteca Nacional, 1984), 179.

68. De María y Campos, *Teatro de género chico,* 378. The title character "Don Simón" appears in other zarzuelas and revistas. The earliest mention I have found is *Buenas noches señor don Simón* (*Good Night Don Simón*), an 1853 zarzuela by Luis Olona and Cristóbal Oudrid. De María y Campos mentions another work entitled *Don Simón . . . los sesenta ha cumplio* (*Don Simón . . . the Sixties Are Fulfilled*), but I have yet to find a date and librettist. See de María y Campos, 238.

69. For more information about the use and function of the revista in Mexican cinema, see Jacqueline Avila, "*México de mis inventos:* Salon Music, Lyric Theater, and Nostalgia in *Cine de añoranza porfiriana,*" *Latin American Music Review* 38, no. 1 (Spring 2017): 1–27.

70. Rafael Aviña, *Aquí está su pachucote . . . ¡Noooo! Biografía narrative de Germán Valdés* (Mexico City: Consejo Nacional para la Cultura y las Artes, 2009), 10–13.

71. Monsiváis, *Mexican Postcards*.

72. Advertisement for "Pachuco's Review," *La Opinión,* December 14, 1943, 4.

73. Advertisement for Paco Miller's variety show, *La Opinión,* October 24, 1944, 4; advertisement for live appearance by Tin Tan and Marcelo, *La Opinión,* March 16, 1947, 8.

74. Sandi, "Story Retold," 619.

◇◇◇◇◇◇◇◇◇◇

RAMONA IN THE CITY

MEXICAN LOS ANGELES, DOLORES DEL RIO, AND THE REMAKING OF A MYTHIC STORY

Desirée J. Garcia

In an elaborate marketing installation, the United Artists Theater, a relatively new movie house in downtown Los Angeles, converted its lobby into a simulacrum of the studio's latest release, *Ramona* (1928). The studio sought to capitalize on the existing popularity of the story, which was first published as a novel by Helen Hunt Jackson in 1884. For the premiere of the film, "special mission sets were built," reported the *Exhibitors Herald and Moving Picture World*, "and Indians who played in the picture were engaged as atmosphere." As patrons filed in to the theater, they witnessed a faux-mission wall, in front of which sat a group of "Indians" making blankets, pottery, baskets, slippers, and straw hats.[1]

Whether or not these were the same Indians who "played in the picture," as the studio claimed, this particular exhibition strategy underscores the ways in which the 1928 release hinged on the marketing of nostalgia. United Artists intended for the premiere to transport audiences back to a time when docile Indians wore traditional dress, lived in simple abodes, and engaged in timeworn handicrafts. The theme song for the film, "Ramona," recorded by both actress Dolores Del Rio and the Paul Whiteman Orchestra, extolled the virtues of the "mission bells" and the glories of the pastoral landscape. And the film itself participated in this carefully constructed experience, set in the last days of the languid haciendas run by old *californio* families.

Despite marketers' efforts, however, evidence of the twentieth century surrounded the spectator. The United Artists Theater was an opulent movie palace that was outfitted with every modern convenience. In order to access the theater's entrance, patrons would have to traverse Broadway, one of the busiest commercial thoroughfares in downtown Los Angeles. And the marketing for the film depended on national networks of entertainment media that saturated trade

papers, fan magazines, radio programs, and storefront windows. In particular, the song "Ramona" was publicized across all these platforms, spreading its pastoral message according to the opportunities made possible by technology and mass communication.

In addition to the marketing and distribution of *Ramona*, the film itself was, first and foremost, a product of the modern era. Reviews noted that director Edwin Carewe had used only "up to date" camerawork in order to capture spectacular scenes set in the countryside. Notes from the production emphasized location shooting in Zion, Utah, for which the film crew had to travel by train and automobile—modes of transportation that had become available to most Americans in only the last couple of decades. Last and perhaps most important, the film reflected the city's massive demographic shifts in its casting of Dolores Del Rio, a Mexican actress whose identity, newspapers noted, was closely aligned with the character she played. Her presence in the film made the subject of recent Mexican migration to Hollywood and Los Angeles one that could not be ignored.[2]

The many paradoxes introduced here convey how *Ramona* resonated in multiple ways for different audiences. First and foremost, it engaged with the Spanish fantasy heritage that the novel had done much to inspire in the late nineteenth century. That fantasy, however, was a "useable past" that ultimately served the needs of the present and, most specifically, the fast pace of social change that the city of Los Angeles was undergoing at the time of the film's release. Fleeing poverty and the political turmoil of the Mexican Revolution, mostly working-class Mexican immigrant families settled in Los Angeles in great numbers, growing from a population of 30,000 in 1920 to 97,000 by 1930. Many in the Los Angeles metropolis saw this drastic shift in population as a cause for concern. In *Ramona*, they found an image of Southern California that was free of these social transformations and a Mexican actress who was light-skinned, beautiful, and ultimately nonthreatening.[3]

To focus solely on the film's romanticization of the past, however, obscures the ways that the filmmakers, director Edwin Carewe and his screenwriter/brother Finis Fox, complicated the story's relationship to escapist fantasy. The 1928 version was the first to be created by self-identified Native Americans. Carewe and Fox were of Chickasaw descent. They used the text of *Ramona* to satisfy white audience's desires for the romantic melodrama set in old California while offering a scathing critique of intolerance. We see this manifest in the film's poetics and, in particular, its musical sequences and treatment of racial violence.

The film's release should also be appreciated for the ways it functioned as a cultural event for the Mexican community of Los Angeles. For them, *Ramona* represented the arrival of one of their own into the Hollywood firmament. Dolores Del Rio, whom the Spanish-language press referred to affectionately as

"Lolita," not only suggested the success of Mexicans in American culture but also, in her role as Ramona, drew explicit attention to her Mexican identity at a time when positive representations were rare in Hollywood and American culture writ large. The Mexicans of the city showed their support of Del Rio as spectators of the film and as cultural consumers who navigated the politics of racial otherness on the screen. In this way, to dismiss *Ramona* as a caricatured depiction in keeping with white fantasies of old California would be to miss the film's aesthetic, cultural, and local importance. The *Ramona* of 1928 presents us with an opportunity for analyzing a truly polysemic text. The mainstream appeal of the film certainly owes much to its inheritance of and dialogue with a pervasive, white-serving cultural narrative of California and the nation. An analysis of its poetics and local spectatorship among the Mexicans of Los Angeles, however, reveals that the film registered in different ways to multiple constituencies. Such an approach reveals the film text's ability to both circulate and challenge entrenched cultural representations. It also demonstrates the enduring significance of studying local and marginalized spectatorship when writing film history.

CAREWE'S *RAMONA* AND THE SPANISH FANTASY HERITAGE

As Carey McWilliams has written, the Ramona narrative created a powerful symbol that allowed white Californians to celebrate a romantic Spanish past in which "all members of one big happy guitar-twanging family . . . danced the fandango and lived out days of beautiful indolence in lands of the sun that expand the soul." Reinforced by Ramona tourism, John McGroarty's *Mission Play* (1912), film versions from D. W. Griffith (1910) and Donald Crisp (1916), and the annual Ramona Pageant (est. 1923), the Spanish fantasy heritage allowed for a reinterpretation of the past in ways that comforted white Californians of the present. In this fictive narrative, the Indians of California lived in pastoral harmony with their Catholic colonizers, which conveniently erased the history of suffering and violence inflicted upon them. While Jackson's novel stemmed from her desire to right the wrongs against the native population of California, its intention was eclipsed by her readers' sentimental fixation on the forbidden romance between Ramona, a woman of mixed blood, and Alessandro, her Indian lover. Such an interpretation easily explains why the United Artists Theater would engage Indians as "atmosphere" in the theater lobby. The film and its exhibition allowed white Californians to experience an imagined past.[4]

In the opening of the film, we witness Ramona's mostly happy existence with her childhood companion Felipe, whom she loves like a brother. They frolic in the countryside surrounding the hacienda only to be disturbed by Señora Moreno, the *patrona*, who devotes herself to her son while showing disdain for her foster daughter. The señora knows that Ramona is of mixed heritage—white (identified as Scottish in the novel) and Indian. The patrona reveals this racial

history as a means of blocking the budding romance between Ramona and Alessandro, a visiting sheep shearer who is a Temecula Indian. Ramona receives the information with exuberance, realizing that her bloodline positions her closer to Alessandro than she had thought. The two flee the hacienda, marry, and have a daughter, but their happiness is short lived, as racial prejudice harms them at every turn. When their daughter falls ill, the local doctor refuses to treat her because of her race. The neglect results in the infant's death. Marauding and blood-thirsty Anglos decimate their Indian village, and Anglo prospectors swindle and murder Alessandro. Psychologically and emotionally disturbed as a result of these events, Ramona wanders the countryside. Felipe eventually finds her and brings her back to the hacienda, which he now governs after the death of his mother. In the final scene of the film, Felipe restores Ramona's memory with a song from their childhood.[5]

The film's engagement with the Spanish fantasy heritage narrative relies on the use of music and location settings. In Zion, Utah, the director found an idyllic landscape seemingly untouched by modernity in which Ramona's hacienda home could be set. Furthermore, over the course of four song sequences, we see multiple shots of guitar strumming and the ringing of mission bells, two iconic symbols of the Spanish fantasy heritage that indicate a happy and carefree pastoral past in Southern California. In this way, *Ramona* is a cultural extension of the antimodernism that prevailed in American society after World War I. Films like Robert Flaherty's *Nanook of the North* (1922) elicited sympathetic portrayals of native peoples from a safe distance from the colonialist practices that caused their demise. Such films satisfied a longing for the "simpler" ways of native peoples while reinforcing the racial dominance of the onlookers. In *Ramona*, this same dynamic is at work through much of the film as hacienda life presents itself as a bucolic space for audiences to indulge in.[6]

And yet the story of Ramona also includes interruptions of the pastoral ideal. Carewe told the *New York Times* that "racial prejudice" received "psychological treatment in the picture." Whereas Griffith and Crisp had portrayed the white settlers' cruelty toward Alessandro and Ramona in a matter of seconds, Carewe and Fox did so with remarkable frankness and over the course of five minutes. So explicit was their visualization that Mordaunt Hall dismissed it as Carewe's "concession to movieism," claiming in disbelief that "the white men shoot to kill, aiming their guns at everybody, including women and children."[7]

The scene to which he refers is the decimation of the Indian village where Ramona and Alessandro live. The intertitle card reads, "Marauders, motivated by hatred and greed, descend upon the defenseless Indian village." Dozens of white men on horseback ride through the village, shooting as they go. A sequence of dolly shots showing the assassination of Indians in front of their houses demonstrates the senselessness of the act. Carewe focuses on a medium shot of a woman praying and making the sign of a cross. One of the marauders singles her out

and shoots her point-blank. We see blood streaming down her face as she slumps against a statue of a mother and child.

By far, however, the most brutal occurrence comes toward the end of the scene, when the camera finds a woman running away with a papoose on her back. One of the marauders pursues and kills her. We see a close-up, angled shot of the baby's face as he screams while lying next to his dead mother. Not satisfied, the same man rides closer to the mother and shoots once again, this time killing the baby, which we see as the child's face freezes midscream. Ramona and Alessandro watch the bloodbath from a distance and decide to flee themselves, after which the gang of killers sets their house on fire and takes their cattle.

While it directly references the historical violence enacted against Native Americans by whites, the scene's excessive brutality also evokes contemporary and local racial tensions. One of the reasons *Ramona* appealed to Los Angeles audiences is because it placed the conflict with Native Americans in the distant past and depicts Ramona's mixed-race heritage as tragic and nonthreatening. Outside of the United Artists Theater, Los Angelenos were increasingly nervous about the increase in Mexican immigration to the city and used racial logic to treat them as aliens who were physically and mentally inferior. Rather than deal with the structural issues of public housing and education, the city's public health department targeted Mexicans as diseased and immoral and as a social problem. Natalia Molina's research on this topic points to the many instances in which Mexican homes in the city were referred to as "filthy" and "pestholes." Such descriptions enabled the armed occupation of Mexican neighborhoods by Los Angeles police during the 1920s. Ultimately communicating that Mexicans were unwelcome in the city, police and city officials initiated deportation raids and repatriation campaigns in the late 1920s and early 1930s.[8]

Another scene in the film makes reference to contemporary debates regarding Mexican life in the city. After Ramona and Alessandro have fled the hacienda, a flash-forward shows the happy couple with a young daughter. Ramona busily cooks in her sparse but tidy kitchen while the child looks on. They busy themselves with the process of making masa and then cleaning their faces and hands. Ramona and her daughter join Alessandro, who is smoking a pipe on the front porch with the family dog at his feet. The scene evokes the American nuclear household and a family's pride of ownership—in stark contrast to the derogatory ways that Mexican homes were represented in the Los Angeles press.

Carewe also challenges popular depictions of Mexican motherhood. Shortly after this happy domestic scene, sickness falls over Ramona's household. Her daughter becomes ill, and Ramona suffers in agony near the child's cradle. Alessandro arrives with the news that the white doctor will not help the child because she is an Indian. Left untreated, she dies. This scene would have struck a chord with those watching it, as Mexican motherhood was under close scrutiny in the 1920s. High infant mortality rates in the Mexican community, like disease

epidemics, had much to do with the poor conditions in which they were forced to live. Yet Los Angeles society ascribed the death rate to "ignorance and slovenly habits" among Mexican women, casting them as poor mothers. The death of Ramona's daughter recalls the death of young Mexican children in the city but contextualizes the tragedy quite differently. Carewe makes it clear that the racism of white society has caused this child's death, not Ramona's shortcomings as a mother.[9]

In contrast to previous versions of the story by Griffith and Crisp, Carewe offers a corrective to the intolerance of society. The film's characters divide into two groups: those with tolerant views (Ramona, Alessandro, Felipe, and the hacienda dwellers) and those without (the señora, the Anglos). The mise-en-scène and the musical sequences promote the association of the socially enlightened characters with spirituality and nature and the music that emanates from it. Remarkably for a silent film, *Ramona* relies heavily on the visual indication of diegetic music. In the film, the music is not merely background but foregrounded as a central means by which the narrative progresses and the theme of social harmony get advanced. In this way, these song sequences serve a dual purpose. They are one of the fundamental ways in which the film operates on the cultural register of the Spanish fantasy past at the same time that they communicate the need for an eradication of intolerance.

The first musical sequence is a case in point. While at the hacienda, Felipe implores Ramona to dance for him. He initiates the song, strumming a guitar and singing. Quickly, others join them. They represent a range of social positions, including Indians, Mexicans, men, women, children, and even a dog. During the number, the camera pans across their faces and demonstrates their intertwined existence in this social space. The film introduces comedy when the plump cook, a woman coded as Mexican by her skin color and dress, dances for the group in a suggestive way. Carewe both pronounces and overcomes social positions of the hacienda dwellers in this number. The camera movement and the editing of the scene, in which the group applauds and encourages each successive performer in the circle, suggest that social difference can be swept away—if only for a moment.

One might interpret the musical sequences in the film as signs of Carewe's investment in romanticism. Indeed, sequences such as these confirm an underlying premise in the Spanish fantasy heritage, and in American culture more broadly, that people of color have a "natural" ability to sing and dance, a stereotype that is relatively positive. However, this stereotype also hinges on the presumed inferiority of racialized peoples, who are, as Eric Lott has described in his study of blackface minstrelsy, "creatures of feeling" who dwell closer to nature and are therefore more apt to be emotionally and musically expressive. We see some of this minstrelsy in the body of a full-figured hacienda dweller who performs in the circle, rolling her eyes and dancing provocatively. She is a familiar

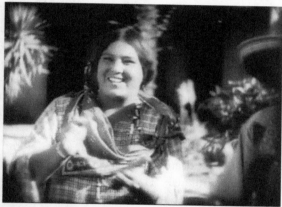

Figures 2.1–2.3. *Ramona*'s musical number "Dance for Me," in which all members of the *hacienda* take part.

caricature of Mexican women that parallels the black mammy figure, and much of the humor she elicits comes from the stark contrast she provides to Dolores Del Rio's lithe and beautiful figure.[10]

As essentializing as such depictions are, we must remember that peoples of color have also represented their own culture in similar ways. For example, the popular musical genre of Mexican cinema, the *comedia ranchera*, regularly portrayed groups of singing and dancing Mexicans in cantinas and on the hacienda. While these have been interpreted as reactionary vehicles that elide the social hierarchies of Mexican society, they were also beloved by Mexican migrants and immigrants living in the United States, for whom such images reminded them of their homeland.[11]

DEL RIO'S *RAMONA* AND MEXICAN LOS ANGELES

It was both the content of the film and Dolores Del Rio's celebrity that made *Ramona* culturally significant for Mexican moviegoers. To Spanish-speaking Los Angelenos, the film was not the subject of ethnic caricature or another attempt to reinterpret California history according to Anglo visions of the region. Rather, *Ramona* presented their *compatriota* (compatriot), Dolores Del Rio, in a role that both positioned her as a star and gave prominent attention to her Mexican identity.

Her cultural background received significant attention in the English-language press. She is "a Mexican with Spanish blood in her ancestry," wrote one reviewer, who then continued, "This is the first time in her brief but rapid screen career that Miss Del Rio has portrayed a character at least partly parallel in heritage to her own nationality." There is no doubt that Del Rio's Mexican identity conveyed an added level of verisimilitude to the film, a quality that was a feature of the frontier/borderland film genre of which *Ramona* is a part.[12] In this instance, however, it was not just the outdoor settings that provided authenticity but the actress herself. This, not surprisingly, descended into race-based notions of her aptitude for the role. In the United Artists pressbook, for example, one ad line suggested by the studio read, "Fiery! . . . Glowing! . . . Fervid! . . . The embodiment of high-wrought, alluring femininity. . . . This is Dolores Del Rio—the ideal Ramona by right of heritage and talent and temperament!"[13] And the studio provided "an appreciation of [Del Rio's] dramatic art" by claiming that "this slender, dark-eyed girl from Mexico, without dramatic training," had risen to stardom with *Ramona*, investing her role with an "aura of realism." According to the article, "she is not an actress playing a part, she is 'Ramona,' living, loving, suffering, triumphing." References to Del Rio's "temperament" abound and are in keeping with contemporary stereotypes about "Latins" as being emotional, even volatile, beings. Nevertheless, such comments about Del Rio's aptitude were encouraged by Carewe, who cast her deliberately as a revision to past performances of the

role and banked on her "exotic" looks to sell the picture. The strategy was successful, as Del Rio's "Mexicanness" and "Latin looks," much discussed in the star discourse surrounding her rise to fame, infused her role with the perfect combination of aspirational beauty and racial difference.[14]

Los Angeles Mexicans viewed her star turn as an achievement. As *Cine Mundial* declared soon after her arrival in Hollywood, "One of the most notable events of *Cinelandia* [Spanish-speaking Hollywood] in the past month was the triumph of Dolores Del Rio."[15] The Spanish-language papers of Los Angeles, *La Opinión* and *El Heraldo de México*, both announced the coming of *Ramona* with great anticipation and frequently referred to Del Rio as "nuestra compatriota" (our compatriot). Claiming her as one of their own allowed the Mexican community of the city to share in her success. They assumed a distinct familiarity with "nuestra Lolita" (our Lolita), as they frequently referred to her, and recorded her comings and goings from the city.[16]

Significant in the history of *Ramona* interpretations, Del Rio's performance mandated an acknowledgment of the Mexican experience. In past iterations, the story had focused on white/Indian relations and had largely ignored the Mexican setting and its people. As Chon A. Noriega points out, the novel and the earlier film version by Griffith indicated Ramona's whiteness by using racialized markers such as the character's blue eyes or the lightness of Mary Pickford's skin.[17] With Dolores Del Rio in the role, the Mexican identity of the character could not be ignored and was indeed emphasized by the Mexican audience of the city. While the English-language press persisted in describing Ramona's identity as half white, half Indian, the Spanish-language press insisted that Ramona is clearly Mexican. The announcement of the film "has provoked enthusiasm among the *colonia mexicana* [the Mexican community] for the subject matter that the film deals with," heralded *La Opinión*. "It is the history of a young Mexican woman," the paper described, "loved by an Indian and by a white man." As Gabriel Navarro, reviewer for *La Opinión*, observed, Del Rio's part in the film is a triumph for the ways that she represents *la raza* (the Mexican people). He contrasted the performance of Felipe by Roland Drew to Del Rio's. The reviewer took issue with Drew's "typical" representation of a "Spaniard," the likes of which can be seen in "trading cards and pictures of bullfighters," which, he suggested, was a concession to the Anglo audience. Despite such a "type," however, Navarro pointed out that Del Rio's presence and performance in the film corrected any "disturbing" representations of Spanish-speaking people that might exist.[18]

The paper went further to describe why Mexicans of the city would be interested, pointing out that the story takes place in old California, a place that was Mexican before it was American. This point was a significant one given the many ways in which the city of Los Angeles made it apparent that Mexicans were unwanted additions to the city. Ironically, the Ramona novel had played an important part in bringing tourists to Southern California in the late nineteenth

century and helped transform the area into one that served white interests exclu-
sively. Released many decades later and amid increasing racial tensions, *Ramona*
offered the Mexicans of the city a chance to reassert their claim to the region.[19]

Their support of the film is remarkable given that it was a Hollywood pro-
duction that exhibited in a downtown, mainstream venue, the United Artists
Theater. In *El Heraldo de México*, the United Artists Theater was the only movie
house advertised that did not regularly show Spanish-language films. For the
run of *Ramona*, the paper gave a prominent place to the theater's advertise-
ments and made special note of its location—on Broadway near Ninth Street.
The theater was approximately eight blocks away from the heart of the Mexican
business community on Main Street, which, as Colin Gunckel has described, was
"a bustling cultural and social corridor" as early as the 1910s.[20] Numerous theaters
existed along that corridor that catered to the Mexican population, such as the
Teatro México at Main Street between First and Second Streets. Yet many in
the community migrated southward to see *Ramona*; some did so, as *La Opinión*
reported, multiple times: "We have calculated that more than 20,000 Mexicans,
admirers of Lolita, have seen the film and many have returned one and two times
to admire it anew."[21]

In addition to supporting Del Rio by buying tickets, Mexican audiences
engaged in an active form of spectatorship that emphasized the actress's impor-
tance to the offscreen community.[22] Many of these activities centered on the role of
music in Mexican culture and were inspired by the film's musical content. One
of the most common graphic advertisements in the Mexican press, for example,
showed Del Rio's figure with her head thrown back with one arm on her hip and
the other framing her head in a dynamic dancing pose. In keeping with Del Rio's
association with musicality, both *El Heraldo* and *La Opinión* publicized Dolores
Del Rio's performance on the radio of the film's title song hit, "Ramona," as well
as other "beautiful Mexican songs in Spanish." As *La Opinión* suggested to its
readers, those without a radio should ask their neighbors if they could borrow
theirs, for this would be an event not to miss. The press also found it signifi-
cant to report that the musical entertainment on the program surrounding the
film at the United Artists Theater would include "numerous famous Mexican
compositions."[23]

During the run of the film, a group of women from the Belvedere barrio in East
Los Angeles went beyond their role as spectators and traveled to the Hollywood
Hills to applaud Del Rio at her home. These women gave a midnight serenade
to "the celebrated star compatriot of the screen, Dolores Del Rio," *La Opinión*
reported, "in front of the windows of her palatial residence in Hollywood."[24]
The *gallo*, or "serenade," was intended as an act of love for "nuestra Lolita" and
an appreciation of her work on the screen with songs from Durango, Mexico,
where she was born. While there is no record of Del Rio's response to their
efforts, it is clear that Mexican Los Angeles felt inspired by her presence on the

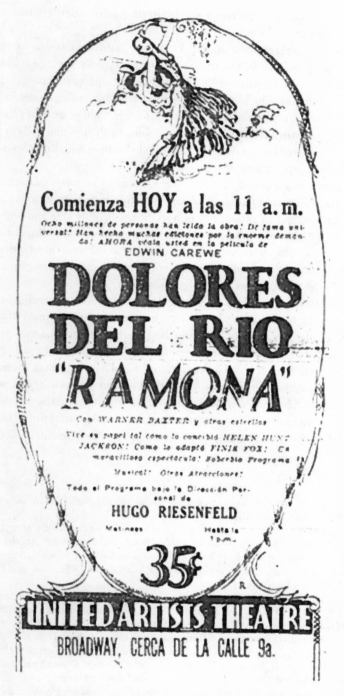

Figure 2.4. Advertisement for *Ramona* in *La Opinión*, March 28, 1928.

Hollywood screen and affirmed her infiltration of primarily white-occupied spaces in the city.

Multiple viewing communities had a stake in claiming *Ramona* for their own in 1928. Easily situated in the stream of Spanish fantasy heritage narratives, to be followed by the creation of Olvera Street as a tourist attraction in 1930 and the establishment of the Mexican Players at the Padua Hills Theater in 1931, the latest version of the film romanticized a premodern California. From the Indians in the United Artists Theater lobby to the tolling of the mission bells in the film, Anglo audiences enjoyed a mythic California in keeping with the reception given to previous interpretations of the work.

As I have demonstrated, however, the *Ramona* of 1928 was much more than an exercise in historical fantasy. The film itself did much to revise and reinterpret our nation's history of racism through its cinematic language and with its narrative content. As the film's poetics and reception show, the filmmakers and the audiences drew out the salient qualities of *Ramona* for their own contemporary purposes, whether to advance a message of social tolerance or to promote positive images of Mexicans on the Hollywood screen.

The last scene of the film serves these various interests at once. Felipe restores Ramona to the hacienda, where she returns to a state of happiness that is associated with the innocence of her childhood, sheltered from the racism that she witnessed firsthand outside of its walls. In this interpretation, the specter of intolerance will forever hover around Ramona and her home and, therefore, will continue to haunt society at large. While the Mexican community of Los Angeles enjoyed no such harbor—city and state officials initiated repatriation campaigns and deportation raids in the years after the film's release—they found in *Ramona* a cultural symbol of belonging in the Los Angeles of the present.

NOTES

1. "The Theatre-Blanket Campaign Breaks House Record," *Exhibitors Herald and Moving Picture World*, April 28, 1928, 89.

2. Mordaunt Hall, "The Screen—an Indian Love Lyric," *New York Times*, May 15, 1928, 17.

3. Natalia Molina, *Fit to Be Citizens? Public Health and Race in Los Angeles, 1879–1939* (Berkeley: University of California Press, 2006); Also see George J. Sánchez, *Becoming Mexican American: Ethnicity, Culture, and Identity in Chicano Los Angeles, 1900–1945* (New York: Oxford University Press, 1993).

4. Carey McWilliams, *Southern California Country: An Island on the Land*, 2nd ed. (Salt Lake City: Gibbs-Smith, 1973), 22. For other analyses of the evolution of the Spanish fantasy heritage, see Dydia DeLyser, *Ramona Memories: Tourism and the Shaping of Southern California* (Minneapolis: University of Minnesota Press, 2005); William Deverell, *Whitewashed Adobe: The Rise of Los Angeles and the Remaking of Its Mexican Past* (Berkeley: University of California Press, 2004); Phoebe S. Kropp, "Citizens of the Past? Olvera Street and the Construction of Race and Memory in 1930s Los Angeles," *Radical History Review* 81 (Fall 2001): 35–60; Kevin Starr, *Inventing the Dream: California through the Progressive Era* (New York: Oxford University Press, 1985).

5. "Miss Del Rio Is Sole Star of 'Ramona,'" *New York Times*, February 19, 1928, 114.

6. Shari M. Huhndorf, *Going Native: Indians in the American Cultural Imagination* (Ithaca: Cornell University Press, 2001).

7. Hall, "Screen," 17.

8. Molina, *Fit to Be Citizens?*, 84.

9. Molina, 77.

10. Eric Lott, *Love and Theft: Blackface Minstrelsy and the American Working Class* (New York: Oxford University Press, 1995), 32.

11. See Ana M. López, "A Cinema for the Continent," in *The Mexican Cinema Project*, eds. Chon A. Noriega and Steven Ricci (Los Angeles: UCLA Film & Television Archive, 1994); Desirée J. Garcia, *The Migration of Musical Film: From Ethnic Margins to American Mainstream* (New Brunswick, N.J.: Rutgers University Press, 2014).

12. "Miss Del Rio," 114; Dominique Brégent-Heald, *Borderland Films: American Cinema, Mexico, and Canada during the Progressive Era* (Lincoln: University of Nebraska Press, 2015).

13. "Ramona" pressbook, United Artists Collection, Wisconsin Center for Film and Theater Research, Madison, Wis.

14. Joanne Hershfield, *The Invention of Dolores del Río* (Minneapolis: University of Minnesota Press, 2000), 9, 13.

15. Don Q., "Lo de Pola Negri y otras cosillas," *Cine Mundial*, July 1927, 537.

16. "Hoy se estrena Ramona," *Heraldo de México*, March 28, 1928, 6; "Mañana llegara Dolores Del Rio," *La Opinión*, March 23, 1928; Gabriel Navarro, "Cómo vimos el estreno de 'Ramona' antenoche," *La Opinión*, March 30, 1928, 4; "Ramona pasara hoy por la pantalla," *La Opinión*, March 28, 1928, 4.

17. Chon A. Noriega, "Birth of the Southwest: Social Protest, Tourism, and D. W. Griffith's Ramona," in *The Birth of Whiteness: Race and the Emergence of U.S. Cinema*, ed. Daniel Bernardi (New Brunswick, N.J.: Rutgers University Press, 1996).

18. Gabriel Navarro, "Cómo vimos el estreno," 4.

19. Navarro, 4. See also DeLyser, *Ramona Memories*.

20. Colin Gunckel, *Mexico on Main Street: Transnational Film Culture in Los Angeles before World War II* (New Brunswick, N.J.: Rutgers University Press, 2015), 3.

21. "Ha sido un exito la exhibicion de 'Ramona,'" *La Opinión*, April 8, 1928, 4.

22. For histories of Mexican and Mexican American spectatorship, see Gunckel, *Mexico on Main Street*; Garcia, *Migration of Musical Film*; and Laura Isabel Serna, *Making Cinelandia: American Films and Mexican Film Culture before the Golden Age* (Durham, N.C.: Duke University Press, 2014).

23. Ad in *La Opinión*, March 28, 1928, 4; Louella Parsons, "Dolores del Río cantara el dia 29, canciones mexicanas," *La Opinión*, March 17, 1928, 4; "La partitura para 'Ramona' concluida," *La Opinión*, March 24, 1928, 4. The emphasis on music references the problematic association of racialized others with music in American popular culture. We see it in this example as well as in subsequent entertainments geared toward white patrons such as the "Mexican Players" at the Padua Hills Theater, inaugurated in 1931 in Claremont, a suburb of Los Angeles. Nevertheless, there are many examples in American cultural history in which Mexicans use music to define their identities in an American context. One prominent example is the popularity of the *comedia ranchera*, a genre of Mexican cinema that featured bucolic expressions of Mexican ranch life set to song. Films like *Allá en el Rancho Grande* (*Over on the Big Ranch*; 1936) were met with great fanfare in the Los Angeles Mexican community, who treated the depictions of song and dance as authentic expressions of their culture that satisfied a longing for Mexico *de afuera* (from outside). See Garcia, *Migration of Musical Film*.

24. "Un 'gallo' mexicano en honor de Lolita," *La Opinión*, March 30, 1928, 4.

CHAPTER 3

◇◇◇◇◇◇◇◇◇◇◇◇

PLEASE SING TO ME

THE IMMIGRANT NOSTALGIA THAT SPARKED
THE MEXICAN FILM INDUSTRY

Viviana García Besné and Alistair Tremps

The Calderón dynasty in Mexican cinema is the story of two young men who left their town in Mexico for the United States to become magnates that produced, distributed, and exhibited movies. Forming a triangle between Mexico City, El Paso, and Los Angeles, they built their business on the tastes of Latino audiences. Always attentive to the Mexican immigrant community in the United States, they took advantage of their feelings of nostalgia and nationalism that emerged in the 1920s and, through music and cinema, contributed to the consolidation of a successful film industry. They never forgot the lessons they learned as owners of a small film theater on the border between Mexico and the United States: the film business can only work if theaters are crowded with audiences enjoying the communal experience of watching a movie to which they can relate.

This approach was one of the keys to the success of José and Rafael Calderón, who started out with a small silent movie theater. With the help of their older brother Mauricio Calderón, who had a successful Mexican music store in Los Angeles (Repetorio Musical Mexicano), they took advantage of the arrival of sound film to produce cinema that both spoke *and* sang to Mexican audiences. Such was their success that they ended up owning a large theater chain in Northern Mexico and South Texas, film studios in Mexico City, and the biggest Mexican film distribution company in the United States.

At a time when five hundred movie theaters in the United States showed exclusively Mexican films, the demand for movies that appealed to the nostalgia and pride of the Mexican immigrant audience in cities like Los Angeles, San Antonio, Tucson, Chicago, New York, and El Paso was an important engine of growth for the Calderón brothers, who were always eager to give audiences what they wanted.[1] Being both the primary distributors of Mexican cinema in the

United States and the main driving force behind film production in Mexico, the Calderóns were major figures in the birth and rise of an industry. Thanks in part to the bond that the Calderón brothers established between Mexican talent and businessmen on both sides of the border, Mexican audiences in the United States—including those in Los Angeles—helped shape the nature and identity of Mexican national cinema.

The Birth of an Industry: The Calderóns, Silent Cinema, and the Mexican Revolution

In the early 1900s, the blurry border between Mexico and the United States ran across a barren and desolate horizon. Crossing "el paso del Norte" between Ciudad Juárez and El Paso, Texas, was as easy as walking straight ahead until one found the sign that marked the border. It was common for Mexicans and Americans to cross freely from one side to the other without needing to have or show any documents. José and Rafael Calderón used to travel hundreds of kilometers from the small town of San Andrés, where they were born, to Juárez and even beyond the border, looking for merchandise for their father's store. In earlier times, their grandparents had also traveled far distances in stagecoaches to supply different regions in Northern Mexico with beans and sugar.

But these two young brothers were not interested in carrying on with the family store, which was managed by two elder brothers. The small business did not make a lot of money, and the most excitement they could ever hope for was to be robbed on their way back to San Andrés. However, they were very excited about the rumors that Arthur Stilwell would bring the railroad to Chihuahua through the Kansas City, Mexico, and Orient Railway Company. As soon as construction began, they joined the building of the railroad track that would change their lives forever. The arrival of the railroad meant a new life: wherever the train passed, progress would soon follow. The possibility of traveling to faraway places to discover the world automatically opened up. This is precisely what happened to the brothers Rafael and José: the construction of a track changed the geography of their town, as well as the personal geography of their life trajectories, forever.

For this reason, when Rafael was able to travel to St. Louis with the railroad company, he felt that all his dreams were coming true. He arrived in Missouri in 1904, just in time for the opening of the St. Louis World's Fair. The fair, in which more than sixty countries participated, occupied such a vast area that it was impossible to see it all in less than a week. It was an extraordinary event for everyone but especially for Rafael, who came from a place where the biggest entertainment was listening to the bands that played from time to time in the town square's bandstand.

Figure 3.1. Rafael Calderón (*far left*) and José Calderón during the construction of the railroad, ca. 1905. Image courtesy of Permanencia Voluntaria, Tepoztlán, Mexico.

One of the fair's greatest attractions was the Hale's Tours show "Scenes from the World," which took place inside a train car adapted for film screenings. Hale had planned to open his show in 1903 but was not able to do so until the following year. Rafael thus saw one of the first performances. The show unfolded as follows: spectators bought a ticket as if they were going on a train trip. An usher wearing a ticket inspector uniform accompanied them to their assigned seats. Once all the passengers were in their seats, the doors closed and the lights went down. Then the whistle blew, and it seemed as though the train was beginning to move. One could hear the sound of the wheels on the rails and see exotic landscapes painted on rolls passing by the windows while huge fans generated an air current to create a feeling of movement. Spectators, who sat facing forward, were astonished when a beam of light started projecting moving images of faraway places. These were seven-minute films, without cuts, which had been filmed by placing cameras on the front of cars, trains, and streetcars. The overall effect was magical, and Rafael saw in that projection a materialization of his dreams.

Rafael was not the only one impressed by the Hale's Tours show. Other spectators who experienced cinema for the first time in one of those train cars ended up having important careers in film: Carl Laemmle, founder of Universal studios; Mary Pickford, actress and cofounder of United Artists; and actor Ronald Colman.[2] When José welcomed his brother back to Chihuahua, Rafael had already chosen a future for both of them. They thought about getting a film camera and, taking advantage of their jobs at the Kansas City, Mexico, and Orient Railway Company, filming spectacular views of Copper Canyon. They didn't succeed. However, shortly afterward, they managed to open a small movie theater in the state capital with uncomfortable wooden seats and a small screen. Without any ventilation, it was warm during summer

and freezing during winter; nonetheless, people were willing to pay to see the new film show.

In a series of letters between Rafael and José, the two wrote about their early years starting out in the movie business. An elderly Rafael appreciated the historical and family value of those letters and gathered them in a volume called *Big Oaks from Little Acorns Grow*. They offer fascinating details of their first years in the film business:

El Paso, Texas

February 9, 1958

My very dear children:

Sometimes you ask me how our film business started. Those questions, to which I answered vaguely with brief words, made me think that it was better for me to remove from my archives the file I created with the correspondence I had with your uncle José when he was in El Paso and I was in Chihuahua . . . I beg you to read it so that you can become aware of how our efforts began, very modestly, of course, but with an enormous dose of faith in success, a success from which you are benefitting from today, making applicable the American saying: "BIG OAKS FROM LITTLE ACORNS GROW."

I want you to realize that these letters were written during those fateful days when the country was still in terrible chaos due to the constant revolutionary outbreaks that emerged everywhere, causing a constant instability and unease, up to the point where, due to this dreadful situation, all the Americans living in the Republic were forced to go back home in order to save their lives, which were threatened by the retaliations and robberies of bandit gangs under the flag of Villismo [the movement led by Pancho Villa], who had sworn to take brutal revenge on Americans because the government in Washington had officially recognized the government of don Venustiano Carranza.

I explain this because, due to this withdrawal of Americans, I was able to convince Mr. Buchoz and Mr. Williams to sell us the Alcázar cinema, a business in which we had always been very interested, as they could not attend to their business from El Paso, Texas.

Had it not been for the circumstances that I'm explaining, we would have probably been forced to abandon our great desire of going into the movie business, which we liked so much.

How true is the saying: "A PEBBLE CAN ALTER THE COURSE OF A RIVER." And that pebble which altered the course of our future was the forced departure of the Americans.

Rafael Calderón

This event undoubtedly marked the development of cinema in Mexico and, one could even argue, in Hollywood as well. As a result of the revolution, a large part of the Mexican population was infected by a consciousness of identity at the same time that an estimated 10 percent of its population fled the country. Borders became more evident—not only physical ones but also ideological ones, which were sometimes much more difficult to cross. Revolutionary *corridos* (narrative folk songs) became oral testimonies of what was happening in Mexico and spread this news across the entire Mexican republic. Disregarding national borders, these songs also reached Mexican immigrants in the United States.

Mauricio, one of the older brothers of José and Rafael, tired of the threat posed to his family by revolutionary outbreaks. He left Mexico and went to Los Angeles, where within a few years he would own Repertorio Musical Mexicano, the most successful Mexican music store in the downtown area. As George J. Sánchez explains,

> According to musician and radio personality Pedro J. González, Calderón was in charge of everything related to Mexican music in Los Angeles. He recruited talented musicians by advertising in the Spanish-language press and kept an ear out for the latest musical trends among the city's performers and audiences. Not only did Calderón make money by serving as a go-between between American companies and the Mexican artists, but he also held a monopoly on the area-wide distribution of these records through his store. A standard practice of the time for such businesses was to sell phonographs as well as records, and stores such as Calderón's profited as well from these items. In fact, Calderón's store, located at 418 North Main Street near the Plaza, regularly promoted itself by using a loudspeaker mounted in front of the store playing the latest corrido. A small group of men regularly stood in front of the store, listening intently and enjoying the music.[3]

As would be the case with cinema, Mauricio also appealed to the nostalgia and national pride of his clientele, with his print ads boasting, "No other store will attend to you better, because we, in a word, treat you as MEXICANS and COMPATRIOTS."[4]

A significant number of short films based on the Mexican Revolution were made in the United States. These films reflected and reinforced negative Mexican stereotypes, completely ignoring the truth of the events that the protagonists of those episodes experienced. The Mexicans, of course, were bandits, villains, and cowards, while the Americans were heroes. Even though there was a kind of common territory along the border where both worlds coexisted, the differences between Mexican and American citizens began to be more clearly defined, as the titles from Hollywood films about the Mexican demonstrate: *The Greaser's Gauntlet* (D. W. Griffith, 1908), *The Mexican's Crime* (Fred J. Balshofer, 1909), *Ah Sing and the Greasers* (1910), *The Girl and the Greaser* (Lorimer Johnston, 1913),

A Species of Mexican Man (Romaine Fielding, 1915), and *Guns and Greasers* (Lawrence Semon, 1918).⁵ These films, which also screened at the little movie theaters north of the border, created a hostile environment. Mexicans did not feel welcome in those cinemas, where they saw themselves slandered and humiliated on the screen. Latino audiences thus became alienated from American movie theaters as individuals and organizations on both sides of the border launched formal complaints about these representations.⁶

Meanwhile, inside theaters in Mexico, the revolution also became a show, but it was seen from a documentary point of view that was completely different from the American one. Cinematographers like the Alva brothers and Antonio Ocañas shot, from different angles and throughout the years, films about the Mexican conflict that were shown throughout the country. Pancho Villa, who was fascinated by movies, was the first person to demand royalties and a salary for allowing American directors to film the revolution from his trench, even though an outraged Mexican who lived in the United States wrote him a letter that read, "I want to let you know about one thing: Don't let any American filmmakers into your territory because they are up to no good. They go and shoot only the worst and place subtitles on those images that do your cause no favors."⁷ Still, Villa signed a contract with Mutual Film Corporation. Cinema, railroad, and revolution converged in the train car that Villa set up for that company, which served to store the equipment and shelter cameramen. It also had a darkroom where daily rushes could be developed.⁸

José and Rafael Calderón also had to team up with Villa in order to continue with their movie business. At the height of the revolution, in the three theaters they owned, images from the Mexican Revolution in favor of the Villistas were screened. However, these theaters were also used to store weapons for the revolutionary fighters. In return, the Villistas allowed the trains with boxes of films that the Calderón brothers imported from the United States to enter the country without taxing them. In addition, they made sure that the Calderóns' theaters were not looted.

Even though Mutual films were fairly successful in Mexican cinemas, José and Rafael believed that audiences in Northern Mexico were fed up with news about the Mexican Revolution and were instead asking for entertainment—films that transported them away from dead bodies and gunfire:

Chihuahua, February 14, 1917

Dear José,

I take a few minutes to write you these lines . . . I received seven boxes, all of them very good, only one of them is very small, with 37 reels, 28 of them being for the second week, and 9 for the emergency week. It is not at all in our interest to have the programs shipped incomplete, as an interruption would be dangerous.

It is very important to reach an agreement with Universal and Mutual in order to have artists from two good companies. With Mutual we would get Chaplin, and, this way, I won't have to buy his films from Mrs. Damiani for twice the price. . . . Actually, right now I am about to go to the theater to welcome the children from the Chihuahuense High School, who got a free screening today from 5 to 6. On Friday, another public school will get a free ticket, and so on. The only expense will be that of electricity for an hour, but I hope the outcome to be excellent as every kid will be a living advertisement that will be delivered to the whole town. Today I even had the good fortune of getting Charlie Chaplin's *Laughing Gas*. So these little kids are going to enjoy themselves, also because the other films I am going to show them are very funny.

I will continue to check the Chaplin films when Miss. Damiani receives them because even though some people don't find them funny, kids go crazy for this clown. And there's nothing like children's laughter to create harmony in the theatre. I have to pay her $2.00 for each screening, but it's worth it.

Rafael[9]

The exhibition business of the Calderón brothers—now with a new partner, José Salas Porras—kept on growing, but they started lacking the films necessary to satisfy the demand of their crowded movie theaters. They often had to run from one theater to another with the films: screenings began in one of the movie theaters a few minutes earlier than in another one, and when the first reel was over, it was quickly taken to the second theater, and so on and so forth. Another fact that began worrying them was that as film language evolved, intertitles became more frequent, providing information that was indispensable to understand the subsequent scene. Rafael wrote,

Until now, audiences have enjoyed the Universal program, even though it would be better to screen 14 films from Universal and 14 from Mutual. . . . What's urgent is that you get a serial, either "The Purple Mask" or "Peg of the Ring." I prefer one starring Grace Cunard, as this actress is very popular among our clientele. She works for Universal, and we have just shown a picture in which she is featured. It is titled "Her Better Self."

I also think that translations will attract a lot of people, but I don't want to introduce this practice until you come, because it would be too much work for me, and we shouldn't be employing so many people. A translator would cost us no less than $50.00 a month. And, once this improvement is introduced, we have to go on with it as nobody will accept English intertitles again.[10]

His brother José replied,

I also send you today three reels of blank film so that you can do the translations. I'm also sending you the necessary carbon paper.

You must start screening the intertitles in Spanish, and that is why I'm sending it to you. It is very easy to do the translations. You put the film on a reel, and then you thread it onto another reel. When you find an intertitle, use a light source to read it clearly and, this way, translate all the film. If you want to, you can just use the typewriter for the translation, or you can write it on a paper and then type it. It is easy to do: insert the film and the carbon paper. The latter should be on top of the film. Remove the ribbon from the typewriter and type, trying not to pound the keys in order to obtain a uniform result. Once this is done, you have the translation.

As for how the machine works, it is really simple. You just put it in front of one of the lanterns, and, in front of it, you place a slide with an opening a quarter of an inch long and as wide as the film (you just have to project the light on the screen, and see how long and wide the perforation on the slide needs to be). When an intertitle that reads "THIS BUSINESS IS YOUR ONLY HOPE FOR PROSPERITY" appears on the screen, the boy that helps with the projection will remove the shutter, and the text "Este negocio será tu única esperanza para la prosperidad!" will appear. Immediately after the shutter is lowered, the film is wound, and the assistant estimates how much time the audience needs to read the intertitle. The next intertitle, "BUT YOU HAVE TO STICK TO IT," (which will read "Pero tendré que atenderlo como se debe") is ready to be projected. This procedure is followed until the film ends.[11]

Those years working as exhibitors were crucial for their training as distributors, their next step in the film industry. They joined forces with other relatives, including their cousin Juan de la Cruz Alarcón, to found International Amusement Company and International Pictures Company in order to exhibit and distribute films in both the United States and Mexico. Now they would also use movie theaters to contribute to the construction of a national identity through entertainment. They sought a language closer to that of Hollywood with historical productions like those of Miguel Contreras Torres, which extolled values of *mexicanidad* (Mexicanness) that transcended the conflicts taking place during the convulsive period of the revolution. As Contreras Torres recalled,

The second film I produced and directed, titled "El Caporal," in 1921, was distributed in Mexico by International Pictures. It was at this company's offices in the old Capuchinas streets, that I met . . . don José Calderón. I then started producing my third film, "El hombre sin patria" (about the Mexican "braceros"), and I went to El Paso, Texas where I met Rafael Calderón. . . . Being

unfamiliar with the business, as they probably were too, I was offered the fixed price of $800 for "El Caporal." . . . The Calderón brothers and their partners made more than $15,000 with "El Caporal." Of course, they doubled their offer for "El hombre sin patria."[12]

The Calderóns went on buying the rights in perpetuity to Miguel Contreras Torres's films. Unlike Hollywood productions, which denigrated Mexicans, the following productions by Contreras Torres appealed to Mexican values and exalted a sense of community among Mexicans: *De raza azteca* (*Of the Aztec Race*; 1921), *El sueño del caporal* (*The Corporal's Dream*; 1922), *Oro, sangre y sol* (*Gold, Blood, and Sun*; 1923), *México militar* (*Military Mexico*; 1925), and *El águila y el nopal* (*The Eagle and the Cactus*; 1929).

In Los Angeles, Mauricio Calderón was in an ideal position to assist his brothers in their efforts. His store was a mainstay for Mexicans in Los Angeles, including those who had found success in Hollywood but felt underappreciated by the U.S. film industry. Lupita Tovar, Lupe Vélez, and Guti Cárdenas were among those who came to buy a record or phonograph and left with the dream of participating in the first Mexican film productions.

AN EXPANDING EMPIRE: THE ARRIVAL OF SOUND AND THE RISE OF MEXICAN CINEMA

With the profits obtained from their movie theaters in Mexico, the Calderóns and Salas Porras were able to buy six cinemas in El Paso, Texas, focusing mainly on Latino audiences. These theaters, which used to charge 10 and 15 cents for a ticket, raised their prices to 40 and 50 cents when audiences started responding positively to Mexican films.[13] Americans did not look very favorably upon these cinemas, where tamales and peeled mangos with chili were sold. They said that one of these theaters smelled so badly, it was nicknamed "The Sock."[14] Another of the Calderóns' and Salas Porras's most emblematic cinemas in El Paso, Texas, was the Colón Theater, which was next to the Casasola photo studio. This movie theater was still showing U.S. films after the arrival of sound, and for a year they tested new ways of creating intertitles and subtitles in their neighbor's lab, especially once the Vitaphone system arrived and they invested in sound equipment, proudly advertising, "See and Listen."

However, a large part of the Latino population did not know how to read or write; instead of being more entertained by these new movies with subtitled dialogue, they were extremely bored by them. From 1928 to 1931, the Calderóns even tested a rudimentary dubbing method: they transcribed the dialogue and placed a man and a woman behind the screen to perform all the film's voices. Naturally, audiences did not like this experiment either. The Calderóns had managed to establish a movie theater chain, they were already film distributors, and

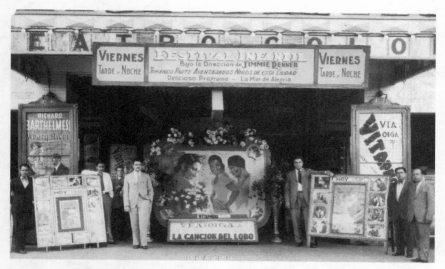

Figure 3.2. Rubén Calderón and Rafael Calderón (*center*) in front of their Teatro Colón in El Paso, Texas, where they presented *La canción del lobo* (*The Wolf Song*; Victor Fleming, 1929), starring Lupe Vélez and Gary Cooper. Image courtesy of Permanencia Voluntaria, Tepoztlán, Mexico.

yet because their audience was mainly Latino and most films were made in Hollywood or other countries, they were losing money.

Hollywood's Spanish-language talkies of the early transitional years—movies filmed in Spanish, usually using the same screenplays and sets as the big-budget English-language productions—were an experiment by Hollywood studios that gave some respite to the film exhibition and distribution business for Mexicans. However, audiences soon felt betrayed; Latinos did not identify with the subject matter and the approach of these movies or with their casts, which featured actors with a mixture of Argentinian, Spanish, and Mexican accents. Still, Metro Goldwyn Mayer proudly announced, "I can speak Spanish now" and sent its famous lion on a publicity tour. The Calderón brothers joined the tour with the hope that it would draw more people to their theaters. Although a lot of people came to see the lion, not many went into their theaters afterward.

Juan de la Cruz Alarcón, the brothers' cousin and partner, was not unaware of the challenge of sound technology and the language barrier. He decided to take matters into his own hands, taking a chance on the biggest project of his life: the production of *Santa*, the first Mexican sound feature. Rafael and José decided to back their cousin on this venture, reaffirming their commitment to Mexican cinema. The brothers José and Roberto Rodríguez, Mexican nationals working in Los Angeles and acquainted with Mauricio, had developed an optical sound system for movies. Thanks to the relationships developed among Juan de la Cruz Alarcón, the Calderóns, and the Rodríguez brothers in Los Angeles, the

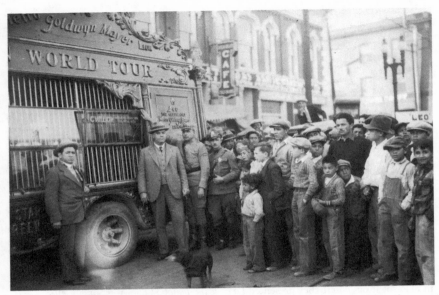

Figure 3.3. Rafael Calderón (*center*) in El Paso presenting the appearance of Leo, the Metro Goldwyn Mayer lion, who toured the country promoting the studio's sound films and, in this case, Spanish-language talkies. Image courtesy of Permanencia Voluntaria, Tepoztlán, Mexico.

first Mexican sound film began to take shape. Apart from these talented sound technicians, *Santa* featured several Mexican actors, like Lupita Tovar and Ernesto Guillén, who had enjoyed a career in Hollywood starring in Spanish-language films. The movie was directed by Spaniard Antonio Moreno, who had previously worked in Hollywood during the silent period as well as in Spain. Filming began in November 1931.

Rafael and José knew that they had to distribute Mexican movies in the United States, and along with other partners, they financed *Santa* through an advance on distribution. In order to show this first sound film on U.S. screens, they created Azteca Films Distributing Company, knowing that there was a Latino audience eager to establish a connection with their culture and language. After its successful release in Mexico, *Santa* was shown in El Paso and San Antonio, Texas. This allowed them to generate great expectations for their following move: a lavish premiere in Los Angeles, on May 20, 1932, at the California Theater. They decided to reinvest the money the movie had made up to that point in a sumptuous event for the Los Angeles premiere in order to prove to Hollywood that Latino movies made by Latinos could be a hit.

Francisco (Frank) Fouce, a producer of Spanish-language films for Columbia, was as passionate about Spanish-language films as the Calderón brothers and, just like them, saw the potential of providing Latin American audiences with

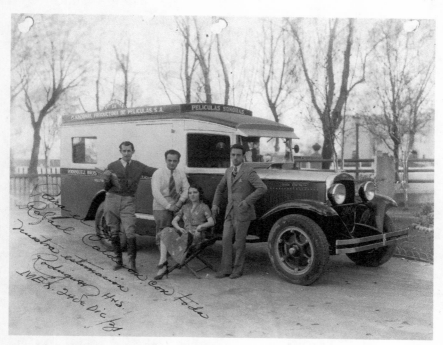

Figure 3.4. A photo dedicated to Rafael Calderón on December 24, 1931, by the Rodríguez brothers, who stand here on either side of Lupita Tovar, star of *Santa*. Image courtesy of Permanencia Voluntaria, Tepoztlán, Mexico.

movies that they would feel were their own. Thanks to Fouce's interest in the film, it was possible to celebrate the release of *Santa* at the California Theater. Rubén Calderón, son of Rafael Calderón, who was in charge of the Azteca Films office in Los Angeles, recalled for the newspaper *La Opinión*:

> News about the success of "Santa" in American territory soon reached Mexico, and the producers were able to breathe again, releasing another movie, "La llorona," which also became very popular among Mexican audiences in Los Angeles. . . .
>
> It was under these circumstances—Mr. Calderón tells us—that Mr. Fouce took charge of the California Theatre. An exhibition place had been created, and now it was necessary to obtain movies at all costs. Azteca Films in El Paso, Texas, began boosting Mexico's film industry, acquiring as many movies as it could. Meanwhile, Fouce was fighting to keep open the only movie theatre that offered Spanish-language movies . . . in Los Angeles.
>
> In 1935, Mr. Fouce abandoned the film distribution business completely in order to devote himself to the exhibition of Mexican films. He bought the movie theatres El Eléctrico, El Hidalgo, El México. . . . Now, with enough

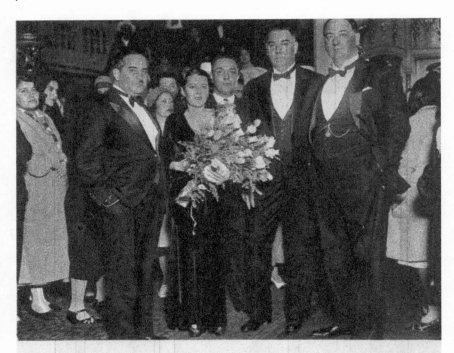

Momentos después de la función de gran gala habida en el teatro California, se tomó esta foto en la que aparecen don Juan de la C. Alarcón, Lupita Tovar, don Juan Salas Porras, don Rafael y don Mauricio Calderón.

Figure 3.5. The gala premiere of *Santa* at the California Theater in Los Angeles in 1932. *From left to right*: Juan de la C. Alarcón, Lupita Tovar, Juan Salas Porras, Rafael Calderón, and Mauricio Calderón. Image courtesy of Permanencia Voluntaria, Tepoztlán, Mexico.

cinemas to exhibit our films, a branch of Azteca Films was established in this city.[15]

Santa's success was fundamental for the Calderóns. In photographs of the premiere published in newspapers, Lupita Tovar stands beside Mauricio and Rafael Calderón, a strategic alliance that created a Mexican cinema that would be enjoyed in the United States. By the same token, this strategic alliance demonstrates the centrality of individuals who moved between Mexico and Los Angeles, revealing the crucial role that this city had in the birth and growth of a national cinema. After the success of *Santa*, the Calderón brothers distributed hundreds of movies through Azteca Films until 1954 in addition to financing many other films through their system of giving an advance on distribution to producers and promising projects. During this period, the Calderóns remained very attentive to what Latino audiences in the United States wanted, and they practically imposed on producers certain formulas and topics in exchange for funding. For example, they gave more or less

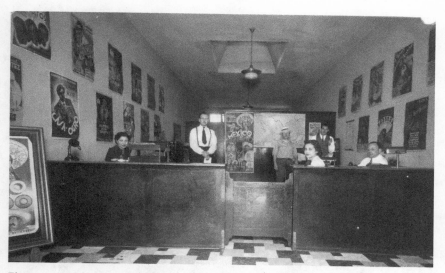

Figure 3.6. Rubén Calderón (*far left*) and Gustavo Acosta (*far right*) at the offices of Azteca Films in the early 1940s. Image courtesy of Permanencia Voluntaria, Tepoztlán, Mexico.

money in advance depending on how many popular songs were going to be included in the movie.

Mauricio Calderón, being well aware of the most popular songs and singers among the Latino community, was in charge of recommending artists and songs to his brothers so that they could buy the rights and use them in their films. Pedro Vargas, Pepe and Tito Guízar, Luis Aguilar, Agustín Lara, Libertad Lamarque, and Pedro Infante not only provided the music for a large amount of the films financed by Azteca Films Distributing Company; they also performed live in U.S. movie theaters that screened Mexican films with much success.

Always eager for more Mexican films to feed their screens and their insatiable distribution business, José and Rafael used the Azteca Films Distribution Company to make producers out of their sons and several of their acquaintances. They financed their films with advances on distribution, provided that they accepted the formulas that had proved to be successful among Latino audiences in the United States. One of these formulas was the inclusion of singers and popular melodies, but another was the addition of scenes full of nostalgia for Mexico—its food, its landscapes, and its customs.

Soon, Azteca Films became the most important film distribution company of Spanish-language movies in the United States. By 1943, there were five hundred movie theaters in the country that screened Spanish-language films.[16] The distributor opened offices in El Paso, San Antonio, Chicago, Denver, New York, and of course, Los Angeles. These movie theaters, where tamales were eaten instead of popcorn, were not just cinemas but gathering places for the Latino

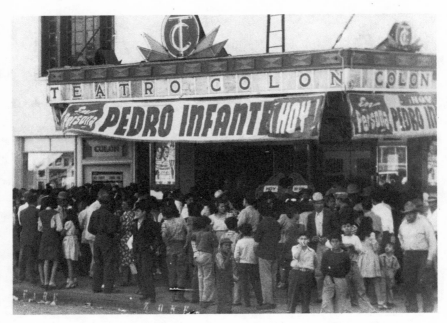

Figure 3.7. Crowds wait outside the Teatro Colón in El Paso to see a live performance by Pedro Infante, ca. mid-1940s. Image courtesy of Permanencia Voluntaria, Tepoztlán, Mexico.

community. Mexicans went there to spend some time together and attend events in which their favorite singers and actors appeared. Lonely immigrants without documents and entire families congregated with the same (or even more) fervor with which they attended church. Cinema was a religion too. During almost two hours, inside these dark and stinking theaters, a feeling of belonging was created—a collective catharsis, a shared experience in which people sang, cried, and laughed. During those hours, in the cinemas, they could be Latin American or Mexican without reservation and with pride.

By visiting these theaters and buying records, these Latino audiences in the United States had unwittingly helped forge production criteria and generic conventions that guided the emergence of Mexican cinema through its Golden Age. These early audiences imposed their musical tastes and cherished scenes that appealed to their nostalgia, seeking to establish a connection and pay tribute to their native land, which was so near and yet so far. It is through an examination of the impressive career of the Calderón family that we can fully appreciate the truly transnational foundations of this national cinema and the intertwined nature of its textual characteristics, itinerant talent, various audiences, and economic logic. It also illuminates the underappreciated role that Los Angeles played in shaping and sustaining the Mexican film industry since its inception.

Notes

1. Rogelio Agrasánchez Jr., *Mexican Movies in the United States: A History of the Films, Theatres, and Audiences, 1920–1960* (Jefferson, N.C.: McFarland, 2006), 169–191.

2. Lynne Kirby, *Parallel Tracks: The Railroad and Silent Cinema* (Durham, N.C.: Duke University Press, 1997).

3. George J. Sánchez, *Becoming Mexican American: Ethnicity, Culture, and Identity in Chicano Los Angeles, 1900–1945* (New York: Oxford University Press, 1993), 183.

4. Advertisement for "Repertorio Musical Mexicano," *La Opinión*, May 19, 1918.

5. David Dorado Romo, *Ringside Seat to a Revolution: An Underground Cultural History of El Paso and Juárez: 1893–1923* (El Paso, Tex.: Cinco Puntos Press, 2005), 175. For a discussion of these controversial representations of Mexicans in early U.S. cinema, see Juan J. Alonzo, *Badmen, Bandits, and Folk Heroes: The Ambivalence of Mexican American Identity in Literature and Film* (Tucson: University of Arizona Press, 2009); and Dominique Brégent-Heald, *Borderland Films: American Cinema, Mexico, and Canada during the Progressive Era* (Lincoln: University of Nebraska Press, 2015).

6. See Laura Isabel Serna, "'As a Mexican I Feel It's My Duty': Citizenship, Censorship, and the Campaign against Derogatory Films in Mexico, 1922–1930," *Americas* 63, no. 2 (2006): 225–244.

7. Serna, 225–244.

8. For discussions of Villa's relationship to cinema, see Aurelio de los Reyes, *Con Villa en México: Testimonios sobre camarógrafos norteamericanos en la revolución* (Mexico City: Universidad Autónoma de México, 1985); and Margarita de Orellana, *Filming Pancho Villa: How Hollywood Shaped the Mexican Revolution* (New York: Verso, 2004).

9. Letter from Rafael Calderón to José Calderón, February 14, 1917.

10. Letter from Rafael Calderón to José Calderón, August 12, 1917.

11. Letter from José Calderón to Rafael Calderón, September 2, 1917.

12. Miguel Contreras Torres, *El libro negro del cine mexicano* (Mexico City: Edición del Autor, 1960), 264.

13. Contreras Torres, 264.

14. Oral history interview with Rafael Calderón, El Paso, Tex., April 2007.

15. "Don Rubén Calderón habla sobre los proyectos de la Azteca Films Dist. Co.," *La Opinión*, May 7, 1939.

16. Agrasánchez, *Mexican Movies*, 169–191.

A MASS MARKET FOR SPANISH-LANGUAGE FILMS

LOS ANGELES, HYBRIDITY, AND THE EMERGENCE OF LATINO AUDIOVISUAL MEDIA

Lisa Jarvinen

By the time that synchronized sound had become a standard feature of the commercial cinema in the late 1920s, Los Angeles had emerged as the capital city of the American film industry. Hollywood was one of Los Angeles's neighborhoods, but the two were never quite synonymous.[1] Los Angeles was concrete, Hollywood was concept. Hollywood had first been dubbed "the dream factory" in 1931 by Russian intellectual Ilya Ehrenberg. He wrote a book with that title after spending time at Paramount's studios in Joinville, France, where the studio was engaged in the production of multiple-language versions (MLVs) of its films. The conversion to sound had created a crisis of translation. How would Hollywood resolve the problem of selling films performed in English to international audiences that spoke a Babel's tower of different languages? At Joinville, Paramount applied the logic of the assembly line to the problem by making up to fourteen different versions of a single script in succession, each one acted by a cast fluent in the target language. Ehrenberg saw in this a grotesque amplification of all the problems of modernity that stemmed from the effects of mass production and mass consumption on culture and society. In his view, these led to the fracturing of a stable reality in which even dreams were mechanically made.[2]

Far away in Los Angeles, home to the "real" Hollywood, studio heads continued to worry about the language problem throughout the 1930s. During a decade of worldwide economic recession followed by a series of geopolitical crises that would lead to the outbreak of a second world war, the ability of the American

film industry to maintain its position in all its global markets was far from a sure thing. Although the studios attempted to streamline the production of films for non-English-speaking audiences through technologies of translation such as MLVs, voice dubbing, and subtitling, language—the most distinctive characteristic of humankind—proved stubbornly difficult to rationalize.

In most histories of the cinema, this grand experiment in remaking films in the target language as a way of translating sound films is described as a failure— even for the Spanish-speaking market, which was second only to English in terms of audience. In the course of researching the ten years of production and more than 170 films that comprised Hollywood's Spanish-language output, I ultimately rejected this narrative of failure. Instead, I argued that the significance of Hollywood's Spanish-language production was the way it had transformed the market for films in Spanish and intersected with the rise of production in Spanish-speaking countries. Some of the key evidence in support of this argument was my finding that Hollywood's Spanish-language production had not failed with audiences or even at the box office; it had failed to achieve the immediate goals of the major studios.[3] Here I want to discuss the origins of a mass market for Spanish-language films in the Los Angeles–based production of the 1930s and its relationship to early Latino audiovisual media. I argue that Hollywood's Spanish-language films showed characteristics of an incipient Latino audiovisual culture that reflected these films' places of production.

Both at the time and since, cultural nationalists have been taken at their word when they claimed that Spanish-language films produced in Los Angeles in the 1930s did poorly with audiences because of their mix of accents, lack of cultural specificity, and low production values. In fact, popular audiences did not reject these films on those grounds, although critics and audiences at first-run theaters often did. As productive and necessary as nationalist frameworks have been to the history of Spanish-language filmmaking, they have obscured the hybridity of most early Spanish-language films. Cultural nationalists throughout Latin America and in Spain tended to regard these films not only as Ehrenberg's soulless products of an assembly line but as Trojan horses in which Hollywood's use of a supposedly common language shared throughout the Hispanophone world broke down one of the most important barriers to an invasion of U.S. American culture. The often deeply negative responses of critics to films that came out of a diasporic setting affected production decisions at the time and have echoed in the historical understanding of the transition to sound. Such responses have obscured the often positive reception that Hollywood's Spanish-language films received among popular audiences, both locally and in Latin America; the influence that they had on the growth of film industries in Spanish-speaking countries; and the ways in which they represented a new and hybrid cultural form—one that in fact reflected some of the realities of having been made in Los Angeles.

In the new world of film audiences grouped by language, economies of scale meant that languages with many speakers and access to movie theaters suddenly became priorities for film producers. Yet whereas economies of scale point to the tendency toward mass production, language in its actual usage tended toward the specificity of the local. This apparent contradiction embodied Hollywood's dilemma. Whereas producers hoped language would be amenable to mechanization, they continually confronted the complexities of symbolic expression. For the Spanish-language market in particular, Hollywood's local context suddenly became quite real. As Los Angeles–based film studios sought to manage the disruptive effects of synchronized sound, the need to employ professionals and appeal to audiences of Spanish speakers forced these studios into new relationships with local Spanish-speaking communities, with newly arrived immigrants from Latin America and Spain who sought work in the sound film industry, and with the larger Spanish-speaking world.

VERSIONS AND *CINE HISPANO*

To understand the significance of Hollywood's Spanish-language filmmaking that would come to be known as *cine hispano* (Hispanic cinema), one must first examine the larger context that led studios to commit to MLVs. By 1929, when sound film had become standard in the United States and Europe, American companies began to look seriously at the language question. While approximately half of their international profits came from fellow English-speaking countries, the other half comprised a myriad of languages.[4] On October 29, 1929, the very day that the U.S. stock markets crashed, signaling the beginning of a decade-long depression, Arthur Loew of MGM declared that the production of multilingual films would be a race among studios to see which would first complete foreign versions, "particularly in Spanish."[5] Not only did the industry need to supply films that could satisfy foreign-language audiences; they also desperately sought to forestall the rise of competition, given that the situation offered "European producers the greatest opportunity ever for developing their home markets."[6] As we shall see, the threat that language would serve as a protective barrier for developing sound film industries was quite real—but its locus was not primarily in Europe.

From late 1929 through 1931, most of the American film industry committed itself to the production of MLVs as adjuncts to their regular English-language originals. The studios hoped that the versions would satisfy local demands for native language films, increase audience attendance (thus creating a larger film market), hinder competitors, and avert the enactment of protectionist legislation. Large-scale production of MLVs ended by about 1932, but the technique persisted, particularly for Spanish—and almost always at studios in Los Angeles. MLVs are generally held to have failed in most histories of the transition

to sound. The classic explanation for this is that the tension between studios' need to standardize MLV production in order to maximize efficiency and audience desires for cultural specificity could not be resolved. According to this view, MLVs were still expensive to produce, compared to subtitling or dubbing, but too obviously standardized for audience acceptance, and therefore they were rarely profitable or popular enough to achieve the industry's goals.[7] Spanish versions, because they were the most numerous of any single language, have been particularly important evidence for this argument. The tension between the studios' attempt to make differentiated production affordable through standardization and the reality of a wildly diverse, multinational, and diasporic language market that would constitute the audience for these productions seems to demonstrate that this circle was impossible to square.

Contemporary accounts written in Spanish sometimes referred to Hollywood's Spanish-language productions as *cine hispano*. In the early 1930s, the term had meant any film made in the Spanish language, but by the mid-1930s, when Mexico, Spain, and Argentina began producing substantial numbers of sound films, the term *cine hispano* was used more often for those films made in Spanish in the United States because the films of specific countries could be identified as Mexican, Argentine, Spanish, and so on. In an example of the term used in context, a 1934 piece in the New York–based publication *Cine Mundial* declared, "If Hispanic Cinema is going to survive in Hollywood, the only solution is to bring in all available talent from all of our countries."[8] When film historians looked back at this time period, they picked up on this designation and used it to emphasize that the films were spoken in Spanish but did not belong to a specific national tradition. Given the frequently caustic commentary that can easily be found in primary sources from the time period that criticized many of the Hollywood Spanish films, the term *cine hispano* retrospectively became derisive, as some film historians have used it to point out the ways in which Hollywood studios made these films carelessly with the intention of maintaining their hold on Spanish-speaking film markets at the least possible expense. It also implied a contrast between films that had a specific national identity and those of Hollywood that were "Hispanic" in name only.[9] In this view, these films did not speak to "the specificity of national cultures and values [but] to a generic 'Hispanic' culture artificially concocted by 'Hispanic' films through a forced syncretism of accents, locations, and cultural practices."[10] Such interpretations have a basis in the responses of critics at the time. For instance, Peruvian intellectual César Miró, who wrote a book about his experiences working for the industry in the late 1930s titled *Hollywood, la ciudad imaginaria* (Hollywood, the imaginary city), decried the emptiness of Hollywood's Spanish-language films: "Cinema, like literature . . . is a reflection of its environment and must necessarily be national. National above all. For this reason, Hollywood's Spanish-language films do not have character, nor spirit, nor tone of their own. They reflect the reality

of Hollywood. Nothing more."[11] This cultural nationalism was typical of the era, but it begs the question of what the reality of Hollywood was. Significantly, it ignores the context of the actual Hollywood in a city that not only had a substantial Mexican community but attracted film hopefuls from many countries when the possibility of Spanish-language filmmaking first arose.

Film historians have long argued that Spanish versions failed due to the linguistic missteps of the varied accents and idioms used by their haphazardly multinational casts.[12] This interpretation has been based on numerous sources from the time period that were often withering in their descriptions of the films' linguistic inadequacies and the poor quality of the performances that were partly attributed to the fact that Spanish-speaking actors were being directed by English-only speakers.[13] Trade publications likewise carried news items that reinforced the notion that audiences in Latin America and Spain simply would not stand for films that were so obviously made in the United States. An item in *Variety* cited a film critic from Buenos Aires who informed the paper that Argentines "have no objection to Castilian Spanish or Mexican Spanish or even the Spanish of the gallego, but they don't want all the patois mixed up in one film."[14] This insistence on the primacy of the national as expressed through language and culture is a key theme in explanations for the "failure" of Spanish-version films, and these explanations are abundant in contemporary sources, whether trade publications, Spanish-language film magazines, or industry correspondence. In spite of what seems like a consensus on the question, close examination of all available evidence suggests that, in fact, popular audiences responded positively to Spanish versions.[15] Many of these films ultimately did quite well in terms of ticket sales and even, in the long run, return on investment. In addition, while Los Angeles–based production of films in Spanish sputtered after 1931, it did not disappear. Indeed, many of the most interesting of the Hollywood Spanish-language films were produced after this date.

What explains these apparent contradictions, and most important, why did contemporaries often (but not always) fail to see it? There are four key factors. First, due to the slow rate of wiring for sound in Latin American countries, many audiences did not have a chance to experience the new sound films until several years later than audiences in the United States or Europe. This meant that the Spanish-version films had a distribution life of approximately three to four years in the first half of the decade. Second, ticket prices in Latin America, particularly at provincial or neighborhood theaters, were lower than in Europe, and thus film rentals had a smaller profit margin. Third, rates of illiteracy remained high in Latin America (as they did in rural Spain), which meant that subtitled films were not well received, while dubbed films seemed less natural than version films even as the latter risked rejection on the same grounds as version films if the voice doubles spoke in ways unfamiliar to the target audiences. Finally, the vast majority of the caustic commentary on the aesthetic failures and cultural tone deafness

of the Spanish-version films came from the pens of well-educated and frequently highly nationalist critics, while observations of negative audience responses were typically drawn from the first-run houses in national capitals.[16]

This last point is particularly important. Studio executives anxiously waited for news of how versions were faring with audiences, and when they received critical reviews from the Spanish-language press and learned that initial grosses were low, they became disheartened. Over the course of the first half of the 1930s, many Spanish-version films—and not just the musicals of figures such as Carlos Gardel that are typically held up as exceptions to the claim that Hollywood-made Spanish-language films failed with audiences—did quite well, but studios were not able to foresee this in 1930–1931, when they were making decisions about whether to continue the production of versions. One must also place the move toward subtitling and dubbing—the techniques of translation that the industry turned to once MLV production mostly ceased—in historical context. In 1932, at the low point of the Great Depression, many Hollywood studios were on the verge of bankruptcy, and their profits in Europe and elsewhere were being squeezed by falling rates of currency exchange and increasingly protectionist legislation driven by the economic crisis and political tensions. In such circumstances, economies of scale did not favor the production of MLVs due to Europe's great diversity of languages. All these factors combined to make subtitling and dubbing English-language films for export the best available option at the time. Studios mostly applied this logic to Spanish-language versions as well, despite the fact that this market was much larger than that of the other major European languages.[17] It was during the years following 1932 and the restriction of version film production that new sound film industries arose in several Spanish-speaking countries, as we shall see in the following section. In this sense, one might indeed claim that MLVs failed, as they did not forestall the rise of competition in the American hemisphere that would quickly become a very important market for Hollywood. Furthermore, this competition would push Spanish-language filmmaking in Los Angeles in new directions by the late 1930s, one that would again call into question what "Hispanic cinema" might mean.

MEXICAN LOS ANGELES / SPANISH LOS ANGELES

At the beginning of the 1930s, Hollywood studios certainly failed to anticipate the intensity of the scrutiny that their Spanish-language films would receive both locally and abroad. Ultimately, more than 170 Spanish-language films were produced by U.S. companies in these years, more than for any other non-English language.[18] The fact that the majority of these would be made in Los Angeles had much to do with the initial reception and longer-term development of this production.[19] One might assume that studio heads would have made this decision to take advantage of local Spanish-speaking talent and even the setting of

Southern California itself, which could support location shooting for films set
in Latin America. There is little evidence to suggest that these were significant
factors, although studios did look to established stars who were bilingual. Most
of the Spanish versions made by the major studios were simply remakes of
English-language originals—such as *Dracula*, *The Benson Murder Case*, or *The
Trial of Mary Dugan*—that did not seem to have been chosen for any intrinsic
cultural appeal that they might have for Latin American or Spanish audiences.[20]
Nor did studios factor into account the existence of a vibrant local Spanish-
speaking theater scene that served the Mexican community, was covered in the
Spanish-language press, and would soon become the most logical place to hold
premieres of the studios' Spanish-language productions.

This initial disregard for local realities that embedded Los Angeles in the
larger Spanish-speaking world was of a piece with the city's strange relation-
ship to its past. Los Angeles was marked by its history as a town founded by
the Spanish as an outpost of its enormous empire in the Americas. Then from
1821 through 1848, Los Angeles was part of the Mexican state of Alta California
until the United States defeated Mexico in the Mexican-American War of 1846–48
and acquired nearly half of that country's territory. The historic and continuous
presence of people of Mexican descent was augmented by waves of immigra-
tion from Mexico that responded to the economic pull of American develop-
ment and the push of political turmoil in postindependence Mexico. Yet only
rarely did the imagined world of Hollywood's cinema recognize these aspects
of the city's past or present. More frequently, cinematic representations of Los
Angeles—produced in the city itself—were characterized by a "slippage of place
and space" that denaturalized its Native, Spanish, and Mexican past and replaced
it with a "dominant image of Los Angeles as white and racially pure." The traces
that were left of the city's actual past were typically seen in films through archi-
tectural building styles that referenced Spanish influences or place names that
were undeniably Spanish.[21]

These kinds of erasures did not change the fact that Los Angeles in the 1930s
had a significant community of Mexican immigrants and Mexican Americans
that was part of the larger culture of the Southwest and was linked culturally
to the Spanish-speaking worlds of both Latin America and Spain as well as U.S.
cities such as Chicago and New York. Further, this community participated in
extensive local and transnational networks of entertainment that included
vaudeville, theater, and musical performances.[22] For these reasons, although
Hollywood studios would soon recognize the urgency of producing Spanish-
language versions, the very first films made in Spanish in the United States did
not come from the studios. From the outset, ambitious outsiders had grasped
the potential of the new medium. Those best placed to quickly take advantage
of market demand for filmed entertainment in the Spanish language were art-
ists already working on the musical or dramatic stage in New York and Los

Angeles theaters. Many of the earliest films made in Spanish in the United States consisted of a series of musical acts or brief comic sketches put together into a revue.[23] The example of Romualdo Tirado is instructive for understanding the ways in which these independent productions intersected with the Spanish versions of the studios.

Tirado had left his native Spain at a young age to tour the theaters of Latin America. He settled in Mexico before fleeing the revolution in 1919. First in Arizona and later in Los Angeles, Tirado made a name for himself as an actor on the Southwest's theater circuit. Working first at the Teatro Capitol and later at the Teatro México, Tirado starred in, directed, and often wrote revues, zarzuelas, and other pieces of light entertainment. He excelled in the role of the *pelado*—an urban bum who was a stock character in popular Mexican theater. Tirado soon became one of the most important figures of Los Angeles's Spanish-speaking stage during the 1920s, but the economic crises of the 1930s hit the stage hard.[24] In 1930, Tirado tested the waters of independent film production when he wrote the screenplay for, directed, and starred in a film called *La jaula de los leones* (*The Lion's Cage*), a light love story set in the world of the circus. Los Angeles's Spanish-language daily newspaper, *La Opinión*, wrote of the film on its premiere at the Teatro México that it was "the first talking film in Spanish made by elements from our theater who are known and applauded by Los Angeles's Mexican audiences." The article included a statement from Tirado's frequent business partner, Ernesto González Jiménez, who recognized that while the film might not be comparable to a big-budget studio production, the "poverty of means [had] not led to a poor effort" but rather one that he believed would go straight to the heart of its audience.[25]

Tirado was far from alone among Latino entertainment *empresarios* in hoping to prevent Hollywood from cornering the market on Spanish-language film production in the United States. In the early 1930s, other independents made entirely original Spanish-language films set in the United States. These include titles such as *Las campanas de Capistrano* (1930), which takes place in California—although in the years when it was still part of Mexico. Yet independent producers rarely made more than one film. Without a contract with a major film studio, it was difficult and expensive to get a film distributed widely enough to make a profit. Tirado, for instance, left production behind and established himself as one of the most frequently featured character actors of Hollywood Spanish-language films made in the 1930s, appearing in more than thirty-one.[26]

Acting or producing was not the only point of entry for Spanish-speaking theater workers. Hollywood studios consistently discriminated against both U.S. Latino and Latin American writers in favor of importing playwrights from Spain. Although talented local writers had no opportunity to write original scripts, they were sometimes chosen to adapt English scripts into Spanish or to work on the set as dialogue directors. Script adapters were at first employed

merely to translate English-language scripts into Spanish. After making just a few films, studios quickly realized that they needed to employ people who not only could translate but were also adept at writing convincing dramatic dialogue. Thus upon comparing the English and Spanish versions of many scripts, one finds significant differences between the two. The lowly titled and poorly paid dialogue director on Spanish-language films was often the de facto director of the film. When a studio-appointed English-only director could not understand the language in which the film was being performed, the dialogue director had enormous latitude to shape the actors' interpretations of the script.

Without question, however, studios largely made conservative choices for their Spanish-version films. In many cases, this meant that they preferred to employ well-known stars who were Spanish speakers (such as Antonio Moreno, Ramon Novarro, or Lupe Vélez), seek out internationally known stars from the theater (such as Ernesto Vilches, Virginia Fábregas, or Catalina Bárcena), and rely on Spanish playwrights (such as José López Rubio or Enrique Jardiel Poncela) as script adapters. Above all, though, in the first years of Spanish-version production, they made choices that emphasized the superiority of the Castilian version of the Spanish language. Colin Gunckel and I have written in detail elsewhere about the controversies known as "the war of the accents" that this sparked between Spaniards and Latin Americans.[27] Studio heads tended to have a superficial understanding of the serious and long-standing debates within the Spanish-speaking world over the cultural ties that language usage implied. As one Mexican critic wrote at the time, "The businessmen in Hollywood . . . forget that we in Latin America speak more than fifty languages, all of them derived from Spanish. There is nothing more grotesque than seeing and witnessing an argument between two North Americans, one speaking in Argentine, the other in Mexican."[28] The author presumably referred to a Hollywood Spanish-version film that was set in the United States but acted by a multinational, Spanish-speaking cast. The notion of mixing national language styles in the film seemed like an affront—one more reminder of the ignorance of Hollywood producers who assumed that Spanish was a unitary language. Nevertheless, the fact that such films would often succeed with popular audiences meant that these same producers were baffled by the contradictory responses their films received.

No film better illustrates this dynamic of apparent failure but eventual box office success than the 1931 Spanish version *El hombre malo* (based on the 1930 English-language original, *The Bad Man*). Although this was one of the very few early Spanish-language studio films that were set in the American Southwest, it was an odd choice given that the story featured a Robin Hood–style Mexican *bandido* character of the type that had provoked repeated protests by the Mexican government over the years. Warner Brothers / First National (WB/FN) aggravated the situation by casting well-known star Antonio Moreno, a Spaniard, over the Mexican actor Leo Carrillo. The film's producers soon faced

a sustained campaign in the local Spanish-language press (as well as in Mexico City publications) to eliminate any negative stereotypes, cast Mexican actors in supporting roles, and ensure that the language and pronunciation of dialogue in the film reflected Mexican usage. The proximity of the local Mexican community and its ties to Mexico gave the critics substantial leverage over a studio production. The producers did their best to calm the storm, and although many of the stereotypes remained intact, they complied with the other demands. By the time the film premiered in Los Angeles's Spanish-language theaters, it received good local reviews. Nevertheless, the producers soon began to receive sharply negative reviews from the international Spanish-language press. From Spain to Argentina, critics agreed that El hombre malo was just one more example of the vast insensitivity of Hollywood to Hispanic cultures. The film's box office returns were also initially disappointing, leading distributors to plead with the studio not to make any more films of this type. This depressed the hopes of the producers and led WB/FN to reduce its schedule of Spanish versions—and eventually cease producing versions at all.[29]

While this outcome would seem to support in every detail the notion that Spanish versions could not—and did not—succeed, it is misleading. In the longer term, archival records reveal that El hombre malo was one of the most successful of the Spanish-version films. By 1934, three years after its initial premiere, it had grossed more than five times that of any English-language WB/FN film released in Mexico.[30] This was in line with the ultimate success of other MLVs that appealed to popular audiences who valued films that were acted in their native language, even as these same films distressed critics who saw them as obviously second-rate products of an American industry that had little respect for the integrity of other cultures. This should not, however, be taken to mean that MLVs would have succeeded indefinitely or that they were optimal solutions to the challenge of linguistic diversity. Ultimately, what they pointed to was the viability of film production in the Spanish language. More concretely, they demonstrated an important gap between critical and popular reception—one that ignored the fact that popular audiences were quite willing to accept films with multinational casts because the films were spoken in Spanish.

MEXICO–SPAIN–ARGENTINA–LOS ANGELES

From 1932 on, Hollywood faced the alarmingly fast growth of sound film industries first in Mexico and Spain and later in Argentina. Just as the studios were cutting their Spanish-language production, competitors began to appear. These developments were partially related. When studios terminated the contracts of their Spanish-speaking actors and writers, quite a few decided to try their luck either back in their home countries or in a third country. Numerous film professionals who had gained some experience in sound film production in

Hollywood were able to contribute to the transition to sound these other industries were going through. The networks that formed between these different sites of Spanish-language film production had their original nexus in Los Angeles, and all these industries had a markedly transnational character. Many film workers would circulate through various industries and sometimes return to Hollywood to work on sporadic Spanish-language films during the mid-1930s or to take minor roles in English-language films. At the same time, audience demand was expanding. As we have seen, outside of first-run cinemas in the large cities that had wired for sound early and tended to serve more elite sectors of the population, Hollywood's Spanish-language films had found accepting audiences. While one of the goals of MLV production had been to gain new spectators, distributors had not anticipated how strongly provincial and rural audiences would respond, and just as more theaters were being wired for sound in these areas, Hollywood severely curtailed its version production.

By the late 1930s, the trickle of Spanish-language films produced in Mexico and Argentina (Spain's industry had been knocked out due to the start of civil war in 1936) became a flood. One industry publication reported that in Cuba, where exhibitors formerly had been averse to playing anything but American films, two hundred of the country's three hundred theaters were playing primarily Spanish-language films in 1938.[31] Another U.S. account attributed the tremendous growth of audience attendance in Mexico to "the growing use of films recorded in the native language which have proved highly popular in the rural sections." This tendency was widespread—a distribution manager for Peru reported that in just a few years, screen time that had been 100 percent American had been reduced to 50 percent because of the popularity of Spanish-language films "in the subsequent runs in Lima and in the smaller towns in the territory."[32]

Throughout the 1930s, U.S. observers of the foreign market suggested that the only solution to audience resistance to dubbing and subtitling would be films with "considerable action, simple stories and . . . unusual quality."[33] While audiences would become accustomed to these modes of translation over time, it is the recommendation of how to overcome resistance to them that is of note here. Those who worked in the distribution sector of the industry observed that spoken language continued to complicate audience reception and argued that, at least in the short term, part of the solution was a return to a key characteristic of the silent era: films would need to rely less on dialogue. As Michael Walsh has noted, it was frequently difficult for American distribution managers to accept that what they saw as inferior local productions outperformed American films with these audiences. Hollywood had always justified its saturation of foreign markets by claiming that its films were technically superior and had universal appeal.[34] One contemporary observer noted that Latin American audiences were going to films that were "sold on low terms" but "doing outstanding business" because they were in Spanish and had "a domestic flavor."[35]

Back in Los Angeles, studios vacillated on the appropriate course of action. In the mid-1930s, only Fox committed itself to a substantial slate of Spanish-language film production, cultivating stars with serious box office appeal and talented writers who could ensure quality scripts. While most of these films succeeded with audiences, Fox also cut its Spanish department when the company merged with 20th Century in 1935 and studio executives chose to streamline production practices. Given that this was the point at which Spanish-language industries elsewhere were taking off, studios quickly had to develop new strategies to head off this competition. This primarily involved negotiating coproduction and distribution deals with companies in Latin America and Spain. Even so, there were risks to this strategy. At least one studio representative argued that the U.S. industry should avoid participating in Spanish-language films because they were too popular with audiences in Latin America and studios risked "[freezing] their own product out of this territory."[36] Yet the temptation remained strong.

From 1938 to 1939, a last rush of Hollywood-made Spanish-language films came out. Although largely produced by independents, they benefitted from being distributed by the major studios, most of whom participated in this final round. As Brian O'Neil has detailed, a larger geopolitical context in which many foreign markets were being closed off due to the onset of war and the pressure of facing competition for Latin American markets from not just domestic producers but also Europeans does much to explain this. Even so, the characteristics of this group of films are striking. The majority are set in the United States and feature Latino themes. From *Verbena trágica*, which takes place in New York's Spanish Harlem; to *Cuando canta la ley*, whose action is on the U.S.-Mexico border; to *El milagro de la calle mayor* (*Miracle on Main Street*), which is set in the Mexican neighborhood of Los Angeles, these films finally embrace the reality of the existence of Spanish-speaking communities in the United States.[37] They were not intended only for domestic consumption, however—they circulated throughout the Spanish-speaking world, playing in theaters from Chile to Mexico to Puerto Rico.[38] *Variety* noted that the Spanish version of *El milagro de la calle mayor* was possibly the "best Spanish production out of Hollywood and first real competition for Spanish version supremacy of Argentine producers."[39]

The film starred an actress who used the single name Margo. She had been born Marguerita Bolado in Mexico City in 1917 but was moved to the United States by her family at a young age. She first began appearing on stage and onscreen as a teenager. In a review of one her stage performances in the Spanish-language film magazine *Cine Mundial*, the author noted that English-language reviews had described Margo as an exotic foreigner, a claim he dismissed by noting that "Margo is nothing of the kind. She came to this country at age three or four and the language she knows best is English. . . . She is not Mexican at all. . . . She is a legitimate product of the United States. If the Yankee press wants

to describe her as a foreigner . . . it is because they have been trained to classify everyone who is not descended from the English that way." Nevertheless, a few years later when *Milagro* was in production, a journalist from this same publication described her as "this wonderful Mexican artist" who would be "a glory of the Hispanic Cinema." He noted that the actress had insisted when approached about making a film in Spanish (she had had minor roles in English-language films prior to this, her first starring role) that she play a Mexican character.[40] The seeming contradiction is easy enough to resolve. The main character was, like the actress herself, a Mexican woman who lived in Los Angeles. The "Main Street" of the film's title referred to an actual street in Los Angeles that ran through the heart of the Mexican neighborhood. It was where the Spanish-language film theaters were located—venues that hosted the films from all of the countries that produced in that language, including the United States.

CONCLUSION

Milagro was one of the very last Spanish-language films that would be made in Los Angeles for decades to come. The onset of World War II would lead studios to again abandon Los Angeles–based Spanish-language film production in favor of making English-language Latin American films that supported President Franklin Roosevelt's Good Neighbor initiative and coproduction or distribution deals for Spanish-language films made primarily in Mexico (a key ally of the U.S. during the war). Still, this last burst of films made in LA had many of the characteristics of what in recent years would be described as Latino cinema. The earlier Spanish-language films as well—from straight MLVs to adaptations to original productions—acknowledged the reality of a domestic Spanish-language media market that was associated with an enormous transnational community of Spanish-speaking peoples. Histories of these films have too often missed the ways in which they reflect a developing Latino culture and a response to this on the part of the film industry. While it is true that studios were motivated by profit and that their film producers and distributors had little understanding of or respect for Latin American or Spanish cultures, these facts have obscured that this cine hispano was an important precursor of Latino media.

As scholar of Latin American and U.S. Spanish-language television John Sinclair has argued, U.S. Latinos are a kind of diaspora in reverse. Where diasporas are usually defined as a community of people who are related to each other by a common place of origin, U.S. Latinos are related to each other by a common destination despite a diversity of origins. Many, but by no means all, share Spanish as a common language and certain cultural traits and historical experiences, yet it is only in the United States that this grouping of peoples is understood to have a common identity—one that is largely based on experiences in the United States.

This formulation has implications for what we designate as Latino media.[41] While a full discussion of these is beyond the scope of this chapter, what the history of Hollywood and, more important, Los Angeles–based Spanish-language films of the 1930s show us is that however odd and sometimes artificial these early films seemed to critics, they were often reflective of their context. One recent writer who has reflected on the history of Hollywood's cine hispano has recognized as much when he noted, not with much appreciation, that those early films are the direct ancestors of today's Spanish-language television shows and that "whether we like it or not, we have entered into the Tower of Babel of accents, in a flood of diversity that doesn't ask permission from the linguistic authorities, and we will be caught up in the unavoidable edges of *Spanglish*, that some consider a contribution, and others a disgrace."[42]

When studio executives employed multinational casts who spoke in a range of accents, this was an accurate representation of the milieu in which Los Angeles studios operated. The city had a local Spanish-speaking community, and it attracted ambitious immigrant strivers who sensed an opportunity when Spanish-language film production started. If the resulting films made by profit-seeking studios in the context of Los Angeles did not observe the niceties of formal Spanish usage or respect the boundaries of national forms of speech, this was part and parcel of how and where they were made.

None of these observations are intended to justify or diminish the real ways in which the dominant players in the industry frequently demeaned Latin Americans, Spaniards, and Latinos and their respective cultures. Nor should this be taken as a celebratory counternarrative. Hollywood only engaged in Spanish-language film production for strategic purposes and abandoned it whenever it found new ways to best or forestall competition. Likewise, as scholars of Latino history and culture have noted, there are real dangers to linking Latino identity to the Spanish language, particularly in terms of the media. If, on the one hand, the ability of U.S. Latinos to participate in and consume media as part of a vast, transnational Spanish-language market gives them greater power as producers and consumers, this carries the concomitant risk that the majority English-speaking population will identify Latinos with the foreign and view them as unassimilable.[43] Whether this will change as Spanish gains recognition as a national language and as Latinos themselves embrace a range of linguistic identities remains to be seen. A close examination of the early years of Spanish-language film production in the United States leads us away from placing it solely in the context of Hollywood's role as the world's dominant industry and nationalist responses to it and toward a better understanding of local, popular, and regional experiences that often escaped this binary. Thinking of "Hollywood" as embedded in Los Angeles, and Los Angeles as embedded in a larger *American* context, helps us see this more clearly.

CODA

The actress Margo who had starred in *The Miracle on Main Street / El milagro de la calle mayor* was later blacklisted for her leftist sympathies and had a hard time finding work in film. She remained in Los Angeles along with her husband, the actor Eddie Albert, and committed herself to social causes in the Latino community. This included teaching acting and the arts to youth in East Los Angeles starting in the 1940s. Eventually, Margo became one of the founders and the director of the Plaza de la Raza, a Chicano educational and cultural center in the Lincoln Park neighborhood. Her obituary in the *Los Angeles Times* quoted her as having said that the acting classes she taught there were for Latinos, who "'don't have enough access and training to compete' in show business." One of the Plaza de la Raza's recent exhibitions was titled "Latinos in Hollywood" and was held in the Margo Albert Theater.[44]

NOTES

1. Mark Shiel, *Hollywood Cinema and the Real Los Angeles* (London: Reaktion, 2012), 8.

2. Ilya Ehrenberg, *Die Traumfabrik: Kronik des Films* (Berlin: Malik-Verlag, 1931); Nataša Durovicová, "The Hollywood Multilinguals," in *Sound Theory, Sound Practice*, ed. Rick Altman (New York: Routledge, 1992), 143–144; Siegfried Zielinski, *Audiovisions: Cinema and Television as Entr'actes in History* (Amsterdam: University of Amsterdam Press, 1999), 130.

3. Lisa Jarvinen, *The Rise of Spanish-Language Filmmaking: Out from Hollywood's Shadow, 1929–1939* (New Brunswick, N.J.: Rutgers University Press, 2012).

4. James P. Cunningham, "Industry Statistics," *Film Daily*, August 29, 1929, 4.

5. "Arthur Loew Sees Race in Multi-lingual Films," *Film Daily*, October 29, 1929, 1, 6.

6. "Europe Enthusiastic over Talkers, Says Fineman," *Film Daily*, November 17, 1929, 4.

7. Ginette Vincendeau, "Hollywood Babel: The Coming of Sound and the Multiple-Language Version," in *"Film Europe" and "Film America": Cinema, Commerce and Cultural Exchange, 1920–1939*, ed. Andrew Higson and Richard Maltby (Exeter: University of Exeter Press, 1999), 211–213.

8. Miguel de Zárraga, "La divina Berta se asoma a la pantalla," *Cine Mundial*, June 1934, 347.

9. For another example of how the term was used in context in the 1930s, see Elena de la Torre, "La ciudad desierta," *Cine Mundial*, January–December 1935, 512. For the use of *cine hispano* (or its translation, "Hispanic cinema") by film historians, see Emilio García Riera, "Cine Hispano," in *Historia documental del cine mexicano*, vol. 1, *1929–1937* (Mexico City: Ediciones Era, 1969), 38–44; and Carl J. Mora, *Mexican Cinema: Reflections of a Society, 1896–2004*, 2nd ed. (Jefferson, N.C.: McFarland, 2005), 30–38.

10. Paul A. Schroeder Rodríguez, *Latin American Cinema: A Comparative History* (Berkeley: University of California Press, 2016), 78.

11. César Miró, *Hollywood, la ciudad imaginaria* (Los Angeles: Imprenta de la Revista México, 1939), 200.

12. Ruth Vasey, *The World According to Hollywood, 1918–1939* (Exeter: University of Exeter Press, 1997), 98–99.

13. See, for example, Alejandro Aragón, "Spanish Talkies," *El Ilustrado*, August 29, 1930, reprinted in Luis Reyes de la Maza, *El cine sonoro en México* (Mexico City: Universidad Nacional Autónoma de México, 1973), 216–222.

14. "S.A. Hungry for Native Talkes, Sez B.A. Pic Critic," *Variety*, April 3, 1934, 13.

15. There were also contemporary sources that questioned the dominant narrative of failure. See, for example, "El fracaso de las películas parlantes en español no reza con todos los productores," *Mundo Cinematográfico*, February 1931, 11.

16. I discuss the evidence for these assertions at length in Jarvinen, *Rise of Spanish-Language Filmmaking*, 51–55.

17. Jarvinen, 114–118.

18. Studios had fewer concerns for Latin America about the kinds of quota laws and currency remittance restrictions that had driven the turn toward European-version production for languages such as French and German. For a complete a filmography of Hollywood's Spanish-language production, see Juan B. Heinink and Robert Dickson, *Cita en Hollywood: Antología de las películas norteamericanas habladas en español* (Madrid: Ediciones Mensajero, 1990).

19. The exceptions are Paramount's Spanish-language films that were largely made at its studios in Joinville (France) and in Astoria (New York).

20. Jarvinen, *Rise of Spanish-Language Filmmaking*, 44–45.

21. Shiel, *Hollywood Cinema*, 50–51, 170–174.

22. Colin Gunckel, *Mexico on Main Street: Transnational Film Culture in Los Angeles before World War II* (New Brunswick, N.J.: Rutgers University Press, 2015), 14–88; Douglas Monroy, *Rebirth: Mexican Los Angeles from the Great Migration to the Great Depression* (Berkeley: University of California Press, 1999), 40–44.

23. Jarvinen, *Rise of Spanish-Language Filmmaking*, 17, 27–32.

24. Nicolás Kanellos, *A History of Hispanic Theatre in the United States: Origins to 1940* (Austin: University of Texas Press, 1990), 30–64.

25. Fidel Murillo, "Teatrales," *La Opinión*, August 9, 1930, 6. Author's translation from the original Spanish.

26. See Tirado's filmography in the American Film Institute's online catalog at http://www.afi.com/members//catalog/SearchResult.aspx?s=&TBL=PN&Type=CA&ID=134562.

27. Gunckel, *Mexico on Main Street*, 98–100.

28. "De lo ridículo a lo grotesco," *El Universal*, 1929, cited in Reyes de la Maza, *Cine sonoro en México*.

29. Jarvinen, *Rise of Spanish-Language Filmmaking*, 72–78; Gunckel, *Mexico on Main Street*, 102–104.

30. Gaizka de Usabel, "American Films in Latin American: The Case History of United Artists Corporation, 1919–1951" (PhD diss., University of Wisconsin–Madison, 1975), 158.

31. "Studios Urged to Do Spanish Films for Latin America," *Motion Picture Herald*, June 4, 1938, 40.

32. "Pan-American Good Will Seen Helping US Showbiz," *Film Daily*, April 6, 1939, 6; "Spanish Language Films Cut into Peruvian Time," *Film Daily*, May 31, 1939, 4.

33. "French Exhibitors Win Fight in Round on Tax," *Motion Picture Herald*, February 8, 1936, 50.

34. Michael D. Walsh, "The Internationalism of the American Cinema: The Establishment of United Artists' Foreign Distribution Operations" (PhD diss., University of Wisconsin–Madison, 1998), 173–177.

35. "Hutchinson Says Latin Films Compete with U.S. Product," *Motion Picture Herald*, March 5, 1938, 14.

36. "Production of Spanish-Language Pix by U.S. Firms Seen as Dangerous," *Film Daily*, May 2, 1939, 1.

37. Brian O'Neil, "Yankee Invasion of Mexico, or Mexican Invasion of Hollywood? Hollywood's Renewed Spanish-Language Production of 1938–1939," *Studies in Latin American Popular Culture* 17 (1998): 79–105.

38. Heinink and Dickson, *Cita en Hollywood*, 261–274.

39. "Hollywood Inside," *Variety*, January 11, 1940, 2.

40. Riverón, "Chistes Malos y Buenos en Broadway," *Cine Mundial,* December 1935, 756; Don Q., "Hollywood," *Cine Mundial,* July 1939, 318.

41. John Sinclair, "From Latin Americans to Latinos: Spanish-Language Television in the United States and Its Audiences," *Revista Fronteiras: Estudios Mediaticos* 1, no. 1 (January–June 2004): 7–20.

42. Reynaldo González, "Introducción: Primeros tropezones del español en el cine," in *La lingua española y los medios de comunicación,* vol. 2, ed. Luis Cortés Bargalló (Mexico City: Siglo XXI Editores, 1998), 742.

43. Hector Amaya, *Citizenship Excess: Latino/as, Media, and the Nation* (New York: New York University Press, 2013), 123–115; José del Valle, "US Latinos, *la hispanofonía,* and the Language Ideologies of High Modernity," in *Globalization and Language in the Spanish-Speaking World: Macro and Micro Perspectives,* ed. Clare Mar-Molinero and Miranda Stewart (New York: Palgrave, 2006), 27–46.

44. Michael Seiler, "Margo Albert, Head of Latino Center, Dies," *Los Angeles Times,* July 18, 1985, http://articles.latimes.com/1985-07-18/local/me-7197_1_plaza-de-la-raza; Victoria Price, *Vincent Price: A Daughter's Biography* (New York: St. Martin's Press, 1999), 172–173; "La Madrina Margo Albert," *Bunnybun's Classic Movie Blog,* October 12, 2015, https://bunnybun .org/2015/10/12/la-madrina-margo-albert/.

CHAPTER 5

◇◇◇◇◇◇◇◇◇◇

CANTABRIA FILMS AND THE LA FILM MARKET, 1938–1940

Jan-Christopher Horak

In the first decades of the twentieth century, Los Angeles became a key destination for immigrants leaving Mexico en masse to escape the instability of the revolution and find work in Southern California's rapidly expanding agricultural production. By the 1920s, downtown Main Street, near the Plaza district, had become a vibrant cultural and commercial epicenter of Mexican life in Los Angeles. A number of theaters along this corridor—including the Hidalgo and the Metropolitan—offered their immigrant clientele a diverse range of entertainment: silent films from all over the globe, vaudeville-style presentations, musical concerts, and dramatic theater.[1] With the emergence and growth of Mexican sound cinema in the mid-1930s, downtown Los Angeles had become home to numerous first- and second-run Spanish-language theaters, including the Teatro Eléctrico, California, Mason, Million Dollar, Arrow (a.k.a. Azteca), and Roosevelt Theaters, quickly making the city the undisputed capital of Mexican cinema culture in the United States. The result was a vibrant Latino film culture in Los Angeles that not only embraced the so-called Golden Age of Mexican films but also saw a significant number of films from Argentina, Spain, and Spanish-speaking Hollywood.

There was, in fact, intense competition for screens in the Los Angeles market, as will be demonstrated later on in this chapter. As a result, Spanish-language film production in Los Angeles met with mixed success in penetrating that market, which may account for the brevity of engagements accorded to Mexican American producers, especially in the late 1930s. Lisa Jarvinen has divided Hollywood Spanish-language film production into several phases: (1) 1930 to 1931, when Hollywood produced multilanguage versions of American films, including German, French, and Spanish versions; (2) 1931 to 1935, when the Fox Film Company (1931–1935) and Paramount (1934–1935) produced

original Spanish-language films; and (3) 1938 to 1939, when independent produc-
ers in Hollywood created Spanish-language originals that were distributed by
the Hollywood majors.[2] While the failure of the first wave has been attributed to
American producers' lack of knowledge of Spanish and Latin American culture
as well as their unfulfilled financial expectations, the second wave expired due
to management changes at Fox (which merged with 20th Century) and the death
of Carlos Gardel at Paramount, since both series were financially successful.[3]
The third wave remained short lived, it has been theorized, because the industry
began direct investment in Mexican film production and because Hollywood
"lost interest" in producing Spanish-language films for Latin America.[4]

Focusing on the California-born Cantabria Films, which produced two films
in the late 1930s, La vida bohemia (1938) and Verbena trágica (1939), this chapter
will document that it was not "Hollywood" speculating on the Latin American
market but rather Los Angeles–based, independent, Spanish-language film pro-
ducers (albeit with studio distribution deals) who attempted to cash in on the
boom in Mexican cinema, resulting in the last wave of American-made Spanish-
language film productions.[5] Second, looking at the intense competition for cin-
ema screens in the LA market, I will show that the failure of these films had
less to do with Hollywood—although their distribution deals almost guaranteed
failure for Latino producers—than with the specifics of the Spanish-language
film market in Los Angeles and, possibly by extension, the Latin American
market. Cantabria's financial records reveal a company that was undercapital-
ized, its films financial failures. While creative studio accounting kept most box
office receipts in distributor coffers, the close financial relationship between
Frank Fouce, who operated many of LA's downtown cinemas, and Azteca Films,
the Mexican American distribution company, may have influenced screen time
accorded to some films distributed by American majors. Finally, the economics of
Spanish-language film production only allowed for low-budget productions;
thus the Cantabria Films productions and most others were relegated to short
engagements and second runs.

In order to understand the history of Spanish-language film production
in Hollywood, we need to have more data on the actual reception of classic Latin
American cinema than quotes from a few contemporary critics. By focusing on a
geographically specific location, Los Angeles, this chapter will provide an analy-
sis of screen time in that market. LA is appropriate as a case study because it is
both the center of the largest film industry of the day and a transnational nodal
point between Anglo and Latino cultures; it was therefore also a front line for
nationalist aspirations. Focusing on the fate of the Cantabria Films productions
and other independently produced cine hispano films on the screens of Main
Street LA, I will quantitatively and qualitatively analyze to what degree these
films succeeded in entering the public consciousness of the Mexican American
community using data culled from La Opinión, specifically advertisements and

reviews. I will demonstrate that the overproduction of a nationalist-oriented Mexican cinema led to a flooding of the market, lessening chances of success for any Hollywood-produced Spanish-language films.

SPANISH-LANGUAGE FILMMAKING IN HOLLYWOOD

Lisa Jarvinen's *The Rise of Spanish-Language Filmmaking: Out from Hollywood's Shadow, 1929–1939*, represents the first important book-length study on the subject. She notes that the Hollywood studios decided by 1930 to produce multilanguage versions of their films because they were faced with having to sonorize films for specific language groups, when previously they needed only to translate written titles. The same English script translated into French, German, Spanish, and in some cases, as many as five other languages was produced on the same sets and while different groups of actors wore the same costumes. Thus Universal produced its now famous Spanish version of *Dracula* (George Melford and Enrique Tovar Ávalos, 1931), starring Spanish actor Carlos Villarías and Mexican actress Lupita Tovar, which is now considered superior to the English version starring Bela Lugosi.[6] Meanwhile, MGM produced *Monsieur Le Fox* (Roberto E. Guzmán and Hal Roach, 1930), the Spanish version of *Men of the North* (Hal Roach, 1930), both starring Mexican actor Gilbert Roland, and Paramount set up a whole foreign-language department in their Joinville studio in Paris.[7] Nevertheless, the foreign versions were produced for significantly less money than American originals, often starring little-known actors rather than homegrown foreign stars.[8] Despite criticism of these versions in the Latin American press, Jarvinen establishes—against conventional wisdom—that Spanish versions of Hollywood films frequently did better at the box office in Latin America than the English originals.

However, there were problems. Hollywood was deaf to the various forms of spoken Spanish, disregarding the fact that sound technology suddenly made class and social hierarchies as well as national characteristics clearly audible. That led to another problem—namely, clashes between Spaniards and Mexicans for starring roles. Jarvinen analyzes the case of Warner Brothers' *El hombre malo* (Roberto E. Guzmán and William C. McGann, 1930), which was heavily criticized in the Mexican American press because Spaniards in the cast and crew had supposedly discriminated against Mexican actors.[9] Furthermore, the film's star, Antonio Moreno, played the old stereotype of the Mexican *bandito*.[10] Hollywood reacted to such criticism by stating that Hispanics were "too sensitive," indicating its insensitivity to cultural difference.[11]

The multiversion period ended relatively quickly because the technology for dubbing and subtitling improved rapidly, making it unnecessary to reshoot films with Spanish-speaking actors, as was the practice between 1930 and 1931. Jarvinen's discussion of titling versus dubbing reveals the shocking fact that Hollywood did not consider the Latin American market large enough to justify investment

in sophisticated dubbing (subtitles were more cost effective) at least until the mid-1940s, when films from Mexico and Argentina were providing serious competition to Hollywood in local markets.[12] Hollywood's Spanish-language film productions were often rejected by Latin American critics because they were shot in Castilian Spanish or included mixed casts of Spanish-speaking actors (whether from Argentina, Colombia, Mexico, or Spain). Finally, Hollywood's translation of its own films mirrored the gross racial and ethnic stereotypes employed by Hollywood films, blocking systems of identification for Latin American audiences. Nevertheless, the American film industry churned out more than 170 Spanish-language versions of Hollywood films.[13]

Not all Spanish-language films produced in Hollywood were versions of existing English-language films. Between 1932 and 1935, the Fox Film Company not only produced numerous Spanish-language films but gave their Hispanic talent more autonomy to pursue their own cultural agendas, thanks in part to the incredible box office success of José Mojica in *El precio de un beso* (Marcel Silver and James Tinling, 1930), the Spanish version of *One Mad Kiss* (Marcel Silver and James Tinling, 1930).[14] An opera star, Mojica would make no fewer than sixteen Spanish originals, many of them light musicals, while he considered two films his best: *La cruz y la espada* (Frank R. Strayer and Miguel de Zárraga, 1933) and *La fronteras del amor* (Frank R. Strayer, 1934). Meanwhile, at Paramount, Carlos Gardel had become a huge Spanish-language star for the studio, appearing in a series of films at Paramount's Joinville operations, then at Astoria Studios in New York. Directed by John Reinhardt and Louis Gasnier, the series included *El tango en Broadway* (1934), *Tango Bar* (1935), and *El día que me quieras* (1935) but was cut short by Gardel's death in a plane crash in Colombia in 1935. In reviewing Spanish-language Hollywood films from the 1930s, Jarvinen concludes, "Although the studios cared about the potential profits from Spanish-speaking markets, attempts to cater specifically to those markets displayed signs of marginality whether through cultural missteps in films, or treatment of Spanish-speaking film professionals or disregard of linguistic variations in Spanish."[15]

By the mid-1930s, both Mexico and Argentina had begun producing feature films, which constituted a serious challenge to Hollywood's hegemony. In particular, the box office hit *Allá en el Rancho Grande* (Fernando de Fuentes, 1936) took Hollywood by surprise. By that time, only Metropolitan Pictures was involved in Spanish-version production, shooting three films at Talisman and other rental studios in Los Angeles: *De la sartén al fuego* (John Reinhardt, 1935), starring Rosita Morena; *El capitán Tormenta* (John Reinhardt, 1936), starring Fortunio Bonanova and Lupita Tovar; and *El carnaval del diablo* (Crane Wilbur, 1936), starring Bonanova. *El capitán Tormenta* must have been the most successful, given that it was reprised in Los Angeles theaters several times as late as 1938. George A. Hirliman, who produced films for more than a decade, was financed through Consolidated Film Laboratories and founded Regal and Metropolitan

in 1935 for English and Spanish films, respectively.[16] In fact, the three Spanish-language films were shot simultaneously or afterward in English as *Captain Calamity* (John Reinhardt, 1936), and *The Devil on Horseback* (Crane Wilbur, 1936). Later, Metropolitan produced almost exclusively Bob Steele westerns, but it released its Spanish pictures through Metro-Goldwyn-Mayer and 20th Century Fox.

A final wave of Spanish-language films produced in Hollywood emerged briefly in the 1938–1939 period. Brian O'Neil, in his seminal article "Yankee Invasion of Mexico, or Mexican Invasion of Hollywood? Hollywood's Renewed Spanish Language Production of 1938–1939," was the first to identify the thirteen Spanish-language films shot in Los Angeles during this time.[17] O'Neil discusses the deep distrust of Mexican film critics and filmmakers toward anything coming out of Hollywood. While providing some details of individual productions, O'Neil states that "the cause behind Hollywood's renewal of Spanish-language productions in 1938–1939 was very similar to that which had engendered the industry's previous Spanish cycle in the early 1930s: fear."[18] In other words, Hollywood feared competition from the ever-expanding Mexican and Argentine film industries and therefore initiated Spanish-language film production. However, it was actually due to the initiative of independent Spanish-language producers attempting to break into the Latin American market that these films emerged. Given that their production was initiated between 1938 and 1940, one can assume that all these films were attempts by independent producers to cash in on the popularity of Mexican and Argentine films after the worldwide success of *Allá en el Rancho Grande*. For the most part undercapitalized, these independents were forced to negotiate distribution deals with American majors before or after their productions were finished, resulting in contracts that were seldom favorable.

Another indication that these Spanish-language films were produced independently is the fact that they were shot not on the lots of Paramount RKO or Columbia but exclusively in Los Angeles rental studios. Novice moviemaker Jaime del Amo (Cantabria Films) independently produced *La vida bohemia* (Josef Berne, 1938) and *Verbena trágica* (Charles Lamont, 1939), both of which were eventually distributed by Columbia. The first film was shot on the general services lot in Hollywood, the second at Talisman Studios on Sunset Boulevard. While producer Edward LeBaron signed a contract for six Spanish-language features in late 1937 with poverty row's Monogram, only *Castillos en el aire* (Jaime Salvador, 1938) was actually completed and released because the distributor failed to pay an advance for further productions.[19] RKO film producer Maury M. Cohen and Fortunio Bonaventura followed in the footsteps of the actor's Metropolitan pictures to produce *La inmaculada* (Louis Gasnier, 1939) through Atalaya Films—also shot at Grand National Studios but distributed by United Artists.[20] RKO International also distributed several William Rowland productions, with *Di que me quieres* (Robert R. Snody, 1939) shot at Eastern

Service Studios in Astoria, New York, while *Perfidia* (William Rowland, 1939) and *Odio* (William Rowland, 1940) were produced in Mexico City at CLASA Studios with all-Mexican casts.[21] Meanwhile, actress Rosita Morena and her husband, Melville Shauer, produced *Tengo fe en ti* (John Reinhardt, 1940), shot at Grand National Studios and released through RKO.[22] Rafael Ramos Cobian, a Puerto Rican theater impresario who relocated to Hollywood to establish Cobian Productions, produced *Mis dos amores* (1938), starring Tito Guízar, directed by Nick Grinde, and released through Paramount. He then signed a four-picture distribution deal with 20th Century Fox but only produced *Los hijos mandan* (1939), starring Blanca de Castejón and directed by Gabriel Soria.[23] Dario Lucien Faralla, an Italian-born film producer who briefly worked at Paramount in the mid-1930s, signed a contract in early 1939 with Tito Guízar to produce four films through his independent company, Dario Productions Inc. The first film to be announced was *El retorno del pródigo*, which was eventually released in August 1940 as *El otro soy yo*, directed by Richard Harlan.[24] Indeed, that film was released after *Papá soltero* (1939), *Cuando canta la ley* (*El rancho del pinar*; 1939), and *El trovador de la radio* (1939), all of which were shot at Grand National Studios and directed by Harlan.[25] *El milagro de la calle mayor* (N. A. Cuyas and Steve Sekely, 1940) was a final Spanish version adapted from the American original, *Miracle on Main Street* (Sekely), produced by Sekely and Cohen for Arcadia Pictures Corp.[26]

JAIME DEL AMO AND CANTÀBRIA FILMS

In order to better understand how independent Spanish-language productions distributed by Hollywood majors were almost guaranteed to fail—due, on the one hand, to studio accounting practices and, on the other, to the crowded Los Angeles exhibition market—this chapter will look first at the case of Cantabria Films. The company was founded in early 1937, possibly April, by Jaime del Amo.[27] Born on May 21, 1913, in Los Angeles, Jaime del Amo was the adopted son of Gregorio del Amo González and Maria Susanna Delfina Domínguez, who had inherited through her father the Rancho San Pedro, Carlos III of Spain's first land grant in California in 1784. When oil was discovered on the ranch in 1921, the family's wealth increased exponentially, allowing Jaime to live the life of a playboy tennis star and later to enter into the film business. In May 1937, Cantabria Films, which now included del Amo as president, Eugene Cabrero as secretary-treasurer, and John Alton as head of the camera department, added American director Josef Berne to its roster and announced that they had signed Rosita Díaz to a twelve-picture contract, with *El camino de Hollywood* as its first production. After difficulties with the script developed, Cantabria announced in mid-June that Díaz would star in *La vida bohemia*, and Mexican American actor Gilbert Roland was hired in July, followed by Miguel Ligero, José Crespo, and Romualdo

Tirado.[28] Meanwhile, José López Rubio was loaned from 20th Century Fox in late June to write the script, which was based on *Scènes de la vie de Bohème* by Henri Murger and the Giacomo Puccini opera, the latter without credit.[29] Originally scheduled to go into production on August 2, a delay in finding studio facilities led to a start on August 17. The eighteen-day shooting schedule concluded on September 11 after five extra days were scheduled for reshoots of Díaz and Gilbert with John Alton on camera and Josef Berne directing.[30] Jaime del Amo sold the film to Columbia for release in early November while a news item in February 1938 indicates that he had a contract for *La vida bohemia* and other "Spanish pictures he will produce during the 1938–39 season."[31] That same month, *Cine Mundial* announced that the film was ready for distribution through Columbia and published a film still of José Crespo, Díaz, and Roland.[32] The contract for *La vida bohemia* called for a $15,000 advance, paid upon delivery of the negative. After the recovery of 50 percent for distribution, prints, and other costs as well as the advance, the producer was to receive 100 percent of the balance of the receipts. Cantabria's bank account shows a $15,000 deposit on December 2, 1937, so one can assume the contract was probably signed in November 1937. However, according to a letter from Columbia Pictures dated May 3, 1940, the film still needed to earn another $26,000 before the producers would see a penny returned on their investment.[33]

In late February 1938, Columbia apparently sent sixteen prints to Latin America before submitting the film to the New York State Board of Censors for release. That submission alerted the Motion Picture Production Code (MPPC) administration (Hays Office) to the fact that the film had not been submitted to them for an official seal of approval; they complained bitterly about it and stated that the film could not be shown in the United States without their approval, although they did not demand that the prints already in circulation in Latin America be censored.[34] After viewing the film on March 14, the MPPC rejected Columbia's application because of the film's sexual content, specifically the fact that Mimi was seen sleeping with her lover and the sexual implications surrounding her relationship with the wealthy count. After the removal of several shots and the insertion of an intertitle stating that Mimi and Rudolfo were now married, the film received tentative approval in April 1938 but was not screened in New York until almost a year later in February 1939, apparently with the censor cuts.[35] Inexplicably, the film was not screened for the Los Angeles Mexican community until July 25, 1939, when Frank Fouce programmed it at the California Theater on Main Street for a one-week run at the bottom of a double bill with Harlan's *Perfidia*. It was then reprised at the Arrow on August 26 for three days and at the Eléctrico Theater for three more days between December 10 and 12, 1939, before disappearing from LA screens.[36]

Production on *Verbena trágica* apparently began in March 1938, when an English-language screenplay by Broadway playwright Jean Bart, originally titled

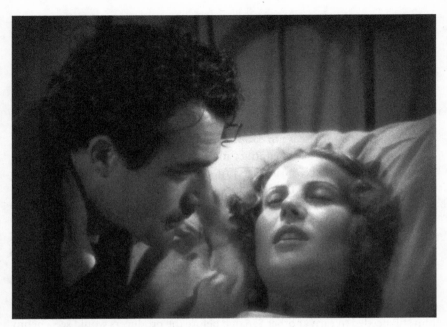

Figure 5.1. Gilbert Roland and Rosita Díaz in *La vida bohemia* (Josef Berne, 1938).

"Block Party," was submitted to the MPPC administration.[37] However, in April, Cantabria again announced it would be producing *El camino de Hollywood* from a script by Ramón Romero, with Berne directing, and that they would shoot their next three films at Grand National Studios. However, only a week after publicizing Antonio Moreno as the star of the film, Cantabria scheduled *Block Party* on May 14 and began production on May 19 with Fernando Soler and Luana Alcañiz starring. In the meantime, Josef Berne had departed the company, and American director Charles Lamont was hired to direct while Frederick A. Spencer was hired as the general manager and associate producer. By June 11, 1938, the film was in the cutting room, and Cantabria was preparing their next feature, which never materialized.[38] Also starring Juan Torena, Carlos Villarías, Romualdo Tirado, and Cecilia Callejo, *Verbena trágica* was to have been photographed by John Alton, but he had not returned from Argentina, where he had gone in March, so the Italian American cameraman Arthur Martinelli was hired as director of photography.[39] Finally, *Film Daily* reported on June 16, 1938, that Cantabria's film would be called *Verbena trágica*. And *Cinelandia* blurbed about the film in September 1938, shortly before its premiere.

Verbena trágica was one of the more successful U.S. Spanish-language productions playing in the Los Angeles market. It had its premiere in Panama City, Panama, on October 13, 1938. The film opened in Los Angeles the second week of March 1939 in Frank Fouce's California, and it was reprised

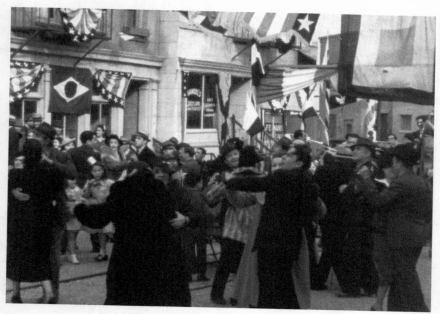

Figure 5.2. Festival scene in *Verbena trágica* (Charles Lamont, 1938).

for week-long runs at Fouce's Eléctrico in August and November and at the Arrow for three days in September through October 1939. *Verbena trágica* was reprised in June 1940 for two days at the Unique and three days at the Azteca (formerly Arrow). The film also played for a day at the Monterey in May 1941 and for three days in October at the Verdi in San Francisco. New York State Censorship Board papers suggest that the film also screened in New York City. This is a better than average performance in the LA market, as will be demonstrated in what follows.

Anecdotal information from reviews in *La Opinión* also indicated a warm reception for the film: "One of the most applauded films in this town is the one that is being screened at the 'California' theatre, on Main and 8th. The movie we are referring to is titled 'Verbena Trágica,' and features the ace of Mexican actors, Mr. Fernando Soler, in a role completely different to the ones he usually plays. It is hard to imagine Fernando Soler as a boxer, but, after watching the movie, we can't imagine any other artist in that role. Soler leaves nothing to be desired, and it looks as though the part was tailor-made for his talent."[40] The second notice in the paper mentions the fact that students from Fremont High School had chosen to see the film as part of a Spanish-language course, noting that students "came out of the theatre praising it."[41] In 1996, the National Film Registry at the Library of Congress added *Verbena trágica* to its list of twenty-five "culturally significant" titles for that year.

Columbia's distribution contract for *Verbena trágica* with Cantabria was only slightly more advantageous to del Amo and Cantabria Films than the previous deal for *La vida bohemia*. It called for a $17,500 advance after delivery of the negative, with the recovery of 50 percent for distribution, prints, and other costs as well the advance before 10 percent of income was to be returned to the producer. As of January 27, 1940, the film still evidenced a deficit on Columbia's books of $11,752.30, and it was predicted that another $18,700 would have to be earned for the company to recoup its advance to the producer.[42] In other words, like *La vida bohemia*, the film was a financial failure, at least on paper.

While no actual budgets of these two films survive, we can reconstruct how much operating capital Cantabria accumulated over the course of its three years of existence. The surviving Union Bank book for Cantabria films lists all deposits, allowing us to calculate how much capital went into the company, if not expenditures.[43] We must assume that except for the advances noted previously from Columbia Distribution, all other deposits were made by Jaime del Amo and other investors. Between April 6, 1937, and November 19, 1940, the Cantabria Films account recorded deposits totaling $138,702.36. That breaks down into $74,000 for 1937 (*La vida bohemia*), $62,000 for 1938 (*Verbena trágica*), and $2,840 for 1939–40. We can assume from these figures that the income in the first two years approximates actual expenditures for the two films, while the income for the last two years (mostly small deposits) constitutes earnings. If we subtract the advances from Columbia, we must assume that Jaime del Amo invested at least $106,000 in Cantabria Films's two productions, against Columbia's $32,500, and lost almost all of it. No wonder the company dissolved before a third production could get off the ground.

We can contextualize the budget for Cantabria and other such Spanish-language films by comparing them to what Hollywood was spending on average for film productions in this time period. The distribution deal called for the delivery of a negative, which meant that 100 percent of production and postproduction costs had to be covered by the producer, Cantabria Films, before they received "an advance" on box office earnings. In point of fact, the average cost of film productions in 1939 at the major studios for features was close to $400,000, while even most poverty-row, studio B-films cost around $50,000, which was also an average cost for Hollywood's Spanish-version films earlier in the decade.[44] Seen in that light, the $15,000–$17,000 advance given by Columbia for a finished negative was merely chump change and would probably not even come close to covering costs for a poverty-row production, much less Cantabria's investment. Cantabria's expenses were in line with most lower-budget Hollywood productions.

On the other hand, film production costs for the Mexican competition in the Los Angeles market and elsewhere in Latin America were significantly lower, making Cantabria's advance seem quite reasonable. An Azteca balance sheet for the 1944–1953 period reveals the following income levels and does not even include

box office receipts in the years prior to 1944: while *Allá en el Rancho Grande* was an anomaly with a negative cost of $48,070, earning $16,569 over cost in all markets, or a 34 percent return on investment, *Santa* cost merely $4,481 and saw receipts of $23,941, or a 433 percent return.[45] *Allá en el Rancho Grande*'s two sequels fared even better: *Bajo el cielo de México* was produced for $3,168 and generated $17,003 over cost, a 536 percent return, while *La zandunga*'s negative cost was also only $2,365 with a total income of $15,347, or 548 percent return.[46] Given that ticket prices in Frank Fouce's LA theaters seldom if ever rose above twenty-five cents and hovered around fifteen cents to a dime for second runs— one can hardly imagine higher ticket prices elsewhere in Latin America— Mexican films with budgets far smaller than the two Cantabria Films works could potentially earn a healthy return for their producers. However, Mexican producers working with Azteca did not have to account for the much higher distribution costs charged by the Hollywood majors. Columbia calculated distribution costs as if the film were competing in the first-world American market rather than in an emerging third-world market, unlike Mexico's greatest successes.

Meanwhile, independent Spanish-language productions, which cost the U.S. distributor a fraction of what it would cost the company to produce a film on their own lot, hardly put Columbia or Paramount in financial jeopardy. Clearly, the risk was almost wholly on the side of the undercapitalized Latino producers, while the distributor guaranteed that they would see a return on their minimal investment, regardless of a film's success or lack thereof. Completely untransparent in this process is what Columbia's distribution costs must have been because in both cases, sums larger than the initial advance still needed to be earned more than a year after their release for the films to break even and return income to the producers. It was essentially a no-win situation.

Despite their relatively small investments in distributing independent Spanish-language productions, the Hollywood majors, including Paramount, Fox, and Columbia, decided rather quickly that the income from such projects was not worth their attention. In October 1939, *Variety* published a front-page article, "Studio Dropping Talkers in Spanish," which stated, "Hollywood is going sour on Spanish-Language films as bait for increased revenues from Latin American countries, and is readying to substitute English-dialog pictures back-grounded against South America, Mexico, and West Indies."[47] In other words, as in the case of the early 1930s multilanguage versions, the studios decided not to spend any extra money on the Latin American market; instead, they would only invest in films that would be amortized domestically, where any income from abroad would be a profit against distribution, not production costs. The article goes on to note that the number of cinemas wired for sound in Latin America (4,571) and the extremely low ticket prices in that market mitigated against any kind of profit, even with a minimal investment. As examples of films that failed

to make a return on their investment, *Variety* mentions the otherwise modestly successful Tito Guízar films produced by Ramos Cobian and Dario Faralla.

DISTRIBUTING AND SCREENING HISPANO FILMS IN LOS ANGELES

The ability of a film to make box office was, of course, dependent on the local theatrical market. And while it would go beyond the scope of this chapter to analyze the whole Latin American market, a look at the Los Angeles movie theater scene should provide an indication of how Spanish-language Hollywood films in the late 1930s fared in competition with other films from Latin America, specifically Mexico. Almost shockingly, virtually 100 percent of Mexico's film productions received play dates in Los Angeles between 1938 and 1940, while Argentine films started making inroads too. That meant that increases in Mexican and Argentine productions brought with them a degree of saturation of the LA market, making it more difficult for homegrown Spanish productions to succeed. The sheer volume of Spanish-language films playing annually made the LA market an important—maybe even the most important— showcase for Spanish-language films vying for the Latin American market. Indeed, through Spanish-language film critics covering the U.S. film scene, it is likely that national film distributors and exhibitors in Latin America would have been well informed about which films were successful in the belly of the beast.

The Los Angeles Spanish-language theater market cannot be separated from the name of Francisco (Frank) Fouce. As Rogelio Agrasánchez Jr. has demonstrated, Fouce first managed the Teatro Hidalgo and then was involved in refurbishing the California when *Santa* premiered on May 20, 1932. Eventually becoming the most important exhibitor in the city, Fouce was operating the California, the Teatro Roosevelt, the Mason, and the Teatro Eléctrico in 1937, all of them (except the Mason) on Main Street parallel to the English-language movie palaces on Broadway.[48] The California usually operated as a first-run house, the Mason presented live theatrical shows, and the other two theaters functioned as second-run houses, although Fouce would often open a big film in all three Main Street cinemas at once, as he did when he opened *Bajo el cielo de México* (1937), Fernando de Fuentes's sequel to *Allá en el Rancho Grande*, on February 9, 1938.[49] Fouce also still occasionally utilized the Teatro México on South Main Street, which he had acquired in 1935, programming Tito Guizar's *Mis dos amores* there in June 1939, for example.[50] The Arrow opened in late March 1939 and was utilized by Fouce as both a first- and second-run theater, putting the Roosevelt out of commission for at least a few years.[51] The only competition to the Empresa Francisco Fouce were the cinemas of James C. Quinn, who operated the Monterey on Whittier Boulevard in East Los Angeles, the Unique on First Street in Boyle Heights, and beginning in December 1940, the Teatro Vernon on Vernon

Street, just south of downtown in Huntington Park; all were suburban theaters that offered a split week of English- and Spanish-language programming.[52] The Unique began programming Mexican films in August 1939, while the Monterey opened on September 24, 1939, both of them functioning as third- and fourth-run theaters.[53] Thus in the time period under question, Los Angeles had an average of three to five screens available, and if an independent Spanish-language film distributor wanted to have their films screened in Los Angeles, their choices were limited to these theaters. According to Agrasánchez, the demand for Mexican films was so great that the production of new Mexican films could not meet the increasing demand as contract laborers and other immigrants began flooding into the United States.[54] Spanish-language theater owners thus increasingly turned to screening older films that had proved popular in the past.

Analyzing both advertisements and short "reviews" in *La Opinión* from 1938 to 1940 to ascertain the number of Spanish-language films shown yearly, it becomes apparent that virtually every new Mexican film played in Los Angeles. Not surprisingly, given the mostly Mexican American clientele, films from Mexico dominated the LA market. Of the 96 films produced in Mexico from 1937 to 1938, merely 2 were not screened in Los Angeles before the end of 1940.[55] As the Mexican and Argentine film catalog of new and older films expanded, the number of films screened in Los Angeles also grew, leading to a large increase in reruns. In 1938, there were 46 premieres and 138 reprises of older films, totaling 184 play dates. By 1939, that number had jumped to 303 play dates, with 67 premieres and 236 reprises. In 1940, a total of 410 play dates broke down into 70 premieres and 340 reprises. Thus the number of play dates more than doubled in this short pre–World War II period, and despite a significant cut in Mexican film production in the same years due to overproduction, the number of second- and third-run screenings increased and surpassed the number of premieres. Had demand for Spanish-language films outstripped supply with an increase in the number of screens or was some other factor at work?

Ironically, while the number of films produced in Mexico declined over this period due in part to labor issues—from 57 films in 1938 to 39 in 1939 and 29 in 1940—premieres increased due to the availability of films from Hollywood, Argentina, Spain, and even Cuba.[56] Thus in 1938, LA theaters screened as premieres or reprises 69 Mexican films, 9 U.S. Spanish-language productions, 5 Argentine films, and 1 from Spain, totaling 84 films with 184 play dates. In 1939, 105 films were screened from Mexico, 11 from Spain, 4 from Argentina, and 7 from the United States, totaling 127 films but 303 play dates.[57] In 1940, films from Mexico increased to 150 titles, while Argentina supplied 29 films, Hollywood 18, Spain 7, and Cuba 6, totaling 210 premieres and reprises with 410 play dates, which means that the reprises increased significantly over the time period. Just in these three years, the total number of films shown in Los Angeles increased by 60 percent, and play dates increased 56 percent. Even accounting for reprises, it

becomes apparent that the Argentine cinema had made significant inroads into the Los Angeles market in this time period but also that independent Spanish-language film producers in Los Angeles had to contend with ever more competition in the local market, which may explain why many of these films did not perform to their makers' expectations.

Of the 35 most popular films screened in the 1938–1940 period (8 percent of all films screened) based on number of runs (6 or more), all except 5 were Mexican films, the exceptions being *Morena clara* (1936) from Spain and *Mis dos amores*, *Papá soltero*, and *Odio* from U.S. producers, with the last-named title being essentially perceived as a Mexican film. The most popular premiered films by far were *Bajo el cielo de México* (1937) and *La Adelita* (Guillermo Hernández Gómez, 1937) with 14 runs each, followed by *¡Así es mi tierra!* (Arcady Boytler, 1937), *Amapola del camino* (Juan Bustillo Oro, 1937), *Huapango* (Juan Bustillo Oro, 1937), *La zandunga* (Fernando de Fuentes, 1937), and *Mientras México duerme* (Alejandro Galindo, 1938) with 10 and *El cementerio de las águilas* (Luis Lezama, 1938) with 9. *Bajo el cielo de México* was, of course, another comedia ranchera, as was *La zandunga*, the latter starring Lupe Vélez in her first Mexican feature, both considered sequels to *Allá en el Rancho Grande*, the film credited with initiating the Golden Age of Mexican cinema.[58] That film racked up 9 reprises in 1938–1940 after 13 runs in 1937. *¡Así es mi tierra!* was an early Cantinflas comedy, Arcady Boytler's "brilliant parody of Eisenstenian cinema," which also played in a rural environment, while *Huapango* continued the tradition of promoting *mexicanidad* through folk culture.[59] Based on folk ballads, *La Adelita* and *Amapola del camino* were likewise nostalgic movies about Mexican country life with plenty of folk or faux-folk songs. As Colin Gunckel notes about *Amapola del camino*, critics, including those at *La Opinión*, began to deride these films about "chinas and charros, peasants and oxen, songs and guitars."[60] Only *El cementerio de las águilas*, a historical costume drama illustrating Mexico's process of nation building in 1847, harkened back to the many films about the Mexican Revolution that had dominated the screen in the early 1930s. The next most popular titles, with at least 8 runs in different theaters, included *Los millones de Chaflán* (Rolando Aguilar, 1938) and *Juan soldado* (Louis J. Gasnier, 1938). *Juan soldado* was a remake of a 1920 silent film that again offered a conservative reading of the Mexican Revolution. In point of fact, only *Mientras México duerme* and *Los millones des Chaflán* offered a contemporary and urban view of Mexico. In other words, as Gunckel has demonstrated, films that unabashedly promoted Mexican nationalism and folk culture proved to be the most popular.

In contrast, the films produced by independent Spanish-language producers in Los Angeles offered narratives that in the majority of cases involved American or European locations. As Brian O'Neil noted, these films "were set partially or entirely in the United States: six in Los Angeles, three in New York, and one in the border region."[61] The remaining five played in Paris and Madrid or

had Mexican locales. Only Harlan's *Odio* achieved the level of popularity of the Mexican titles listed previously with eight play dates. Next in popularity were the Tito Guízar productions situated in Los Angeles, each of which garnered at least five or six runs, due most probably to the star of *Allá el en Rancho Grande: Mis dos amores*, *El trovador de la radio*, and *Papá soltero*. As Colin Gunckel has ascertained, the Guízar films proved popular with LA audiences given his constant presence as a live performer, but the films themselves were subject to extreme controversies in the Latin American press.[62] Two other productions with LA locations were seemingly less successful due to their late releases—namely, *El milagro de la calle mayor* (two runs in 1940 but six reprises in 1941) and *Tengo fe en ti*, not released until 1941. Of the films playing in New York, two did an average amount of business—*Di que me quieres* and *Castillos en el aire*—while *Verbena trágica* had a respectable seven runs. Clearly, the films playing in Europe, *La vida bohemia* and *Perfidia*, were the least popular, with again only four runs each. Thus there seems to be less of a correlation between popularity and narrative than one might assume, but in general, those independently produced Spanish-language films that strayed from Mexican or Mexican American themes seemingly fared less well and did significantly less business than the most popular Mexican films.

Finally, even a film that garnered seven engagements, like *Verbena trágica*, may have been a moderate success in terms of our metric but nevertheless failed to earn back its investment. Apart from topics that may have been of less interest to Mexican audiences, one wonders whether the issue of Spanish accents, which had plagued earlier Hollywood productions, also played a role. Actors appeared in *La vida bohemia* from Spain (Rosita Díaz), Mexico (Gilbert Roland), and Chile (Blanca Posas), while in the case of *Verbena trágica*, audiences heard Spanish-speaking actors from Mexico (Fernando Soler), Spain (Carlos Villarías), the Philippines (Juan Torena), Puerto Rico (Cecilia Callejo), and Cuba (Jorge Mari). However, as noted earlier, Columbia's position as a distributor may have influenced financial outcomes, since other films with the same number of engagements, like Azteca's *El fanfarrón* (Fernando A. Rivero, 1938), did correlate with actual financial success.[63]

Most strikingly, except for the Mexican American films listed above—which were distributed by Paramount, Columbia, and RKO, respectively—every other film in the top thirty-five were distributed by Azteca Films Inc. and/or Cinexport Distributing Company.[64] And while *La Opinión* advertisements in many cases did not list distributors, it is clear that these two companies had a virtual monopoly on distribution of Mexican films to the United States. In point of fact, just as the Hollywood majors controlled film exhibition in the United States through vertically structured companies that included production and distribution, so too did Mexican nationals and Mexican Americans monopolize the Los Angeles theatrical film market through control of theaters, distribution, and increasingly,

production. The key to understanding that system is the relationship between
Francisco Fouce and the Calderón brothers, which began as early as the premiere
of the first Mexican sound film in Los Angeles, *Santa* (1932).

According to an article in *La Opinión*, that film had been coproduced by José
and Rafael Calderón, who brought *Santa* to Los Angeles but were initially unable
to find a screen to show the film. The Calderóns are visible in many surviving
photos of the *Santa* premiere at the Teatro California on May 20, 1932. Through
the intervention of Frank Fouce, who at that time was working in distribution
for Columbia Pictures, the California Theater was procured for the premier, even
though its owner, "a certain Mr. Finger," was not interested in showing Mexican
films.[65] The Calderón brothers had started out as exhibitors in Chihuahua, Mex-
ico, in the 1920s and then expanded across the border to El Paso and San Antonio,
Texas.[66] By the 1930s, they had moved into production with José's son, Pedro A.
Calderón, producing films like *La zandunga* and owning their own studios and
laboratories in Mexico City.[67] With capital from the Calderón brothers, Frank
Fouce was able to purchase the California and then expand his exhibition chain
with the acquisition of the Hidalgo, the Eléctrico, and México in 1935, simultane-
ously abandoning his position at Columbia. Fouce also apparently kept his hand
in distribution. His letterhead in 1938 included not only the names of his theaters
but also "Spanish International Pictures. Motion Picture Producers, Brokers, &
Distributors"; the film titles listed on the letter's left margins are titles distributed
by Azteca, indicating that, in fact, Fouce's company and the Calderón brothers'
operations were economically linked, if not identical.[68]

Meanwhile in 1932, the Calderón brothers, with their business partner, Alberto
Salas Porras, established Azteca Films Distributing Company in El Paso and Los
Angeles, with offices at 1906 South Vermont Street. They named Rubén Anto-
nio Calderón, Rafael's son, as manager and Gustavo Acosta, another blood rela-
tive, as booker for the Los Angeles exchange. Interestingly, the Azteca logo on
film advertisements listed El Paso as its headquarters, possibly because Rafael
Calderón was still identified as the president in trade address books, although
he directed the mothership of the Calderón exhibition operations: the Circuito
Alcázar. It is likely that the distribution business for both North America and
Mexico was based in Los Angeles.[69] Azteca Films then "began boosting the film
industry in Mexico, buying as many films as it could," as well as establishing dis-
tribution offices in San Antonio, Denver, Chicago, and New York. Azteca's work
was clearly perceived as promoting the interests of Mexican culture.[70] In 1939, the
Los Angeles exchange was sending out an average of twenty films a day to cin-
emas in California, Arizona, and Nevada. When Azteca was nationalized by
the Mexican government in 1954, the Cinematográfica Mexicana Exportadora
(CIMEX) underpaid $1.7 million for the distribution company; at the time,
Azteca owned more than four hundred titles from Mexico and constituted a near

Since 1931—The Country's Leading Distributors of Spanish-language Films.

• • •

Now Releasing to the American Market — through its SPECIAL FEATURES DIVISION, Exceptional Spanish-dialogue Pictures, equipped with English Subtitles.

• • • •

For detailed information, send for our catalogue. . .

AZTECA FILMS, Inc.
1743 So. Vermont Avenue
Los Angeles 6, Calif.
Republic 3-2191

Figure 5.3. Advertisement for Azteca Films in the
Film Daily Yearbook, 1951.

monopoly in the distribution of Mexican films abroad. As Agrasánchez notes, "Azteca operated practically without competition from 1932 until 1942."[71]

Returning to the distribution of Spanish-language films produced by U.S. and Mexican American independents, the evidence demonstrating that the Fouce-Calderón connection in Los Angeles conspired to keep the product of American distribution companies out of the market is ambiguous given the mixed metrics of film engagements. It may be that market forces, including actual box office receipts as a measure of popularity, were in fact allowed to dictate film engagements in LA theaters and that the increase in competition from Mexican, Argentine, and Cuban producers impacted returns. More important is the fact that Mexicans and Mexican Americans had created and maintained their own monopoly of exhibition and distribution of films produced in Latin America, creating a genuine Latino film culture in Los Angeles. In other words, an ethnic minority in the United States, one that was maligned and discriminated against—especially in Southern California and Texas—and subject to racial stereotyping in Hollywood films, had taken control of its own Spanish-language

media and had done so in the belly of the beast: Los Angeles, the capital of the American film industry. It managed to accomplish this feat by generally keeping production costs far below Hollywood standards, allowing for large returns on minimal investments. We can therefore interpret the act of taking control by Mexican national interests as a form of cultural resistance, allowing us to theorize that Hollywood may not have been as hegemonic as some historians have maintained, especially in the case of late 1930s Spanish-language features produced in Hollywood.

I understand that my mostly quantitative and heuristic approach to this aspect of Mexican and American cultural relations is based on the necessary limitations of not being a Spanish speaker. I therefore have endeavored to develop a methodology that would contribute to the history of this transnational exchange, undergirding some previous research, while hopefully expanding knowledge in other areas. In choosing a quantitative approach to analyzing the Los Angeles film market as a nodal point of film cultural relations, I have contributed to the process of documenting the reception of Spanish-language cinema in Los Angeles. However, the quantifying of film engagements in a fixed time period is an imprecise measurement that must ultimately be augmented by other forms of cultural and language-based knowledge. A more complete picture of actual film reception will have to gather and critically analyze a wider palette of film reviews than much current writing on Mexican film history addresses. Unfortunately, the reviews in *La Opinión* in the period under analysis are hardly often more than short descriptions of the films and their stars. Furthermore, analyzing film reception includes engaging in oral histories, preserving film company and filmmaker document collections, and scouring other forms of media reception like novels and poetry. In documenting the hopelessly exploitive situation of independent Spanish-language film producers in Hollywood, I have suggested causes for their demise and created a model that calls more hegemonic-based theories of the U.S. film industry's pervasive influence into question.

Notes

1. See Colin Gunckel, *Mexico on Main Street: Transnational Film Culture in Los Angeles before World War II* (New Brunswick, N.J.: Rutgers University Press, 2015).

2. Lisa Jarvinen, *The Rise of Spanish-Language Filmmaking: Out from Hollywood's Shadow, 1929–1939* (New Brunswick, N.J.: Rutgers University Press, 2012).

3. Jarvinen, 137.

4. Brian O'Neil, "Yankee Invasion of Mexico, or Mexican Invasion of Hollywood? Hollywood's Renewed Spanish Language Production of 1938–39," *Studies in Latin American Popular Culture* 17 (1998): 103.

5. Jarvinen, *Rise of Spanish-Language Filmmaking*, 157.

6. See Robert Harland, "Quiero chupar tu sangre: A Comparison of the Spanish- and English-Language Versions of Universal Studios' *Dracula* (1931)," *Journal of Dracula Studies* 9 (2007), https://kutztownenglish.files.wordpress.com/2015/09/jds_v9_2007_harland.pdf.

7. Ginette Vincendeau, "Hollywood Babel: The Multiple Language Version," *Screen* 29, no. 2 (1988): 24–39.

8. Jarvinen, *Rise of Spanish-Language Filmmaking*, 58.

9. Jarvinen, 74.

10. See Charles Ramírez Berg, *Latino Images in Film: Stereotypes, Subversion, and Resistance* (Austin: University of Texas Press, 2002).

11. Jarvinen, *Rise of Spanish-Language Filmmaking*, 79–81.

12. Jarvinen, 111–114.

13. Jarvinen, 8.

14. Jarvinen, 123.

15. Jarvinen, 161.

16. Terry Ramsaye, ed., *1937–38 International Motion Picture Almanac* (New York: Quigley, 1938), 137, 454.

17. O'Neil, "Yankee Invasion of Mexico," 83n21, 104.

18. O'Neil, 82.

19. *Hollywood Reporter*, July 18, 1938. After its opening at the California in April 1938, the film was reprised three times until 1942.

20. *La Opinión*, September 17, 1939, 8. Cohen apparently left the field after the production of this film, as no further credits could be found. The film opened at the California in September 1939 and was reprised two more times in 1939 and three times in 1940.

21. See American Film Institute, "Di que me quieres (1938)," AFI Catalog of Feature Films, accessed July 21, 2016, http://www.afi.com/members/catalog/DetailView.aspx?s=&Movie=1206. *Di que me quieres* had four play dates in 1940–41. See also American Film Institute, "Perfidia (1940)," AFI Catalog of Feature Films, accessed July 21, 2016, http://www.afi.com/members/catalog/DetailView.aspx?s=&Movie=1234. While *Perfidia* was less successful, with only four LA dates, *Odio* opened at the California and the Eléctrico in February 1940 and was then reprised eight more times.

22. See American Film Institute, "Tengo fe en ti (1940)," AFI Catalog of Feature Films, accessed July 21, 2016, http://www.afi.com/members/catalog/DetailView.aspx?s=&Movie=1232. After opening at a second-run house, the Unique, in July 1941, the film moved to the California and the Roosevelt in March 1942 and then played the Mason the same month.

23. Cobian's deal fell through because he had failed to clear rights on his first film for 20th Century Fox. See *Variety*, October 17, 1939, 6. Ramos Cobian went on to manage a chain of eleven cinemas in Havana and Camaguey, Cuba, the Circuito Cobian, cofinanced by Paramount with $1 million. See *Variety*, October 31, 1944, 8. Both *Mis dos amores* and *Los hijos mandan* were moderately successful, with seven and five play dates, respectively, in 1939–41.

24. *La Opinión*, February 9, 1939, 4. The film opened at the California in August 1940 and then was reprised three times before year's end and again twice in 1941.

25. Richard Harlan was an American director who had been born in Peru and partially educated in Cuba and therefore spoke Spanish. He began his career in 1919 as an assistant director with Richard Barthelmess, directed a number of Spanish-language versions for Fox in 1930, and then returned as an assistant director to Paramount. After working for Dario, Harlan followed Guízar to Argentina, where he directed a couple more films. Each of these films met with diminishing success: while *Papá soltero* still managed seven play dates after opening in October 1939, *Cuando canta la ley* (*El rancho del pinar*) only had five play dates and *El trovador de la radio* six.

26. O'Neil, "Yankee Invasion of Mexico," 92. *Miracle on Main Street* was released on October 29, 1939. In July 1939, Jack H. Skirball resigned from his studio position to go into independent production, forming Arcadia Pictures. See Terry Ramsaye, ed., *1940–41 International Motion Picture Almanac* (New York: Quigley, 1941), 551. *El milagro de la calle mayor* opened in December 1940 at the California and the Roosevelt and then was reprised five more times in 1941.

27. A Union Bank & Trust Account was set up for Cantabria Films with an initial $3,000 deposit made on April 29, 1937. See Del Amo Estate Company Collection, Archives and Special Collections, California State University Dominguez Hills, Carson, Calif. (DAECC).

28. See *1938 Film Daily Yearbook* (New York: Film Daily, 1938), xx; *Hollywood Reporter*, May 15, 1937, 2, quoted in American Film Institute, "La vida bohemia (1938)," AFI Catalog of Feature Films, accessed August 12, 2016, http://www.afi.com/members/catalog/AbbrView .aspx?s=&Movie=1213. See also *Film Daily*, July 22, 1937; and *Variety*, July 21, 1937, 4; August 14, 1937, 5; August 17, 1937, 7; September 2, 1937, 4. Other actors hired included Barry Norton, who was later replaced by Juan Torena, and silent film star Chester Conklin, who was to play a pantomime role that ended up on the cutting room floor.

29. *Variety*, June 25, 1937, 12; June 30, 1937, 6; July 7, 1937, 6; July 14, 1937, 13; July 31, 1937, 3. Over the course of June and July, the rest of the technical crew was hired, including Frank P. Sylos (art director), Melville "Buddy" Schyer (production manager), Alexander Borisoff (music composer), Miguel de Zárraga (assistant director), and Stanley Blyth (researcher).

30. See *Variety*, July 19, 1937, 9; August 18, 1937, 23; August 26, 1937, 11; *Film Daily*, September 4, 1937, 3; September 9, 1937, 15; and *Motion Picture Daily*, September 24, 1937, 21.

31. *Variety*, November 10, 1937, 5; *Film Daily*, February 15, 1938, 9.

32. *Cine Mundial*, February 1938, 72.

33. Letter from Leonard S. Picker (Columbia Pictures, New York) to John O'Melveny, May 3, 1940, DAECC.

34. Letter from F. S. Harmon to Joseph Breen, March 2, 1938, Production Code Administration Records for *La vida bohemia* (1938), Academy of Motion Picture Arts and Sciences, Margaret Herrick Library, Los Angeles, Calif. (AMPAS).

35. Letter from F. S. Harmon to Hal Hode (Columbia), April 6, 1939, Production Code Administration Records, AMPAS. It is unclear, since this is the last letter in the file, whether Columbia actually implemented all the changes suggested by the censors, but the *New York Times* film review does suggest that the film implied the couple was married. See *New York Times*, February 6, 1939, 13.

36. *La Opinión*, July 25, 1939, 4; *La Opinión*, August 27, 1939, II-3; *La Opinión*, December 10, 1939, II-3.

37. Letter from Joseph Breen to Jaime del Amo, March 24, 1938, Production Code Administration Records, AMPAS.

38. See *Variety*, March 9, 1938, 19; April 13, 1938, 5; April 14, 1938, 11; April 16, 1938, 6; May 5, 1938, 18; May 14, 1938, 2; May 18, 1938, 11; June 11, 1938, 6.

39. See *Film Daily*, February 23, 1938, 7. Martinelli had shot *Mis dos amores* (1937) and would go on to shoot *La inmaculada* (1939).

40. *La Opinión*, March 8, 1939, 4.

41. *La Opinión*, March 12, 1939, II-3.

42. Letter from Leonard S. Picker (Columbia Pictures, New York) to John O'Melveny, May 3, 1940, DAECC.

43. Union Bank & Trust Deposit book, DAECC.

44. Email correspondence with Lisa Jarvinen, September 12, 2016.

45. The negative cost for *Allá en el Rancho Grande* is contested in the literature. Emilio García Riera lists $100,000 pesos as its production cost ($28,000 U.S. at 1936 exchange rates), which is less than what is listed in Azteca Film's accounting. See Emilio García Riera, *Historia documental del cine mexicano*, vol. 1, *1929–1937* (Guadalajara: Universidad de Guadalajara, 1992), 234. Usabel does not list a negative cost but notes that United Artists paid an advance of $10,000 U.S. for Latin American distribution rights for 40 percent of gross box office, spending no more than $2,100 U.S. in all of Latin America for advertising. Unfortunately, Usabel also states that the film did very well but doesn't list any actual grosses. See

Gaizka S. de Usabel, *The High Noon of American Films in Latin America* (Ann Arbor, Mich.: UMI Research Press, 1982), 129.

46. See "Azteca Films, Inc. Recapitulation of Picture Cost & Income. October 1, 1944–August 31, 1953," in Calderón Brothers Estate Collection, Permanencia Voluntaria, Tepoztlán, Mexico (hereafter, Permanencia Voluntaria). Thanks to Viviana García Besné for making these materials available to me.

47. "Studios Dropping Talkers in Spanish," *Variety*, October 17, 1939, 1, 6.

48. Rogelio Agrasánchez Jr., *Mexican Movies in the United States: A History of the Films, Theaters, and Audiences, 1920–1960* (Jefferson, N.C.: McFarland, 2006), 50ff. In an appendix, Agrasánchez lists all Spanish-language theaters in Los Angeles but misses the Arrow, which in 1940 was renamed Teatro Azteca.

49. *La Opinión*, February 9, 1938, 4.

50. Agrasánchez, *Mexican Movies*, 53; *La Opinión*, June 25, 1939, 4.

51. *La Opinión*, March 23, 1939, 4.

52. *La Opinión*, December 22, 1949, II-3.

53. Agrasánchez, *Mexican Movies*, 58; *La Opinión*, August 22, 1939, 4; *La Opinión*, September 24, 1939, II-3.

54. Agrasánchez, *Mexican Movies*, 12.

55. García Riera only lists thirty-eight films made in Mexico in 1937, because Boris Maicon's *Novillero* (1937) is missing. See García Riera, *Historia documental del cine mexicano*, 253ff. The titles that failed to screen in LA were *La mancha de sangre* (Adolfo Best-Maugard, 1937) and *Hambre* (Fernando A. Palacios, 1938).

56. S. de Usabel, *High Noon of American Films*, 130.

57. In a letter to Gregorio del Amo, Frank Fouce notes that he is contemplating purchasing the rights to fourteen films from Spain (mostly older titles) that had become available, including *Morena clara* (Florián Rey, 1936), starring Imperio Argentina, the only film to become a significant moneymaker. Letter from Frank Fouce to Gregorio del Amo, March 10, 1938, DAECC.

58. For a definition of the comedia ranchera genre, see Gunckel, *Mexico on Main Street*, 124ff.

59. Eduardo de la Vega, "Origins, Development and Crisis of the Sound Cinema (1929–64)," in *Mexican Cinema*, ed. Paulo Antonio Paranaguá (London: British Film Institute, 1995), 84.

60. Gunckel, *Mexico on Main Street*, 155.

61. O'Neil, "Yankee Invasion of Mexico," 84.

62. Gunckel, *Mexico on Main Street*, 180.

63. *El fanfarrón* played at the California, Azteca (twice), Roosevelt, and Unique. Its negative cost was $2,609, and it earned a profit of $ 12,620, with a 383 percent return on investment. See "Azteca Films, Inc. Recapitulation," Permanencia Voluntaria.

64. Azteca titles were identified through advertisements, correspondence, and a Calderón Brothers spreadsheet, which listed all films produced by the company when Mexican government forcibly nationalized the distribution company in 1956. See "Azteca Films, Inc. Recapitulation." The Cinexport titles were identified through IMdB.com. Cinexport was based in New York, where company head, José Guerrero, also owned the Teatro Hispano at 136th and 5th Avenue and attempted to organize a Spanish-language theater circuit in New York City. See *Variety*, June 29, 1938.

65. "Don Rubén Calderón habla sobre los proyectos de la Azteca Films Dist. Co.," *La Opinión*, May 7, 1939, 4.

66. A spreadsheet from 1957 for *Los chiflados del rock and roll* shows that the Calderóns owned twenty-five theaters in Mexico at that time. Permanencia Voluntaria.

67. The Calderón family remained in the film-production business until the late 1980s and was responsible for producing hundreds of films—in later years, many of them exploitation titles.

68. Compare letter from Frank Fouce to Gregorio del Amo, March 10, 1938.

69. See "Salió a Texas el señor Calderón," *La Opinión*, December 2, 1939, 4. See also *1941 Film Daily Yearbook* (New York: Film Daily, 1941), 566; Ramsaye, *1940–41 International Motion Picture Almanac*, 755.

70. "Don Rubén Calderón," 4. A shipping label in the Calderón Collection for Azteca Films Inc. (1970) names Los Angeles, San Antonio, Chicago, and New York as branches. Permanencia Voluntaria.

71. Agrasánchez, *Mexican Movies*, 46, 161.

CHAPTER 6

◇◇◇◇◇◇◇◇◇◇

A CINEMA BETWEEN
MEXICO AND HOLLYWOOD

WHAT WE CAN LEARN FROM ADAPTATIONS, REMAKES, DUBS, TALENT SWAPS, AND OTHER CURIOSITIES

Colin Gunckel

Scholars of Mexican and Latin American film studies are undoubtedly familiar with Hollywood's place within prevalent historical narratives of the Mexican Golden Age. Such accounts typically chart a progression from ascendant global domination that stymied the development of national cinemas in the 1920s to the brief and largely ill-fated Spanish-language productions that trained a generation of cineastes who then returned to their home countries to initiate studio-based productions. With the emergence of relatively stable national cinemas in the 1930s and 1940s, Hollywood became a source of simultaneous inspiration and competition, an internationally dominant industry against which Latin American producers strove to differentiate their films. Despite the fact that such narratives implicitly account for Spanish-language cinema of the 1930s as a transnational undertaking and the involvement of the United States in Mexico's Golden Age, they have nonetheless posited a somewhat linear trajectory of "nationalization." Quite usefully, recent scholarship has worked to interrogate these narratives, from formulating the more encompassing, transnational category of "Spanish-language cinema" to demonstrating how Hollywood informed cinematic conceptions of national identity in both Mexico and Argentina.[1]

This chapter examines a number of brief case studies between the 1930s and 1950s that further undermine linear or unidirectional conceptions of national cinemas and transnational flows. By using Los Angeles as a vantage point from which to reconsider the production, circulation, and exhibition

119

of Spanish-language cinema during this period, I argue for an understanding of Mexican cinema as a project that drew from unexpected sources and that moved in multiple directions. In this way, we might understand Mexican cinema of the Golden Age not only as an embrace of a cohesive *mexicanidad* (or even *latinidad*) but one that was a constant negotiation among local, national, and transnational scales—and, in several cases, in multiple languages. In this sense, the Mexican film industry might well be considered the Hollywood of Latin America during the midcentury, as it strove to integrate conceptions of national identity with considerations of an international audience. But this also means that the various meanings attached to Mexican cinema—whether it be an individual film or a broader concept—were products of the contexts through which it circulated.

Perhaps paradoxically, it is by examining various moments of interface and exchange between Hollywood and Mexico that we might glean new insights into the historical operations of both. It is also for this reason that I have chosen to focus on a number of apparent cinematic anomalies—remakes, adaptations, and B movies—that might counterintuitively reveal something meaningful about the logics of these transnational industries by appearing to reverse or defy them. Most notably, these case studies of overlooked films allow us to place in conversation histories that are predominantly treated as separate. On the one hand, histories and analyses of Mexican cinema have not accounted for the fact that these productions were, at least at certain junctures, distributed and marketed to English-speaking audiences in the United States. In that sense, their vision of Mexico and mexicanidad arguably anticipated a decidedly non-Mexican audience, one that had also been primed by existing conceptions of Mexico traveling through popular culture. On the other hand, Hollywood's own visions of Mexico (and by extension, Latin America) not only were inspired by conventions of Mexican cinema but were implicitly designed to appeal to a Mexican audience. In other words, the history of Latino representation in Hollywood films is inextricable from this transnational dynamic, although most studies in this area have not taken this factor into account. This chapter is one attempt to bridge these histories while complicating them in the process.

The Strange Case of *María Elena*

The years 1935 and 1936 were pivotal for the Mexican film industry. As multiple studies of Mexican cinema have demonstrated, *Allá en el Rancho Grande* and the popularity of the *comedia ranchera* genre "saved the industry from imminent ruin," as one critic declared.[2] Indeed, as I have argued in my own work, this genre, as a multimedia phenomenon, effectively incorporated multiple elements of Mexico's official cultural nationalism into mass culture.[3] While the success of *Rancho Grande* looms large in historical accounts, scholars often overlook the forgotten or failed experiments produced alongside it that relied on a similar

formula of idyllic rural setting, identifiable character types, romantic intrigue, and Mexican songs. The range of these productions reveals that the configuration of these cinematic elements within a single text was a transnational undertaking, so much so that one would be hard pressed to identify on which side of the border these conventions ultimately originated. The well-known 1934 Technicolor film *La Cucaracha* (Lloyd Corrigan), for instance, capitalized on the popularity of Mexican music and culture in the United States while spurring Mexican producers to emulate its success. Juan José Segura's 1936 musical short *La cucaracha mexicana* (*The Mexican Cockroach*) was then produced as an explicit cinematic rebuttal to the Hollywood film. In addition, the original *La Cucaracha* perhaps established the practice—one that would become a hallmark of the comedia ranchera genre—of using a popular Mexican song as its title. Significantly, it was also produced alongside a number of Hollywood musicals preceding *Rancho Grande* that featured Latin American settings or dance numbers as a way of cashing in on the Latin music craze. Among these were *Flying down to Rio* (Thornton Freeland, 1933), *Wonder Bar* (Lloyd Bacon, 1934), *In Caliente* (Lloyd Bacon, 1935), and *Rumba* (Marion Gering, 1935).

From the vantage point of Mexico, the 1935 production *María Elena* would seem to fit snugly within a film historical narrative of its national cinema that culminates with the success of *Rancho Grande*. Based on a popular song composed by Lorenzo Barcelata, the film's publicity emphasized its most popular musical number: a dance performance of the song "La bamba" by Amparo Arozamena and Emilio Fernández, the latter of which would go on to perform a similar number in *Rancho Grande*. The inclusion of the song itself tapped into the emerging synergy among cinema, recorded music, radio, live performance, and exhibition practice that would continue to define Mexican cinema for decades. In Los Angeles, for instance, the release of the film was preceded by a musical revue entitled "La bamba" featuring an orchestra led by trumpeter Chino Ibarra and baritone Jorge Negrete (who would go on to be a major star of the comedia ranchera genre).[4] When the film opened in Los Angeles, advertisements promised "Love! Tragedy! Tears! Song. . . . All of them entwined in the bewitching and melodious rhythm of la Bamba." They also provided reprinted lyrics of both "La bamba" and the title song.[5] As would be the case with other films that capitalized on the popularity of Mexican music, screenings were also paired with a prologue during which songs from the film were performed by local artists, including Spanish-language radio staples Los Madrugadores.[6]

Presciently, Los Angeles–based critic Campos Ponce identified the film's use of music and folklore as a strategy of differentiation by which Mexico might compete with Hollywood: he encouraged the embrace of "truly Mexican topics, those that have our customs and music, that take place in our own environment, and those that have the characteristics that in Mexico only we can offer, and that, by the same token, constitute a barrier for foreign competition." By way of contrast, he warns Mexican cineastes against producing "films [that] are compared

with others of the same type that are sent to us from foreign companies; Mexican pictures made with international character puts them into a competition in which Mexico will always be defeated."[7]

While critics lauded this dimension of the film as a potentially effective strategy for Mexican cinema, they also noted the film's production difficulties, technical shortcomings, and peculiar narrative structure. Mexican film historian Emilio García Riera described the fragmented nature of the film as "a mix of musical comedy, truculent melodrama and adventures with natives," referring to the fact that the second half of the film takes place on an island occupied entirely by scantily clad savage women. Critic Hortensia Elizondo, while praising the film from a technical perspective, noted that the film's plot was "attractive, although eccentric and at times absurd," with the second half of the film suffering from "the exaggeration of fantasy that forces situations and robs them of reality."[8] To some extent, *María Elena* then reads as a precursor to *Rancho Grande*, a moderately successful attempt to establish a formula that would soon become one of Mexico's most internationally popular genres. But the very textual qualities about which critics complained also facilitated a different distribution and reception of *María Elena*, revealing another, perhaps unintentional, strategy of differentiation.

Indeed, *María Elena* led a strange and anomalous double life. To my knowledge, it is perhaps the first Mexican film to be dubbed in English, anticipating the ostensible appeal of films like *Rancho Grande* to U.S. audiences. This decision was at least a product of the film's final postproduction (including sound) being completed in Los Angeles, as was apparently the case with other Mexican films produced at this moment.[9] If Spanish-language movie houses in Los Angeles embraced the film as a multimedia phenomenon, the availability of technical expertise and equipment meant that the city also became a hub of production for an emerging Mexican industry that lacked both. Repackaged and distributed as *She-Devil Island*, however, *María Elena* went from being a potential expression of cultural nationalism to an exploitation film that would draw English-speaking audiences with the attraction of Mexican music and scantily clad women. Even when exhibited in Spanish-language contexts, it was billed as "solo para adultos" (for adults only), acknowledging a dimension of its appeal not explicitly mentioned by Spanish-language critics.[10]

As a de facto participant in what Eric Schaeffer has referred to as a "shadow cinema," *She-Devil Island* operated as a sort of perverse "shadow" of *Rancho Grande* in terms of both generic conventions and their respective exhibition histories.[11] Beyond its pioneering use of Mexican music as a strategy of differentiation in the international market, however, we might alternately regard *María Elena* as evidence of another, unacknowledged trajectory—namely, the proximity of Mexican cinema to the transnational exchange of exploitation films. Mexican cinema often pushed the boundaries of acceptable and controversial content

Figure 6.1. The scantily clad warrior women of *She-Devil Island* (Raphael J. Sevilla, 1935).

as a way of attracting audiences and competing with Hollywood films that were beholden to a more stringent code. In the United States, films showing in both exploitation theaters and in Spanish-language theaters were often not subject to revision by the Production Code Administration. As such, Mexican cinema in the United States at least implicitly traded on the promise of more scandalous and frank portrayals of sexuality and violence. If, as Eric Schaeffer has argued, "exploitation producers conceded that because their films lacked identifiable stars or the recognition provided by conventional genres, they needed an extra edge to be 'put over' with audiences," this also aptly describes the predicament of Mexican cinema before the consolidation of its most popular genres or the star system of the Golden Age.[12]

Los Angeles's downtown theaters' alternating between exploitation and Spanish-language cinema—both in terms of the changing programs of individual theaters and the types of theaters sitting side by side along Main Street—parallels another historical proximity in which certain Mexican films could be repurposed as, mistaken for, or in the case of José Bohr's 1936 film *Marihuana*, intentionally designed as exploitation. In a peculiar twist of events, evidence suggests that *She-Devil Island* was selected by an independent distributor as one of the six films (along with *Guilty Parents* [Jack Townley, 1934] and *Slaves in Bondage* [Elmer Clifton, 1937]) that would be dubbed into Spanish to satisfy a Latin American market that *Variety* described as "a lush field for the slightly erotic

product."[13] This would then be a peculiar case of a Mexican film dubbed into English that was then redubbed in Spanish based on its exploitation appeal. If *Rancho Grande* is seen as a germination point for Mexico's prestigious and popular Golden Age, *María Elena / She-Devil Island* perhaps suggests a relatively unexamined shadow trajectory from the experiments of the 1930s to the low-budget horror and sci-fi of the late 1950s and 1960s.[14]

HOLLYWOOD THROWS A FIESTA

Mexican cinema of the 1930s and 1940s—in terms of both production and exhibition—also sustained a multifaceted relationship to the low-budget B movies of both the major studios and poverty row. In the Spanish-language theaters of Los Angeles, Mexican films were often screened as double features alongside a programmer produced in Hollywood. If exploitation, B movies, and Mexican cinema were relegated to second-tier, neighborhood, or specialty exhibition contexts, the transnational popularity of Mexican music also shaped the representation of Mexico and Mexicans in Hollywood cinema. In fact, these representations more often than not occurred in B movies or independent films—including the Spanish-language color features produced by George Hirliman, the Hollywood Spanish-language films starring *Rancho Grande* star Tito Guízar, the singing cowboy films set south of the border (like the Gene Autry vehicle *Rancho Grande* [Frank McDonald, 1940], or the Mexican Spitfire series starring Lupe Vélez).

While many of these films have been forgotten, lost, or otherwise overlooked, their visions of Mexico reveal insights into the nature of cinematic exchange between the two industries as well as the logic that shaped Latino representation in classical Hollywood. As Desirée J. Garcia has demonstrated, for instance, *Rancho Grande* inspired conventions of the Hollywood folk musical, prompted friendlier (if no less exotic) representations of Latin America, and shaped Hollywood's strategy to retain the Latin American market.[15] Furthermore, as several of these cases make evident, the circulation of talent between Hollywood and Latin America was hardly unidirectional. Although the Golden Age of the 1940s and 1950s was facilitated by the return of native talent from Hollywood, that same talent often worked between both industries in various capacities, from acting to dubbing. But what, if anything, do we learn from this exchange aside from the insight that it constituted a prevalent and widespread practice? I argue that considering the nature of the Mexican presence in Hollywood allows us to think in new ways about the politics of Latino representation during this period and about the various ways that Hollywood harnessed conceptions of Mexicanness as part of an attempt to appeal to audiences across the continent.

The ongoing importation and circulation of Mexican music, iconography, and talent to Los Angeles was an undeniable part of this dynamic. In fact, while

a distinction between Hollywood as an industry and Los Angeles as a city is certainly worth upholding, this case demonstrates the difficulty of extricating them from one another relative to Mexican cinema. The prospect of employment in Hollywood was one among many incentives drawing talent to the city during this period. While in town on tour, stars often made appearances at Spanish-language theaters, recorded music, appeared on radio shows, conducted publicity, and worked at a studio. In other words, with the multimedia synergy and transnational exchange on which Mexican cinema was premised came multiple opportunities for stars visiting Los Angeles to monetize their many talents across media. Whether anyone from the studios ever took advantage of this opportunity to gauge the tastes of Latin American audiences, the fact remains that these theaters—by drawing talent and serving as the locus of Mexican cinema's multidimensional appeal—acted as an interface between Hollywood and Mexican cinema, one that facilitated and indirectly shaped Hollywood's cinematic version of Mexico.[16]

To examine this dynamic, I will briefly consider the little-known 1941 Hal Roach film *Fiesta* (LeRoy Prinz) as both a textual artifact and one whose production process reveals the kinds of representational negotiations that occurred among studios and other invested parties. Its release coincides exactly with the concerted collaboration between Hollywood and the Office of the Coordinator of Inter-American Affairs as part of the broader cultural initiatives of the Good Neighbor policy. As such, it marked the incorporation and translation of Mexican themes into a Hollywood production as a way of ostensibly facilitating goodwill between the United States and Latin America, including Mexico.[17] It was also the only U.S. role for Jorge Negrete, who would become one of Mexican cinema's most prominent singing *charros* and who regularly traveled to Los Angeles to perform in Spanish-language theaters (in fact, his untimely passing occurred while he was on tour in Los Angeles in 1953).

What this film makes apparent, along with others that comprise the cycle of Pan-American musicals of the early 1940s, is that Hollywood's vision of and outreach to Latin America borrowed heavily from the successes of Mexican cinema. In particular, *Fiesta* is quite clearly an adaptation of the formula made popular by *Allá en el Rancho Grande* and other films of the comedia ranchera genre: an idyllic hacienda setting, romantic rivalry, copious musical interludes, cultural types like the charro, and a star already associated with the genre.[18] What most scholarship on Latino representation in classical Hollywood cinema often overlooks is the fact that these images were not ever *only* the product of entrenched perceptions of Latinos (although this was undoubtedly a central factor).[19] Instead, these representations, in keeping with the multifaceted address of the Good Neighbor policy, emerged from studios' attempts to create characters and images with potential Latin American appeal that did not violate extant perceptions of Latinos circulating through U.S. popular culture. In other words,

Figure 6.2. Title sequence for *Fiesta* (LeRoy Prinz, 1941), produced by Hal Roach Studios and starring Jorge Negrete and Antonio Moreno.

these representations were undeniably shaped by Hollywood's conceptions of its various audiences and their respective sensibilities. This dynamic is a central yet overlooked dimension of Hollywood's operational logic as an international industry, one that also accounts for the kinds of Latino representations that ended up onscreen, not to mention how and why these changed over time.

In the case of *Fiesta*, producer Hal Roach sustained an ongoing conversation with Addison Durland of the Production Code Authority (PCA) about these very issues. Durland was hired during the Good Neighbor era as an intermediary between Latin American representatives and the PCA and was charged specifically with monitoring representations of the region and its people from a film's earliest stage of production.[20] In the correspondence between Durland and Roach, it is quite apparent that the former gave voice to what television scholar Timothy Havens (in a more contemporary context) refers to as "industry lore" about audiences and their tastes.[21] Likely informed by various Mexican consultants, the critical reception of Hollywood in Mexico, and the previous success or failure of films in that country, Durland warned Roach about a potentially controversial scene played for laughs: "As you know, the Mexican people's moral standards are different in many ways from ours; and even in jest this comedy scene, based not only on the kissing of Pancho's wife by Pedro, but on the fact

that Pedro is willing to pay money for it, is a dangerous one." As a rebuttal to Durland's concerns, Hal Roach and director LeRoy Prinz assured him that because they had consulted "competent authorities on Mexican matters . . . they understood Mexico and Mexican psychology, and that they had many friends in Mexico, and that they were sure that this picture not only would be inoffensive, but in fact, would be quite well received by the Mexican government."[22] Regardless of their accuracy, both sets of claims assert expertise about the tastes and sensibilities of Mexican audiences, with this "knowledge" or "lore" inevitably shaping what ended up onscreen.

In a subsequent letter to Roach, Durland broaches the ever-sensitive subject of language use in *Fiesta*. Of course, a number of scholars have examined the controversies occasioned by language use in the context of Latin America during the sound period.[23] At issue in this particular exchange was the tension building among the Mexican setting, the hiring of Spanish-speaking actors (including Negrete and silent film star Antonio Moreno), and the use of English by the film's characters. What is curious about this correspondence, however, is that it not only addresses the issue of language usage but also reveals the industrial logic that generated very specific kinds of Latino or Latin American representations:

> As stated in our letter to you, dated August 13, 1941, since the story has Mexico for its locale and its characters are Mexican, they will speak in English, due to the accepted convention, in order that American audiences may understand the dialogue; but broken English, especially in this case, will be unjustified and, therefore, annoy our Mexican neighbors. In our opinion, they will raise no objections to the use of a Mexican accent, especially when a great number of the players in this production are Mexican, and, therefore, could hardly be expected to deliver their lines absolutely free of such accent.[24]

What is undeniably remarkable about this brief passage is that it explicitly explains the rationale that has made accents—as some sort of textual compromise—such a persistent marker of difference in U.S. representations of Latinos and Latin Americans. Perhaps equally remarkable is the way the letter directly references both domestic and international audiences, making assumptions about their respective expectations and sensibilities. Any analysis of Latino representation must then take into account the fact that some of what we regard as stereotypical imagery was at least in part designed to appeal to Latin American audiences and was generated by a particular industrial lore about them. It is also the case that both this knowledge and the availability of talent were facilitated by the multimedia nature of Mexican cinema and the exploitation of this by Spanish-language theaters in Los Angeles.

A Traveling *Portrait*, an Altered *Rebellion*

The circulation of talent between the United States and Mexico is inextricable from the circulation and distribution of films and properties between the two film industries. Of course, the persistent travel of Hollywood films to Mexico is perhaps a foregone conclusion, although as Laura Isabel Serna has compellingly demonstrated about the silent era, its impact was as multifaceted as its reception was ambivalent.[25] The dynamics and implications of Mexican film distribution to the United States, however, have only recently begun to be examined by scholars.[26] Given these two dominant cultural flows—of Hollywood films to Mexico and of Mexican cinema to the Spanish-speaking United States—the distribution of Mexican film to English-speaking audiences in the United States might easily be disregarded as too anomalous or infrequent to be worthy of scholarly attention. However, this phenomenon provides a unique point of interaction between the industries, one that allows us to parse distinctions between the standards and conventions of each and additional factors that structured the visions of Mexico they produced.

While analyses of Mexican films most frequently situate them almost exclusively within a national context, during the Mexican cinema's Golden Age of the 1940s, Mexican and U.S. distributors alike were regularly experimenting with the distribution of Mexican film to English-speaking audiences.[27] Independent exhibitors were increasingly motivated to tap into this niche market, while distributors had analogous investments in this practice. MGM, for instance, announced its intentions to distribute foreign film in the United States as part of an attempt to create international goodwill—or at least to establish a reciprocity that would facilitate the ongoing exportation of Hollywood films to foreign markets.[28] At the same time, distributor Azteca Films likely regarded this phenomenon as an opportunity to increase revenues for their releases in the lucrative U.S. market and began distributing their films, either subtitled or dubbed in English, to major markets like Los Angeles and New York City.[29]

The viability of this distribution practice was undoubtedly facilitated by the rise of the art house phenomenon that would flourish in the postwar period. Dubbed in English and distributed in the United States as *Portrait of Maria*, Emilio Fernández's landmark Golden Age film *María Candelaria* was billed by its distributor, MGM, as "an unusual picture." A Los Angeles reviewer noted the characteristics that aligned the film with the kind of taste distinction that typified the logic of the art house phenomenon by declaring that the film "may praisingly be designated 'not a Hollywood picture.'"[30] Obviously, the film's supposedly "unusual" nature coincides with the notion that art films were positioned as "alternatives to mainstream Hollywood cinema—not just in terms of their formal and thematic differences, but in terms of their potentially alternative systems of production, distribution, and exhibition in the United States."[31]

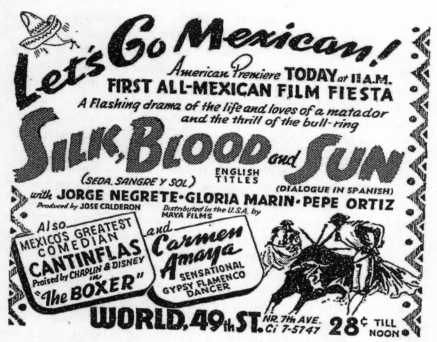

Figure 6.3. Advertisement for the "Mexican Film Fiesta" at the World Theater in New York City. *New York Times*, January 29, 1943.

Perhaps not surprisingly, as a minor element of these transnational cinematic exchanges, Mexican films distributed to English-language audiences in the United States exhibited the logic that largely guided cinematic circulation—intimately tied as it was to transnational stardom. Traveling in an analogous yet opposite direction as the internationally famous Dolores Del Rio (who had returned to Mexico in the early 1940s as her popularity in Hollywood waned), the film's male lead, Pedro Armendáriz, was arguably transformed into a star by his iconic roles in Fernández's films, including *Flor silvestre* (1943) and *María Candelaria*. By the late 1940s, he was playing prominent roles in John Ford westerns, including *Fort Apache* (1948) and *3 Godfathers* (1948).[32] Even more curiously, his stardom was the catalyst and guiding logic for a number of hybrid films that experimented with transnational production in various ways: the release of the 1947 adaptation of Steinbeck's *La perla / The Pearl* in two languages, John Ford's Mexican-filmed adaptation of Graham Greene's *The Fugitive*, and Emilio Fernández's remake of his own iconic *Enamorada* as the English-language film *The Torch*, in which Paulette Goddard assumed the lead role initially performed by María Félix. In all cases, Armendáriz was situated as a central appeal of these films and figured prominently in promotion and publicity. To this extent, these hybrid films—along with the Ford westerns—represent yet another aspect

of Hollywood's timeworn strategy of capitalizing on the transnational appeal of imported talent, a strategy initiated in the silent era.

But aside from Hollywood producers working to attract viewers through Armendáriz's familiarity to both U.S. and Latin American audiences, these films also suggests the attractiveness of Mexico not only as subject matter but as a location. All these hybrid Mexican/U.S. films were produced two or three years after World War II and were released alongside a number of other films shot in Mexico: *Adventures of Casanova* (Roberto Gavaldón, 1948, starring Mexican actor Arturo de Córdova), *Captain from Castile* (Henry King, 1947, a big-budget drama about the conquest starring Tyrone Power), *The Treasure of the Sierra Madre* (John Huston, 1948), *Plunder of the Sun* (John Farrow, 1953), and the Shirley Temple vehicle *Honeymoon* (William Keighley, 1947, originally titled *Honeymoon in Mexico*). Based on theater listings in the *Los Angeles Times* in the late 1940s, a moviegoer could choose from various visions of Mexico screening simultaneously: a Mexican film showing downtown or in a neighborhood Spanish-language theater, an English-language film featuring Mexican talent, a revival of a Latin-themed B movie, or a big-budget Hollywood feature shot in Mexico.[33]

As many of these were shot at least partially at Churubusco Studios in Mexico City, they potentially read as attempts to capitalize on investments made by Hollywood studios during World War II, which included this facility. As the press surrounding this early iteration of "run-away production" attests, Mexico also at least temporarily emerged as an alternative to the labor strife besieging Hollywood during these years. Aside from the attractiveness of what the *New York Times* described as Mexico's "sub-Hollywood wages," its film industry was described repeatedly as being blissfully free from the jurisdictional conflicts at the heart of union clashes in Hollywood.[34] A subsequent article about Hollywood's so-called invasion of Mexico not too subtly mentions some of the factors that made RKO's production of *The Fugitive* so efficient: "One of the reasons for the speed of Mexican studio operations is their union's tolerance of what in Hollywood would be considered the most outrageous crossing of jurisdictional lines. It is not unusual in Mexico to see a prop man pick up a hammer and help carpenters reinforce a set, or for an electrician to join a mixed gang of grips and extras pushing a camera dolly. In Hollywood any such interchange would justify a strike call."[35] As Dolores Tierney has noted, this production strategy also seemed motivated by a renewed interest to regain the Latin American market in the face of diminishing box office returns in the United States, "an attempt to contain and encroach on the Mexican industry."[36] In other words, these cinematic renderings of Mexico attempted to capitalize on the successful elements of Golden Age cinema—whether these were locations, talent, labor, aesthetics, or a combination thereof—to attract audiences on both sides of the border.

As many of the films mentioned previously, whether Mexican or otherwise, were adapted from well-known literary sources, this period also coincides with

postwar aspirations to prestige cinema in both nations. On all counts, the film *La rebelión de los colgados* (Alfredo B. Crevenna and Emilio Fernández, 1954) would seem an obvious choice for U.S. distribution and was released in the United States as *The Rebellion of the Hanged*. Not only was the film initially directed by the internationally recognized Fernández, but it also starred Pedro Armendáriz. It was also an adaptation of the enigmatic B. Traven's novel about the Mexican Revolution, which had been published in an English-language edition by 1952. While set during the revolution, the film would have evoked some of the familiar iconography of the western genre and cinematic precedents like *Sierra Madre*, which was also adapted from a B. Traven work and shot in Mexico. As this one instance of the circulation of talent, properties, and cinema demonstrates, the presence and impact of Mexican cinema in the United States has operated at multiple levels, although its implications remain relatively unexplored.

While *Rebellion of the Hanged* might reveal the mutual influences between Hollywood and Mexican cinema, it also readily demonstrates some of the ways that Mexican cinema continually worked to differentiate itself from Hollywood. Part of Mexican cinema's distinct advantage and appeal, as the precedent of *She-Devil Island* made blatantly apparent, was looser censorship standards that allowed for more graphic depictions of both violence and sexuality. Building on Carlos Monsiváis's astutely phrased observation that for Mexican cinema, "the only defense is excess," Ana M. López has argued that in Golden Age Mexican melodrama, "exaggerated signification and hyperbole . . . become, in the Mexican case, a way of cinematically working through the problematic of an underdeveloped national cinema," another way of competing with Hollywood.[37] This dimension of Mexican cinema's aesthetic and representational logic would become particularly obvious when dubbed or subtitled versions these films were submitted to the Motion Picture Association of America's (MPAA) PCA for approval.

When submitted to the PCA, *Rebellion of the Hanged* presented some formidable challenges. In the film, Armendáriz portrays an indigenous man who is unwillingly conscripted into an exploitative labor camp in the southern state of Chiapas, where he and his family are subjected to brutal treatment that eventually inspires a revolt. In addition to the graphic depiction of the violence perpetrated on the characters, the foremen of the labor camp also enjoy the company of prostitutes, at least one of which wears a nearly transparent blouse. While the PCA had warned of potential difficulties with the script in 1954, the film itself was initially rejected based on the following factors: "First, excessive brutality and, second, over-emphasis on sex suggestiveness and lust. It might be possible to cut the film so as to remove most of this questionable material, but it would involve a major job of re-editing."[38] Evidently, these obstacles were surmounted and the film was eventually released, although not very extensively. Fortuitously, its release coincided with other challenges to the Production Code and the often

sensational marketing used to promote supposedly more risqué art films; its poster played up the precise elements of the film that concerned the PCA, promising "Love! . . . Lust! . . . Violence!"[39]

As this publicity strategy suggests, foreign films during this period were often marketed as quality adult entertainment in a way that conflated graphic material with artistry, or at least used the latter as a pretext for the former.[40] In embracing this approach, Mexican producers could effectively shuttle between apparently opposed regimes of taste: aspirations of artistry or international recognition and the promise of representational practices that exceeded the bounds of the Production Code. The fact that Mexican producers and distributors strategically played both ends of this spectrum is evident through not only a consideration of filmic content but the various contexts of its distribution and reception. On the one hand, Legion of Decency ratings for Mexican films—as part of an apparent collaboration with its Mexican counterpart—consistently found that Mexican films of the period were, on average, more objectionable than those from the United States.[41] On the other, the travels of a film through circuits of prestige could then be leveraged to attract Spanish-language audiences based on the reputation it had accrued for having been dubbed, won awards, or otherwise proved popular with non-Mexican audiences.[42] *Rebelión de los colgados* would have the potential to appeal to multiple audiences seeking distinct and, at times, overlapping levels of appeal.

In fact, the film's producer, José Kohn, mobilized its ostensible cultural, educational, and historical value to defend it against the excessive cuts proposed by the PCA. In one letter, Kohn assured Joseph Breen that "at no time in the course of creation and production have we included a scene, a character, or even a line of dialogue for the purpose of vulgar entertainment; our sole aim has been the presentation of a film honestly based upon a novel which has won the respect and approval of critics and public." While the reference to literary source material rhetorically aligned it with art house cinema of the period, Kohn also cannily gestured toward the significance of national cinema on the international stage: "I felt constrained to present the matter to the Association of Mexican Producers who in turn has referred it to the Ministry of the Interior, which is not only the official censor of films but controls the importation of American and other foreign pictures. It may interest you to know that this federal agency has accepted my script completely and . . . has decided to send it to the Venice Festival as an official Mexican government selection. As a result, your censoring of my picture will be of wider concern than merely my interest as an individual producer."[43]

While there is certainly much worth unpacking in these statements, it does demonstrate the ways in which notions of prestige, cultural nationalism, and trade relations were mutually imbricated logics of international distribution. One could justifiably argue that Mexican cinema's attempts to break into the

Clasificación de Películas

Llamamos la atención sobre la diferente clasificación que hacen la LEGION MEXICANA DE LA DENCENCIA y la NATIONAL LEGION OF DECENCY.

Las películas mexicanas prohibidas están en C-2 y las en C-1 deben evitarse.

Las películas americanas prohibidas están en C y las en B, deben evitarse.

LA DIANA CAZADORA	C-2
(Desnudos reiterados. Se atenúa y casi justifica el adulterio. Conducta reprensible. Suicidio.)	
LOS TRES VILLALOBOS	B-2
DESPUES DE LA TORMENTA	B-3
GRITENME PIEDRAS DEL CAMPO	B-2
LA REBELION DE LOS COLGADOS	C-1
The Light in the Forest	A-1
The Hunters	A-11
The Golden Age of Comedy	A-1
The Vampire's	A-11
The Restless Breed	A-11
Island in the Sun	B
The Devil's Hairpin	B
"The Bravados"	A-11
Spook Chasers	A-1
Fort Massacre	A-1
Across the Bridge	A-1
"From Hell to Texas"	A-1
The Green Eyed Blonde	A-11
House of Numbers	B
The Sheepman	A-1
The Unguarded Moment	A-11
Seven Brides for Seven Brothers	A-11

NOTE: Films considered by the National Legion of Decency to be better than average entertainment, are marked with quotation marks.

Figure 6.4. A regular feature in the Kingsville, Texas, newspaper that aggregates film rankings from the Legion of Decency in both the United States and Mexico. *Notas de Kingsville*, October 9, 1958.

U.S. market relied on a balance forged among capitalizing on curiosity about·
Mexico (and its intersection with the tourism industry), the promise of explicit
content, and aspirations of artistic recognition. If Latino representations in
Hollywood, as I have argued, were at least partially shaped by both Mexican
cinema and conceptions of the Latin American audience, scholars have also
neglected to consider that some Mexican cinema might have operated accord-
ing to a similar logic in its navigation of the U.S. market. That is, the fact that
a number of canonical texts of the Golden Age traveled in this fashion demands a
revision of the way we analyze them while productively prompting a reconsid-
eration of the frameworks through which we approach it as a historical phenom-
enon. For Mexican cinema, particularly from the vantage point of a place like Los
Angeles, where the potential audiences for the various versions of these films were
myriad, the mutable meanings these films may have had as they were designed to
cross linguistic and physical borders remains largely unexplored within the field
of Latin American film studies.

CONCLUSION

So what might all this mean, aside from the perhaps unremarkable fact that Hol-
lywood and the Mexican industry interacted regularly between the 1930s and the
1950s? For one, it allows us to understand how Mexican cinema was shaped by its
interest in securing a foothold in the U.S. market, and not only through Spanish-
language theaters. In other words, if Mexico—in the apt phrasing of Ana M.
López—strove to produce a "cinema for the continent," that continent, at least at
certain moments, included English-speaking or non-Latino audiences.[44] These
anomalous, transnational, or hybrid films—by pressing at the edges of famil-
iar categories—demonstrate that Mexican films circulated along an axis whose
points included exploitation, art house cinema, educational film, B movies,
and Hollywood genre conventions so that the cultural value of a film could be
adjusted and renegotiated according to economic exigency. It's not that a single
film occupied a stable space within this triangulation; producers and distribu-
tors had to strategically insert a film into an existing production, distribution,
promotional, and exhibition landscape through which Mexican cinema might
be legible within and outside of its national borders and to multiple audiences.
It is the very hybridity of this landscape in Los Angeles, and the connections and
interactions it made possible, that allow us, in retrospect, to understand how
these processes functioned. By incorporating these lessons, Mexican cinema also
became a model and example to which Hollywood looked in its own attempts
to produce a "cinema for the continent"—a series of consistent, multidirectional
transactions that not only provide insight into Hollywood's various strategies
for tapping into the Latin American market but also perhaps alter the way we
understand the history and logic of Latino representation in classical Hollywood.

NOTES

1. For key works along these lines, see Lisa Jarvinen, *The Rise of Spanish-Language Film-making: Out from Hollywood's Shadow, 1929–1939* (New Brunswick, N.J.: Rutgers University Press, 2012); Matthew Karush, *Culture of Class: Radio and Cinema in the Making of a Divided Argentina, 1920–1946* (Durham, N.C.: Duke University Press, 2012); and Laura Isabel Serna, *Making Cinelandia: American Films and Mexican Film Culture before the Golden Age* (Durham, N.C.: Duke University Press, 2014).

2. José María Sánchez García, quoted in Emilio García Riera, *Historia documental del cine mexicano*, vol. 1, *1929–1937* (Guadalajara: University of Guadalajara, 1992), 211.

3. See Colin Gunckel, *Mexico on Main Street: Transnational Film Culture in Los Angeles before World War II* (New Brunswick, N.J.: Rutgers University Press, 2015), 122–158.

4. See advertisement for Teatro México, *La Opinión*, March 26, 1936, 4. In New York, screenings of the film also featured live performances of the song. See advertisement for *María Elena*, *Artes y Letras*, February 21, 1936, 10.

5. See advertisement for Teatro California, *La Opinión*, May 24, 1936, II-3.

6. See advertisement for Teatro California, *La Opinión*, May 23, 1936, 4.

7. Campos Ponce, "Cinegramas," *La Prensa*, February 23, 1936, 14.

8. Hortensia Elizondo, "El cinema en México: La película *María Elena*," *La Prensa*, March 8, 1936, 15.

9. This practice was mentioned as being a common one for many films completing production in 1936. See Hortensia Elizondo, "Noticiario del cine nacional mexicano," *La Prensa*, May 24, 1936, 11.

10. Advertisement for *María Elena*, *El Continental* (El Paso, Tex.), November 10, 1936, 5.

11. Eric Schaefer, *"Bold! Daring! Shocking! True!" A History of Exploitation Films, 1919–1959* (Durham, N.C.: Duke University Press, 1999), 12.

12. Schaefer, 4.

13. "Latins Hot for S.A. Films," *Variety*, November 3, 1937, 7.

14. Ana M. López, "Before Exploitation: Three Men of Cinema in Mexico," in *Latsploitation, Exploitation Cinemas, and Latin America*, ed. Victoria Ruétalo and Dolores Tierney (New York: Routledge, 2009), 13–33.

15. Desirée J. Garcia, *The Migration of Musical Film: From Ethnic Margins to American Mainstream* (New Brunswick, N.J.: Rutgers University Press, 2014), 72–98.

16. In a 1941 article in *La Opinión*, Jack Preston lamented the fact that Hollywood producers did not actually visit downtown movie theaters, where they might be best able to gauge the tastes and preferences of the coveted Latin American market. Jack Preston, "El cinema y la América Latina," *La Opinión*, August 24, 1941, II-6.

17. For more on U.S. film during the Good Neighbor period, see Ana M. López, "Are All Latins from Manhattan? Hollywood, Ethnography, and Cultural Colonialism," in *Unspeakable Images: Ethnicity and the American Cinema*, ed. Lester D. Friedberg (Urbana: University of Illinois Press, 1991), 404–424.

18. See Garcia, *Migration of Musical Film*.

19. Mary C. Beltrán, *Latina/o Stars in U.S. Eyes: The Making and Meanings of Film and TV Stardom* (Champaign: University of Illinois Press, 2009).

20. Brian O'Neil, "The Demands of Authenticity: Addison Durland and Hollywood's Latin Images during World War II," in *Classic Hollywood, Classic Whiteness*, ed. Daniel Bernardi (Minneapolis: University of Minnesota Press, 2001), 359–385.

21. Timothy Havens, *Black Television Travels: African American Media around the Globe* (New York: New York University Press, 2013).

22. Letter to Mr. Hal Roach from Addison Durland, August 15, 1941, *Fiesta* (Roach, 1940) Production Code Authority File, Academy of Motion Pictures Arts and Sciences, Margaret Herrick Library, Los Angeles, Calif.

23. See Gunckel, *Mexico on Main Street*; Colin Gunckel, "The War of the Accents: Spanish Language Hollywood Films in Mexican Los Angeles," *Film History* 20, no. 3 (2008): 325–343; Juan B. Heinink and Robert G. Dickson, *Cita en Hollywood: Antología de las películas habladas en castellano* (Bilbao: Mensajero, 1990); and Jarvinen, *Rise of Spanish-Language Filmmaking*.

24. Letter to Mr. Hal Roach from Addison Durland, August 20, 1941, *Fiesta* (Roach, 1940) Production Code Authority File, Academy of Motion Pictures Arts and Sciences, Margaret Herrick Library, Los Angeles, Calif., emphasis in original.

25. Serna, *Making Cinelandia*.

26. See Rogelio Agrasánchez Jr., *Mexican Movies in the United States: A History of the Films, Theaters, and Audiences, 1920–1960* (Jefferson, N.C.: McFarland, 2006); Desirée J. Garcia, "The Soul of a People': Mexican Spectatorship and the Transnational *Comedia Ranchera*," *Journal of American Ethnic History* 30, no. 1 (Fall 2010): 72–98; and Gunckel, *Mexico on Main Street*.

27. One recent example of such an approach is Charles Ramírez Berg, *The Classical Mexican Cinema: The Poetics of the Exceptional Golden Age Films* (Austin: University of Texas Press, 2015).

28. See "Metro Embarks on a New Venture," *New York Times*, September 30, 1945, 51.

29. See Thomas F. Brady, "Color Film Costs Are Cut," *New York Times*, May 21, 1950, X5. As Barbara Wilinsky notes, Azteca often struggled to have their product regarded as art film, as the concept was so closely tied to European cinemas. See Wilinsky, *Sure Seaters: The Emergence of Art House Cinema* (Minneapolis: University of Minnesota Press, 2001), 32.

30. Edwin Schallert, "Magnificent Scenery Backgrounds Tragedy," *Los Angeles Times*, July 13, 1946, A5.

31. Wilinsky, *Sure Seaters*, 15.

32. For an analysis of his performances in U.S. films and their relationship to changing constructions of Latinidad, see Dolores Tierney, "Latino Acting on Screen: Pedro Armendáriz Performs Mexicanness in Three John Ford Films," *Revista Cadaniense de Estudios Hispánicos* 37, no. 1 (Fall 2012): 111–133.

33. See, for instance, "Independent Theatre Guide," *Los Angeles Times*, April 6, 1948, 12.

34. Thomas F. Brady, "Hollywood Digest," *New York Times*, November 24, 1946, 85.

35. Frank S. Nugent, "Hollywood Invades Mexico," *New York Times*, March 23, 1947, SM17. For more about these labor disputes, see Thomas Schatz, *Boom and Bust: American Cinema in the 1940s* (Berkeley: University of California Press, 1997), 303–307.

36. Dolores Tierney, "Emilio Fernández 'in Hollywood': Hollywood's Postwar Inter-American Cinema, *La perla/The Pearl* (1946) and *The Fugitive* (1948)," *Studies in Hispanic Cinemas* 7, no. 2 (December 2010): 90.

37. Ana M. López, "Tears and Desire: Women and Melodrama in the 'Old' Mexican Cinema," in *Mediating Two Worlds: Cinematic Encounters in the Americas*, ed. John King, Ana M. López, and Manuel Alvarado (London: British Film Institute, 1993), 147–163.

38. Letter to Joseph Burstyn from Geoffrey Shurlock, July 15, 1955, *Rebellion of the Hanged* Production Code Authority File, Academy of Motion Picture Arts and Sciences, Margaret Herrick Library, Los Angeles, Calif.

39. See Wilinsky, *Sure Seaters*, 122–127.

40. Peter Lev, *The Euro-American Cinema* (Austin: University of Texas Press, 1993), 13. See also Wilinsky, *Sure Seaters*, 25–27; and David Andrews, *Theorizing Art Cinemas: Foreign, Cult, Avant-Garde and Beyond* (Austin: University of Texas Press, 2013), 58–63.

41. See, for instance, the rating of *Rebelión de los colgados* alongside other features in "Clasificación de películas," *Notas de Kingsville*, October 9, 1958, 5.

42. See the brief item on *La rebelión de los colgados* in Car-Vaz, "Cine-reportes," *La Prensa* (San Antonio, Tex.), December 23, 1956, 6.

43. Letter to Joseph I. Breen from José Kohn, April 23, 1954, *Rebellion of the Hanged* Production Code Authority File, Academy of Motion Picture Arts and Sciences, Margaret Herrick Library, Los Angeles, Calif. (AMPAS).

44. Ana M. López, "A Cinema for the Continent," in *The Mexican Cinema Project*, ed. Chon A. Noriega and Steven Ricci (Los Angeles: UCLA Film & Television Archive, 1994), 7–12.

◇◇◇◇◇◇◇◇◇◇

ON THE *NUEVO TEATRO MÁXIMO DE LA RAZA*

STILL THINKING, FEELING, AND SPEAKING SPANISH ON- AND OFFSCREEN

Nina Hoechtl

On March 3, 1949, the Mayan Theater reopened.[1] The theater's marquee advertised it in both Spanish and English as the "Nuevo Teatro Máximo de la Raza Home of Mexican Film."[2] One week in advance, the theater had also run full-page advertisements in the Spanish-language daily newspaper *La Opinión*.[3] The bilingual advertisement addressed people who understood English and/or Spanish, were Mexican film enthusiasts, or considered themselves part of *la raza*, a term literally meaning "the race" and was used as a synonym for Chicano/a people.[4] This was a clear declaration of the theater being an inclusive space, especially considering that the Zoot Suit Riots of 1943 had occurred just around the corner on Main Street and that segregation based on Mexican descent was still in place "in public accommodations, such as swimming pools and movie theaters."[5]

In 2010, my "curious eye" was triggered by a Lucha VaVoom poster—drawing so clearly on the aesthetics of film posters from the *cine de luchadores* genre—in downtown Los Angeles.[6] My curiosity was only intensified through several visits to the Mayan Theater, attending Lucha VaVoom events, and continued research, but it does not end there. Or, to put it differently, this chapter is ultimately dependent on my visual experiences of the Mayan Theater's architecture and my analysis of both films and archival materials, some of which are reliant on "the Indian as rooted in the symbolic/imaginary, a phantasmatic projection of [people] who now are not-Indian, the site of structure of the *fantasy* of origins and race."[7] I thus use the Mayan Theater as a way of thinking through the intertwined histories of Mexican cinema, downtown Los Angeles, and ideas about as well as

evocations of *indigenismo* (or specters of indigenous Mexico).[8] Through archival materials—print advertisements, articles, cine de luchadores footage, Lucha VaVoom posters, the Mayan Theater itself, and the multiple embodied acts performed within it—I argue that it is possible to explore and contest some of the "phantasmagoric irruptions from which primitivism appeared and reappeared in art, literature and politics in the form of an exoticist fetish-merchandise," especially those drawing on Mesoamerican art and iconography.[9]

The Mayan Theater cannot be missed when going down South Hill Street in downtown Los Angeles. The building is a two-story structure designed by the architectural firm Morgan, Walls and Clements. Its front facade and almost every interior surface are covered with forms and motifs researched and designed by Francisco Cornejo, an architect and designer from Baja California, Mexico.[10] These design elements set the theater apart from other buildings on the street. A giant neon sign written in all capital letters marks the place even more clearly. The act of naming this theater *MAYAN*—although it features forms and motifs derived "from the Zapotec, Maya, Teotihuacán, Xochicalco, Toltec and Mexica cultures of Mesoamerica and the Tiwanaku and Inka of the Andes," whose heydays are separated by several centuries and thousands of miles—places it directly in line with other major theaters of the time, such as the Egyptian in Los Angeles, which opened in 1922, and the Oriental in Chicago and the Aztec in San Antonio, both inaugurated in 1926.[11]

Though originally envisioned as a legitimate theater featuring stage plays, by mid-1929 it had started to operate as a movie palace.[12] With 1,500 seats and accommodations for live entertainment, for the next couple decades it hosted musical comedies, revues, dramatic theater, and motion pictures. Theater chain owner Frank Fouce bought the Mayan Theater at the end of 1948 to revive and present it as something more than a movie theater—as the home for Mexican / Chicano/a / Hispanic / Latin American culture and art: "The 'Mayan' will be our home, it will be the window in which to showcase, for everyone to see, the best of us. The great Spanish-speaking population, FINALLY has THE THEATRE WE DREAMT FOR IT."[13] The showcase meant a combination of movies and live performances that alluded to the Mayan Theater's past as well as its future. From the early 1970s to 1990, it became an adult porn theater, and although functioning primarily as a nightclub since 1990, it has hosted highly popular Lucha VaVoom events—a mix of *lucha libre* wrestling, burlesque, and comedic commentary—since 2003.[14]

The Mayan Theater, as I argue elsewhere, performs a *travestismo cultural* (cultural transvestism) through and within the building itself.[15] The literary theorist Jossianna Arroyo describes travestismo cultural as a process of cultural representation wherein discourses of race, gender, and sexuality are manipulated in order to create a form of double identification that simultaneously articulates two discourses, "one of approach and conciliation and the other of subordination."[16]

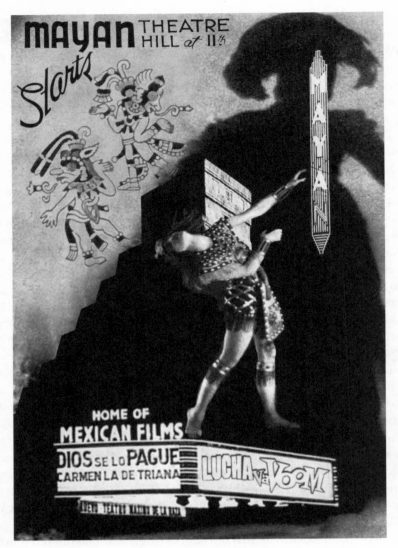

Figure 7.1. "Mayan Theatre Starts," digital collage by Nina Hoechtl, 2015.
Courtesy of the author.

The travestismo cultural of the Mayan Theater has not remained stable and con-
sistent for all time; rather, it has been integrated into a range of cultural work
through performative, embodied, and discursive acts in specific historical
moments. The performative construction of travestismo cultural, drawing
on the theater's references to indigenous Mexico, functions in distinct ways rela-
tive to ideas of community and nation. Each time, a different process of masking
takes place. As Stuart Hall reminds us, the metaphor of masking and displacing

is applied as a discursive practice of nationalism: "The first ideological effect under capitalism . . . is to mask, conceal or repress theses antagonistic foundation of the system."[17] In the construction of a nation, Hall explains, classes (and I might add ethnicities, different genders, and sexual preferences, among others) are fragmented into groups of individuals and then subsequently represented in imaginary unities that mask and replace class (ethnic, gender, and sexual) relations and economic contradictions, thus producing hegemonic consent in the name of the "community" and the "nation."[18] The mask points out the multiple layers of opposing, conflictual, and contradictory political discourses that lie beneath the evident surface.

The implications of actual and/or metaphorical masking in relation to the Mayan Theater are at times overtly and at times implicitly apparent. This chapter will discuss three varying configurations of the Mayan Theater's *travestismo cultural* and processes of masking: the claiming of the Mayan revival style of its architecture as a truly "American" one, the Pan–Latin American community evoked by Fouce's management from 1948 until 1969, and the recent celebratory multiculturalism performed in the Lucha VaVoom events since 2003. At each turn, however, the indigenous has been both evoked and erased while its ghostly presence-made-absence has been underscored in varying degrees and through different intensities.

A NATIONALIST "AMERICAN" MASK: A SELECTIVE MESOAMERICAN TRAVESTISMO CULTURAL

In 1949, Fouce addressed his advertisement in *La Opinión*, "A las Colonias Hispano Americanos en el Sur de California" (To the Hispanic-American Colonies in the South of California), and went on to explain that the Mayan Theater was a "Mexican art treasure, a creation of the great artist Francisco Cornejo, [and] the logical center of the artistic manifestations of our raza."[19] The Mesoamerican-infused architecture and decoration set the theater apart from Fouce's previous venues—the California, Mason, Roosevelt, and Liberty theaters, among others—as it fit perfectly with Fouce's consistent endeavor to maintain his enterprise at the core of Spanish-language entertainment in Los Angeles.[20] All of Fouce's long-practiced exhibition and promotion strategies, press interviews, and even the decoration of his other theaters became a perfect match when he acquired the Mayan Theater. Because of the latter's architectural design, however, there was no need to hang paintings of Mexican historical figures such as Miguel Hidalgo or Benito Júarez, as had been previously done in the Teatro California.[21]

The Mayan Theater, which was built at a cost of $850,000 from 1926 to 1927, is a representative example of the architectural movement known as Mayan Revival or Pre-Columbian Revival in the United States and as *estilo neomaya* in Mexico.[22]

Since the nineteenth century, the United States had felt entitled to appropriate Mesoamerican cultural heritage as its own, and this architectural movement in particular represented "the culmination, rather than the beginning of these attitudes."[23] In 1927, fifteen weeks before the Mayan Theater opened its doors, the journalist, author, and poet Edgar Lloyd Hampton shared his conviction, in an article titled "American Architecture First," that the act of "adapting the prehistoric culture to the needs of modern society"—or, in other words, the act of nationalizing them in order to contain, discipline, and sublimate them—had assured this architecture an indelible place in the world.[24] He declared the Aztec Hotel in Monrovia by Robert B. Stacy-Judd to be "the only structure standing on the earth today that embodies exclusively the art, architecture and decorative design of our prehistoric past. In other words, it is the only building in the U.S. that is 100 per cent [sic] American."[25] He closed his article accordingly: "From a national standpoint this means that we presently shall have, in this country, an architecture and series of decorative principles that are 100 per cent [sic] American, while from a local standpoint the situation is even more fortunate. For this art was born, and took the first steps of its progress, in Los Angeles, California. Here is a fact which no future contingency can ever strike from the world calendar."[26]

Hampton's discursive folding of indigenous motifs into a conception of truly "American" architecture could readily be characterized as an instance of travestismo cultural. As Arroyo argues, travestismo cultural "looks for a place for its vision of the future nation . . . to nonchalantly approach, and so control, the agency of those 'others.' While focusing on the cultural [pre-Hispanic] contributions, these [creators] will dream of their origin in the history of the nation, and in turn, they seek to transcend through its [architecture] their 'racial' mark, in order to imagine themselves in modernity."[27]

In the case of the Mayan Theater, those "others" were not internal signifiers from within the United States—they came from across the border and from a very distant past. Their practices were considered ready to be approached, controlled, and incorporated to serve the U.S. national imaginary and to mask them as their own, as part of their own legacy. During the nineteenth century, several self-proclaimed archaeological researchers of the Maya area had already sought "a way to establish the U.S. as the principal heir to this archaeological legacy."[28] Building on this search, the Mayan Theater embodied the fantasy of a nationalist "American" architecture of leaving an indelible mark beyond its borders.

Through the Mayan Theater's selective evocation of Mexico's Mesoamerican past, however, the indigenous is prominently present-in-absence. It comes as no surprise that the "realities of the contemporary Maya, or some of the Mexican Americans or mass migration from Mexico to Southern California as possible [references] of this architecture" are excluded.[29] Neither is it a wonder that the indigenous of Los Angeles and Orange County—Tongva and Acjachemen (and

others, including the Tatavium, Chumash, Serrano, Kitanemuk, and Luiseño)—themselves are absent. Mariana Botey, in her book *Zonas de disturbio: Espectros del México indígena en la modernidad* (*Zones of Disturbance: Specters of Indigenous Mexico in Modernity*), points out that Mexican anthropology "has played a central role in the ideological construction of the Nation State arguably to such an extent that the specific form of discourse that it has generated—Mexican *indigenismo*—has not had the Indian as object of study, but the nation itself as its true and essential object."[30] Through a double exoticism, she explains, the nature and limits of anthropological discourse are unraveled "by affecting a displacement of the 'other' Indian, to the 'Other' European/*mestiso* in relation to himself."[31] In the instance of the Mayan Theater, I argue, a displacement of the (incorporated) indigenous "other" into a white or whitewashed "Other" is affected to embody the fantasy of the origin in the history of the nation.[32] Building on Botey's argument, I would suggest a triple "alterity whereby the exotic other embodies the fantasy of what is the *Real* and necessary in history: an acute and symptomatic manifestation that unfolds as a paradoxical transference of the [incorporated] indigenous alterity" by absenting, rendering absent, and writing/building out of existence the Native American.[33] The nationalist "American" mask of the Mayan Theater displays motifs from an incorporated indigenous Mesoamerican past while substituting and concealing the local indigenous.

A MASK OF PAN–LATIN AMERICANISM: A SPANISH-LANGUAGE TRAVESTISMO CULTURAL

In 1949, it was the performative construction of the Mayan Theater's *travestismo cultural* that made a Spanish-language *travestismo cultural* possible. Before the theater's reopening, Fouce advertised the building in *La Opinión* as a Spanish-thinking, feeling, and speaking space: "This theatre, which in other circumstances would have cost nearly two million dollars, has been obtained through a series of sacrifices and efforts, with the goal of turning it into the showcase for the art of Our America, that America that still thinks, feels and speaks in Spanish."[34] By March 1949, the interest in the Mayan Revival architectural movement had clearly waned, migration from Latin American countries had significantly increased, and as mentioned at the beginning, racial segregation and tensions were very much in place.[35]

Fouce also considered the Mayan Theater a 100 percent American building—yet in a clearly more expansive sense than the "America" referenced by Hampton, who presumably refers exclusively to the United States. When Fouce talks about "Nuestra América," he evokes a Pan-American "America"—one that, as he emphasizes, "still thinks, feels and speaks in Spanish."[36] This line brings to mind two classics of Latin American literature: "Nuestra América" ("Our America"), a renowned essay written by Cuban poet and activist José Martí in 1891, and "A

Roosevelt" ("To Roosevelt"), a poem by the Nicaraguan Rubén Darío published in 1905, in which the author directly addresses the United States as the "futuro invasor de la América . . . que . . . aún habla en español" (future invader of the . . . America . . . that . . . still speaks Spanish).[37] Both pieces are clearly anti-imperialist and Pan–Latin Americanist, and it is possible that some of the people who read the ad would have caught these references.[38] In this sense, Fouce's line served as both an address to a specific, local community and an appeal infused with Pan–(Latin) Americanism. Through advertising the Mayan Theater as the ideal site for memories and (phantasmagoric) connections to the (mythical) realm beyond the southwestern border of the United States, to which California and Los Angeles once belonged, the Mayan Theater emphasized the centrality of the Spanish language for the Latin American descent community of Los Angeles.

In order to purchase the Mayan Theater, Fouce handed over the California Theater, a movie palace that originally opened in 1918 and had exhibited Spanish-language movies since 1928, with temporary suspensions in 1931 and early 1932.[39] While describing his efforts to obtain the Mayan Theater, Fouce reiterated—albeit in between the lines—his control over Mexican and Spanish-language cinema in downtown Los Angeles as much as he promoted his incessant commitment toward Mexican / Chicano/a / Hispanic / Latin American communities in order to ask them to do their part to keep the Mayan Theater alive. Their support would not only foster the exhibition of Spanish-language films and performances—which would clearly differentiate it from the programming that had preceded it until 1948 and was offered elsewhere downtown, with movies, musicals, and plays being presented only in English—but also provide a site of togetherness free from the racial discrimination that took place at other theaters.[40] Moreover, the Spanish-language focus offered entry into a different kind of national or pannational community as a response to exclusion from a U.S. national identity premised on English. After years of building a transnational Spanish-language community, Fouce could directly market to them as they "also functioned as a stable, identifiable audience":[41] "Here is, finally, the MAYAN THEATRE, at the disposal of the Latin American public. We have done our part. Now it's up to you to decide whether it will be the firm and honorable enterprise we'd like it to be, or the failure of all our efforts and all our illusions."[42]

Though the Mayan Theater was primarily to be the "Home of Mexican Movies," as prominently announced on its marquee, the spectacular opening program featured famous figures of Spanish-language cinema and radio.[43] In a stage revue, none other than Libertad Lamarque, Alfredo Malerba, and Ricardo Duardo were among a cast of thirty dancers, singers, and musicians from Argentina, Mexico, and Los Angeles itself. The community did do their part, as Fouce had requested, and the inauguration program went on for two weeks, enhanced by a selection of films from Mexico, Spain, Argentina, Chile, and Cuba during the second week.

The famous tango singer and actress Libertad Lamarque from Argentina, who had been living and working in Mexico since 1946, was not only part of the opening program; her films would also be exhibited at the Mayan Theater for many years to come. It was her live performance, however, that captured the public's imagination. "There were lines around the block and packed houses," Fouce recalled. "She is the most professional artist that I ever worked with, male or female. She owned the stage. She outlasted everybody. Like Sinatra."[44] An announcement in *La Opinión* called attention to the physicality and live presence of her body on stage instead of onscreen: "But now you are going to see her in person. You will hear her voice, not through the microphones, nor through the synchronization of the film, but directly."[45]

Under Fouce's management until his passing in 1962—and under his son's control until early March 1969—there were to be many more opportunities granted to the public to see and hear well-known comedians, actors, and singers in person. Among them were stars Jorge Negrete and Pedro Infante from Mexico, the comedians Adalberto Rodríguez "Machuchal" from Puerto Rico and Armando Soto La Marina "El Chicote" from Mexico, and the theater group Teatro Popular de México. As such, the sounds of various Spanish accents were routinely heard and spoken in the interior of the Mayan Theater.[46] This diversity of stars and accents bolstered the kind of Pan-Americanism promoted under Fouce's management. It was a Pan-Americanism that decidedly evoked a Pan-Latino community defined in many respects by the centrality of the Spanish language.

The Spanish-language program of two movies or one movie and a live performance per day had a weekly rotation. Tickets were more expensive on the weekends, and prices adjusted in accordance to live spectacles. Almost daily for twenty years, the Fouce management placed an advertisement in *La Opinión*, which on Sundays throughout the 1950s was combined with a short article "Por los teatros Fouce" (In the Fouce theaters) describing upcoming movies and/or performances.[47] The first ten years of Fouce's movie program overlapped with the prolific Golden Age of Mexican cinema and its leading stars: Pedro Armendáriz, María Félix, Pedro Infante, Mario Moreno "Cantinflas," Jorge Negrete, Dolores Del Rio, and Germán Valdés "Tin-Tán," among others. Advertisements in *La Opinión* sometimes featured the stars' names larger and more prominently than the movie titles, and concurrent listings in the English-language *Los Angeles Times* sometimes mentioned their names without including the actual titles of the films to be shown. There was no doubt: readers knew the stars, and their names were simply enough to draw their attention.

The one star who time and again appeared onscreen during this period was the comic actor Cantinflas, who was also known beyond a Spanish-language audience. His film *Si yo fuera diputado* (*If I Were a Congressman*; Miguel M. Delgado, 1952) ran for three weeks in 1952, and *Por mis pistolas* (*For My Pistols*; Miguel M. Delgado, 1968) ran for eight straight weeks shortly before the Mayan

Theater closed its doors in 1969.[48] Only the *sexicomedia* ¡*Mujeres!* ¡*Mujeres!* ¡*Mujeres!* (*Women! Women! Women!*; José Díaz Morales, 1967), starring the *galán* Mauricio Garcés, came close to the success *Por mis pistolas*, as it was programmed for seven weeks in 1968.[49] *Santo vs. el estrangulador* (*Santo vs. the Strangler*; René Cardona, 1963), a black-and-white horror-mystery movie starring a *luchador* (wrestler), ran for two weeks at the beginning of 1968 as a result of popular demand.[50] By 1968, the luchador El Santo (the Saint)—better known as *El enmascarado de plata* (the Silver Masked Man)—had not only become the most famous and iconic luchador in Mexico; he had also already starred in twenty-one movies with thirty-one more to follow, all of which were part of the cine de luchadores genre.[51] On January 21, 1968, *La Opinión* wrote, "There isn't a more dynamic figure in Mexican cinema than Santo, 'The Silver Masked Man,' who once again stars in a film entitled 'Santo vs. The Strangler' in which the luchador and snazzy film star alternates the leads with the singer Alberto Vázquez and the beautiful María Duval."[52] As this commentary reveals, the movie is a mix of musical numbers, wrestling matches, and beautiful women, a formula repeated by many movies in this genre. In the words of film critic Nelson Carro, the cine de luchadores was "always a parasitic genre—of melodrama, of comedy, of horror and of science fiction. At no time did it look to be autonomous—on the contrary, in mixture, in pastiche, in anachronism, one finds much of its power."[53]

Santo vs. el estrangulador starts off with a musical number being performed in a *teatro de variedades* (vaudeville theater). Right afterward, four more—including Begoña Palacios singing "Fever" in Spanish and Alberto Vázquez singing "16 Tons" in English—are intertwined in a wrestling match starring El Santo. It is only by minute twenty that a strangled female cast member is discovered, but El Santo has to wrestle yet another match before the police inspector can finally reach out to him and report about the strangler. Without giving away the end of this movie or the plot of its sequel, *El espectro del estrangulador* (*The Specter of the Strangler*; René Cardona, 1963), it seems apparent that the attendees of these movies might have been musical, wrestling, or horror-mystery fans—and everything in between and beyond.[54]

In April 1968, yet another El Santo film was screened that at the Mayan Theater: *El tesoro de Moctezuma* (*The Treasure of Moctezuma*; René Cardona Jr. and René Cardona, 1966). In this film, El Santo and Jorge Rivero are special agents who receive the mission of "dismantling once and for all a gang of pre-Hispanic art dealers."[55] This call takes El Santo to the top of the Pyramid of the Sun in Teotihuacán and to the Lake Texcoco.[56] Under its dry lakebed, in a space decorated with Toltec, Teotihuacán, Aztec sculptures, and Mayan architecture, lies the treasure that, in addition to other wonders, contains a feather headdress reminiscent of the one at the Weltmuseum in Vienna, Austria.[57] Even though El Santo and Rivero arrive at the lake too late—the bad guys have already managed to take the majority of the treasure outside of the country—El Santo and Rivero rescue

Figure 7.2. Advertisement for *Santo contra el espectro* (probably *Santo contra el espectro del estrangulador*; René Cardona, 1966). *La Opinión*, January 21, 1968.

the treasure from the gang in San Francisco using skilled wrestling holds and throws.

By watching the movie at the Mayan Theater, both seem to merge into one another; the place portrayed in the scene and the actual space fuse seamlessly. Through the evocation of a precolonial past, the filmic and architectural spaces interconnect and converge. This convergence points to the claiming of the Mayan Theater's revival style as truly "American," as much as to the simplifying and/or romanticizing process of a wide range of indigenous groups, languages, communities, and cultural expressions through the cinematic portrayal of these traits found in so many of the productions of the Golden Age of Mexican cinema. Furthermore, the Pan–Latin American community evoked by Fouce's management of the theater converges with the affirmation of a strong, unique, unified,

and stable Mexican national identity. This particular travestismo cultural in relation to the Mayan Theater and Mexican cinema transcended the exclusion from a U.S. national identity premised on English while creating a homogeneous national imaginary of modern Mexico with the luchadorxs becoming its symbols, overcoming and destroying the threats to modernization. Once again, the indigenous is both present and absent: an incorporated, mystified indigenous past from beyond the United States' southwestern border is present while a complex, pluralistic notion of multiple indigenous ethnicities within Mexico is masked. Through the focus on Spanish-language movies, a Pan–Latin Americanism is evoked while absenting from the multiple native languages still spoken in Los Angeles and before settler colonialism. The indigenous is positioned as a ghost from a very distant past clearly remaining at a temporal and/or spatial distance. Nonetheless, if only for the length of a phantasmatic projection of El tesoro de Moctezuma, El Santo was able to protect the precolonial heritage of Mexico, and the feather headdress thus never ended up at the Museum in Vienna. Specters of a past that never took place have been awakened, pointing toward the desire of something not crystallized, as if the future were already present. These specters demand their due restitution in Spanish.[58]

For a non-Spanish-speaking audience, a large number of the cine de luchadores films were dubbed into English and released onto drive-in and television screens in the mid-1960s, and subsequently they have experienced a revival as cult movies since the 1980s.[59] Today, fans of these movies, like myself, could flock to the Mayan Theater to enjoy them through short clips from cine de luchadores films presented during the multifaceted and bilingual programs of Lucha VaVoom.[60] Since 2003, the Mayan Theater's travestismo cultural has taken yet another turn by putting on a mask of celebratory diversity performed in and by Lucha VaVoom.

A MASK OF CELEBRATORY DIVERSITY: A TRAVESTISMO CULTURAL IN SPANISH AND ENGLISH

The first Lucha VaVoom event did not take place at the Mayan Theater; rather, it was part of a film festival organized by the nonprofit Latin American Cinemateca of Los Angeles in 2002.[61] "It was supposed to be two days of the lucha films, and the third day was our show," Liz Fairbairn, Lucha VaVoom's coproducer, recalls. "But the live show went over way better than the films did."[62] Cine de luchadores has been a major source of inspiration for Lucha VaVoom, which has been taking place regularly at the same venue where audiences watched lucha libre movies during the late 1960s. "We try to incorporate those elements into the promo artwork and into the show," Fairbairn explains. "In a lot of those films there was always some hot chick, and Blue Demon and El Santo would stop by the bar, and there'd be some go-go dancer, or a white witch and a black witch they'd have to

Figure 7.3. "Lucha VaVoom, Hot Fun in the Summertime," poster design by Segan Friend, 2010. Courtesy of Lucha VaVoom and Segan Friend.

fight."[63] Rita D'Albert, coproducer and burlesque dancer, adds, "So, there is a precedent for the combination of lucha and dancing."[64]

The Lucha VaVoom events, however, do not only cite the cine de luchadores. Through the act of repetitive difference, they also link the space back to the history of the Mayan Theater itself, including vaudeville shows, musical performances, plays, and movies showing exotic and/or eroticized bodies.[65] The travestismo cultural of Lucha VaVoom uses a mask of celebratory diversity: besides lucha libre matches and burlesque dancing, there are mariachi or rock musicians and folk, hip hop, or Mexica dancers who are announced in English and/or Spanish, and their diverse performances are accompanied by comedic commentary in English. It is the body that comprises the spectacular focus: "Lucha VaVoom brings the emphasis back onto the body, for performers and the audience alike."[66] There is a multitude of different bodies in the audience as there is in the ring and on stage: they are mixed by gender, ethnicity/race, sexual orientation, size, and body type.[67] Such diversity of bodies traces the racial and ethnic diversification undergone over the past four decades by Los Angeles County.[68] In 2010, the population was 50.28 percent white, 47.74 percent Hispanic or Latino, 13.72 percent Asian, and 8.73 percent black or African American, among others.[69] In addition, Los Angeles has the largest population of indigenous peoples in the United States.[70]

In the moment that the body of the other is inserted into the national culture, Arroyo clarifies, it has to undergo a series of negotiations as a strategy of representation.[71] Arroyo identifies this strategy as a travestismo cultural through which one gains access to a subjectivity and agency not available before: "The integration of the body of the other in the national discourse poses the problems of—sexual, racial and gender—representation of that body and the different masks from which the subject has to draw."[72] One of the masks from which the subject has to draw is the mask of language, or being compelled to wear the mask of understanding English as well as speaking "proper" English rather than any other language. Through its announcers and commentary, Lucha VaVoom upholds a bilingual space of English and Spanish. Lucha VaVoom is not interested in creating more "authentic" or politically correct performances or in fixing ethnical/racial, sexual, or gender representations. Actually, Lucha VaVoom deploys familiar imaginaries from lucha libre and burlesque: trained bodies in loincloths or string *tangas*, masks or headdresses, or nipple tassels, among other things. These bodies never pretend to engage social realities or cultural specificity, although they all allude to them. Lucha VaVoom rather capitalizes on stereotypes and exoticist modes of representation, using a good dose of parody to instill fun and incite laughter in the audience. As I have argued elsewhere, however, Lucha VaVoom might also unwittingly serve to mask persistent gender, sexual, and ethnical/racial tensions and divert focus away from sociopolitical issues—discrimination and unequal access as well as gender, sexual, and

ethnic/racial privileges, among others—that are very far from being resolved through alluringly celebrating different bodies.[73]

At a Lucha VaVoom event, the architectural motifs of the Mayan Theater, lucha libre wrestling, Aztec and Mayan mummies appearing in Lucha VaVoom posters, and the Mesoamerican world present in the cine de luchadores instigate a spectral process of unfolding.[74] There is a shadow cast by the absence of the parodic evocations of the indigenous, exoticist modes of representation and, if we follow Joaquín Barriendos closely, a coloniality of seeing, which "consists of a series of heterarchical superpositions, derivations and recombinations, which interconnect, in their discontinuity, the fifteenth century with the 21st century."[75]

One could imagine a speculative film of the not (yet) existing cine de Lucha VaVoom genre: a group of luchadorxs, *buxoticas*, singers, dancers, and cyborgs are able to physically transform themselves at any given moment.[76] There are spin-offs, domino effects, and chain reactions that emerge from their experiments, fighting, singing, and dancing. The film's middle section is not yet written, but it begins with the message that this group had prevented the triple colonization of California. Through aerial maneuvers and persistence, the group would effectively intervene in relocating Native Americans and privatizing native land during Spanish, Mexican, and U.S. occupations. Their heroic efforts prevent the erasure of the 90 percent of the native sacred sites in coastal Southern California; the end of the film takes place in Yangna, which would never become known as downtown Los Angeles.[77] Similarly to *El tesoro de Moctezuma*, specters of a past that never took place have been awakened. These specters demand to see beyond the present, to know histories, and to draw from the past in a way that gives us the capacity to look forward—to see that most changes are often unforeseen.

SPECIFIC MASKS IN SPECIFIC TIMES

As this chapter sets out to show, the Mayan Theater's architecture as travestismo cultural has not remained consistent over time; rather, it has been doing cultural work through performative, embodied, and discursive acts in specific moments, both on- and offscreen. Beneath the nationalist "American" mask of incorporating a distant indigenous Mesoamerican lurked the ghostly presence-made-absence of the local indigenous. Through donning a Spanish-language mask, the Mayan Theater allowed for an inclusive space of togetherness for a community to think, feel, listen to, and speak in the language it felt most comfortable with, and so this space might have even transformed itself into a politicized one.[78] And more recently, the use of a mask of diversity in the setting and context of Lucha VaVoom has been providing a space for complex, transnational, and often contradictory subject positions as they take "place in between the very space of an established hierarchy of sexuality, gender, and ethnicity/race on which sexual, gender and ethnic/racial diversity is predicated."[79] The Mayan Theater

as travestismo cultural has been a space where multiple discourses and performances of identity and/or culture have been and will be negotiated, be it in Spanish, Spanglish, Chicano Spanish, Chicano English, Tex-Mex, or English, among many other languages. These specific travestismos culturales are ambiguous and complex; they overlap with, refer to, and cite numerous shifts, focuses, and/or tensions within the historical and current context of Los Angeles. Through the phantasmagoric return of the indigenous "other" in the form of an exoticist fetish-merchandise, the violent logic of settler colonialism in the United States and colonialism in Mesoamerica is omitted, dissolved, and/or mystified. Nonetheless, as I argue here, the performative aspect of the Mayan Theater's travestismo cultural has enabled it, on the one hand, to construct itself through a complex, contradictory, superimposition of phantasmatic referential processes and, on the other hand, to shift its very own conditions. Through donning different masks, the audience has also been able to constitute itself differently in relation to the Mayan Theater and its program. Several other configurations of the space have taken place throughout the theater's history, beyond the ones discussed here. Aside from exploring the implications these formations may hold, it also remains to be seen what other masks are held in reserve in the days to come.

NOTES

1. Since its opening in 1927, the theater has changed its name three times: the Mayan Theater, the Fabulous Mayan (in the 1970s), and the Mayan (since the 1990s).

2. Julien B. Mitchell, "Night View of Mayan Theater Exterior," 1949, Los Angeles Public Library Photo Collection.

3. *La Opinión* is a Spanish-language daily newspaper published in Los Angeles that has included cinema coverage since its establishment in 1926. For more, see Colin Gunckel, *Mexico on Main Street: Transnational Film Culture in Los Angeles before World War II* (New Brunswick, N.J.: Rutgers University Press, 2015), 34–35.

4. Yolanda Alaniz and Megan Cornish, *Viva la Raza: A History of Chicano/a Identity and Resistance* (Seattle: Red Letter Press, 2008), 25.

5. Alaniz and Cornish, 66. Three years before, in 1946, the *Mendez, et al. v. Westminster, et al.* case finally ended legal segregation of Chicanas/os in California schools, and it was not until the 1970s that a federal appeals court declared that they saw no reason to consider that ethnic segregation is less detrimental than racial segregation.

6. In her essay "Studying Visual Culture," Irit Rogoff encourages the use of "the curious eye" rather than "the good eye" of connoisseurship: "Curiosity implies a certain unsettling, a notion outside the realm of the known—of things not quite yet understood or articulated." For more, see Irit Rogoff, "Studying Visual Culture," in *The Visual Culture Reader*, ed. Nicholas Mirzoeff (London: Routledge, 1998), 24–36. From 1952 to 1983, the golden age of the cine de luchadores produced approximately three hundred lucha libre movies. In these movies, the luchadores liberate the world from crazy scientists, monsters, aliens, vampires, mummies, and other infamous threats. Lucha libre movies are still made nowadays, but they are far less popular than during their golden years. For more on the cine de luchadores, see Nelson Carro, *El cine de luchadores* (México, D.F.: Filmoteca de la UNAM, 1984); and Raúl Criollo, José Xavier Nava, and Rafael Aviña, *¡Quiero ver sangre! Historia ilustrada del cine de luchadores* (Mexico City: UNAM, 2012).

7. Mariana Botey, "The Enigma of Ichcateopan: The Messianic Archive of the Nation," in *Frozen Tears III: Gay Prophecy of the Demonically Social*, ed. John Russel (Birmingham: ARTicle Press, 2005), 314. Italics in the original.

8. Mariana Botey, *Zonas de disturbio: Espectros del México indígena en la modernidad* (Ciudad de México: Siglo veintiuno editores, 2014).

9. Joaquín Barriendos, "La colonialidad del ver: Hacia un nuevo diálogo visual interepistémico," *Nomádas* 35 (October 2011): 23. Translation from Spanish: "Irrupciones fantasmagóricas a partir de las cuales el primitivismo apareció y reapareció en el arte, la literatura y la política bajo la forma de una mercancía-fetiche exotista."

10. Francisco "Pancho" Cornejo (1892–1963) was an interior designer, architect, and fashion and costume designer. Between 1911 and 1930, he lived and worked in Los Angeles. In Mexico he made, along with Ramon Valdiosera, the regional costume of Baja California between 1952 and 1954. He worked for public relations of the Huasteca Petroleum Company. He was the owner of the Rancho del Artista in the neighborhood of Colonia del Valle in Mexico City, where artists, designers, and people from cultural circles gathered for parties, exhibitions, and other meetings. The Rancho del Artista was a landmark of which little is known, but it attracted personalities such as Diego Rivera, David Alfaro Siqueiros, Dr. Atl, José Clemente Orozco, and Miguel Covarrubias, among many others. I would like to thank the curator, art critic, and writer Ana Elena Mallet for the email exchange about Francisco Cornejo.

11. Ruth Anne Phillips, "'Pre-Columbian Revival': Defining and Exploring a U.S. Architectural Style, 1910–1940" (PhD diss., City University of New York, 2007), 195; Nina Hoechtl, "El Teatro Maya como travestismo cultural: Una lectura performativa y descolonizadora de su arquitectura," *Extravío. Revista electrónica de literatura comparada* 7 (2015): 124.

12. "Mayan Changes from Drama to Talking Films," *Los Angeles Times*, August 16, 1929, A11.

13. Before Frank Fouce (1899–1962) purchased the Mayan Theater, he had also been a consultant of the Motions Picture Division (MPD) of Nelson Rockefeller's Office (RKO) of the Coordination of Inter-American Affairs (OCIAA). In this role, in early 1942, Fouce and RKO vice president Joseph Breen toured Mexico's motion picture facilities in order to investigate if cooperating with the motion picture industry in the United States would be possible. See Seth Fein, "Myth of Cultural Imperialism and Nationalism in Golden Age Mexican Cinema," in *Fragments of a Golden Age: The Politics of Culture in Mexico Since 1940*, ed. Gilbert Joseph, Anne Rubenstein, and Eric Zolov (Durham, N.C.: Duke University Press, 2001), 166. As such, Fouce had access to firsthand information about U.S.-Mexico transnational relations and collaborations leading to the Golden Age of Mexican cinema. It might be that this vast Spanish-language movie production influenced Fouce to renounce the California Theater rather than expand his theater chain through purchasing the Mesoamerican-themed Mayan Theater in late 1948 and sublease the Million Dollar Theater in 1949, which also ran as a Spanish-language movie house and vaudeville theater. When Fouce died in 1962, the policy continued under his son, Frank L. Fouce Jr., who bought the Million Dollar Theater in 1969. "Teatro Maya," advertisement, *La Opinión*, February 29, 1949. Translation from Spanish: "El 'Maya' será nuestra casa, será el escaparate en que expongamos ante propios y extraños lo mejor de lo nuestro. La inmensa población de habla española, tiene AL FIN, EL TEATRO QUE SOÑAMOS PARA ELLA." By 1930, the Mexican immigrant population had grown to more than 97,000 individuals. See Eduardo Obregón Pagán, *Murder at the Sleepy Lagoon: Zoot Suits, Race, and Riot in Wartime L.A.* (Chapel Hill: University of North Carolina Press, 2004) 28.

14. In December 1969, Frank L. Fouce Jr. sold the Mayan Theater for about $300,000 to the director, producer, and actor Carlos Tobalina (1925–1989), who owned the theater until his death in 1989 ("Mayan Sold for $300,000," *Los Angeles Times*, November 9, 1969, J2). Tobalina's widow leased the theater to Daniel Sullivan and Sammy Chao. The latter still manages it today. As an adult porn theater, The Fabulous Mayan not only screened but also shot

adult movies in its basement. See Georg Stein, "Old Mayan Theater May Retrieve Glory," *Los Angeles Times*, June 11, 1989. For more about lucha libre in Mexico, see Janina Möbius, *Und unter der Maske... das Volk. LUCHA LIBRE—Ein mexikanisches Volksspektakel zwischen Tradition und Moderne* (Frankfurt/Main: Vervuert Verlag, 2004); Heather Levi, *The World of Lucha Libre: Secrets, Revelations, and Mexican National Identity* (Durham, N.C.: Duke University Press, 2008); and Nina Hoechtl, "If Only for the Length of a Lucha: Queer/ing, Mask/ing, Gender/ing and Gesture in Lucha Libre" (PhD diss., Goldsmiths, University of London, 2012), among others. Besides their events at the Mayan, Lucha VaVoom has sold out one-thousand-seat venues in Amsterdam, Calgary, Toronto, San Francisco, New York, Chicago, Seattle, Portland, and Philadelphia.

15. Hoechtl, "Teatro Maya como travestismo cultural," 103–130.

16. Jossianna Arroyo, *Travestismos culturales: Literatura y etnografía en Cuba y Brasil* (Pittsburgh: Instituto Internacional de Literatura Iberoamericana, 2003), 20. Translation from Spanish: "Se articulan ambos discursos, el del acercamiento y conciliación, y el de la subordinación."

17. Stuart Hall, "Culture, the Media and the Ideological Effect," in *Mass Communication and Society*, ed. James Curran, Michael Gurevitch, and Jane Woollacott (London: Edward Arnold, 1977), 337.

18. Hall, 336–38.

19. "Teatro Maya," advertisement, *La Opinión*, 1949. Translation from Spanish: "Tesoro de arte mexicano, creación del gran artista Francisco Cornejo, [y] centro lógico de las manifestaciones artísticas de nuestra raza."

20. Gunckel, *Mexico on Main Street*, 170–175.

21. Gunckel, 171–173.

22. "New Theater Completed," *Los Angeles Times*, July 31, 1927, E5. Today the construction would cost approximately $10,190,000. The Mayan Revival movement is inspired by the architecture and iconography of pre-Hispanic cultures of Mesoamerica and/or the Andes and reached its peak between the 1920s and 1940s.

For more, see Manuel Amábilis, *La arquitectura precolombina de México* (México, D.F.: Orion, 1956); Barbara Braun, *Pre-Columbian Art and the Post-Columbian World: Ancient American Sources of Modern Art* (New York: Harry N. Abrams, 1993); Marjorie Ingle, *The Mayan Revival Style: Art Deco Mayan Fantasy* (Salt Lake City: Gibbs M. Smith and Peregrine Smith Books, 1984); Jesse Lerner, *The Maya of Modernism: Art, Architecture, and Film* (Albuquerque: University of New Mexico Press, 2011); and Phillips, "'Pre-Columbian Revival.'"

23. R. Tripp Evans, *Romancing the Maya* (Austin: University of Texas Press, 2004), 7.

24. Edgar Lloyd Hampton, "American Architecture First," *Los Angeles Times*, April 24, 1927, J1. The literature that attaches a nationalistic emphasis to the use of indigenous American forms in U.S. art and architecture is too extensive to cite in its entirety here. Representative examples include Rose Henderson, "A Primitive Basis for Modern Architecture," *Architectural Record* 54, no. 2 (1923): 189–196; Robert Stacy-Judd, "Move for True American Architecture Growing: Local Man's Dream of Recalling Mayan Civilization Reflected in New Building Trends," *Los Angeles Times*, August 20, 1923; and Alfred C. Bossom and E. H. Ries, "New Styles in American Architecture: And What We Might Learn from the Mayas," *World's Work* 56, no. 2 (1928): 189–195.

25. Lloyd Hampton, "American Architecture First," J1.

26. Lloyd Hampton, J1.

27. Arroyo, *Travestismos culturales*, 119.

28. Evans, *Romancing the Maya*, 89.

29. Hoechtl, "Teatro Maya como travestismo cultural," 124.

30. Botey, "Enigma of Ichcateopan," 313, emphasis in the original.

31. Botey, 313.

32. Mariana Botey, *Zonas de disturbio*. William Deverell portrays Los Angeles through shifting ideas of race and ethnicity, considering six different developments in the history of the city. He shows that Los Angeles is a city that wished for what it worked diligently to invent, and that inventing, in part, entailed the whitewashing of other stories, other cultures, and other people's memories. For more, see William Deverell, *Whitewashed Adobe: The Rise of Los Angeles and the Remaking of Its Mexican Past* (Berkeley: University of California Press, 2004).

33. Botey, "Enigma of Ichcateopan," 313–314, emphasis in the original.

34. "Teatro Maya," advertisement, *La Opinión*, 1949. Translation from Spanish: "Ese teatro, que en otras circunstancias hubiera costado cerca de dos millones de dólares, ha sido obtenido a través de una serie de sacrificios y de esfuerzos, con el objetivo de convertirlo en escaparate para el Arte de Nuestra América: de la América que todavía piensa, siente y habla en español."

35. Phillips argues that by 1940, there was a waning interest in pre-Columbian aesthetics as modernism and abstract expressionism took hold and as the United States focused on the events of World War II. For more, see Phillips, "'Pre-Columbian Revival.'" Between 1942 and 1964, the bilateral bracero temporary worker program issued 4.6 million temporary visas to Mexican workers. For more, see Marc R. Rosenblum, *Mexican Migration to the United States: Policy and Trends* (Washington, D.C.: Congressional Research Service, 2012), https://www.fas.org/sgp/crs/row/R42560.pdf.

36. "Teatro Maya" advertisement, *La Opinión*, 1949.

37. "Rubén Darío—A Roosevelt," Casa Poema, accessed October 18, 2016, http://judithpordon.tripod.com/poetry/ruben_dario_a_roosevelt.html.

38. Thanks to Lisa Jarvinen for pointing out these references.

39. "Teatro Maya," advertisement, 1949. Colin Gunckel, "The War of the Accents: Spanish Language Hollywood Films in Mexican Los Angeles," *Film History* 20, no. 3 (2008): 339.

40. For more, see Hoechtl, "Teatro Maya como travestismo cultural." As Carlos Sanchez points out, many first- and second-run theater owners in certain parts of California and Texas had no interest in running Spanish-language movies, even when potential revenue from Mexican immigrant populations was high. Moreover, Hispanics and African Americans had to stand in the balcony while white spectators sat in the orchestra section. Carlos Sanchez, "The 'Golden Age' of Spanish-Language Theaters in Los Angeles: The Formation of a Transnational Cinema Audience," *Film Matters* 6, no. 1 (March 2015): 38–44.

41. Gunckel, *Mexico on Main Street*, 142.

42. "Teatro Maya," advertisement, 1949. Translation from Spanish: "Ya está, pues, el TEATRO MAYA, a disposición del Público Latinoamericano. Nosotros hemos hecho nuestra parte. Ahora toca a ustedes decidir si será la empresa firme y honrosa que queremos que sea, o el fracaso de todos nuestros esfuerzos y de todas nuestras ilusiones."

43. Fouce had gained experience in such different exhibition practices since 1933, when he organized for his recently leased California Theater "a gala premiere reminiscent of those prevalent during the heyday of Spanish-language Hollywood, complete with special appearances by tenor José Mojica and comedians Laurel and Hardy." Gunckel, *Mexico on Main Street*, 149. Gunckel shows that in the context of exhibition, the 1930s had seen the emergence of an ongoing relationship among radio programming, vaudeville, and film production.

44. Georg Stein, "Old Mayan Theater," 1998.

45. "El Maya, proximo a abrirse, presentara 'El Alma Del Tango' libertad lamarque," *La Opinión*, February 23, 1949, microfilm. Translation from Spanish: "Pero ahora la van a ver en persona. Oirán su voz, no a través de los micrófonos, ni de las sincronizaciones de la película, sino directamente."

46. Gunckel, "War of the Accents," 325–343.

47. "Por los teatros Fouces," *La Opinión*, December 23, 1951; April 20, 1952; March 7, 1954, microfilm.

48. "Si fuera diputado," advertisement, *La Opinión*, April 28, 1952, microfilm; "Por mis pistolas," advertisement, *La Opinión*, January 1968, microfilm.

49. "¡Mujeres! ¡Mujeres! ¡Mujeres!," advertisement, *La Opinión*, February 28, 1968, microfilm.

50. As the article "Otra pelicula de Santo en el Cine Maya" mentions that Santo will star in *Santo vs el estrangulador* but the advertisement shows the title *Santo contra el espectro del estrangulador* (*The Specter of the Strangler*; René Cardona, 1963), there remains uncertainty about which movie was programmed. "Santo contra el ESPECTRO," advertisement, *La Opinión*, January 21, 1968.

51. El Santo's wrestling career spanned from 1942 to 1982, during which time he became a hero and a symbol of justice through his appearances in comic books (1952–1987) and starred in fifty-two movies (1958–1982). El Santo's son followed him into wrestling as El Hijo del Santo (Son of Santo).
For more, see, among others, Ulíses Delgado and Hugo Ocampo, "El Cine de Luchadores: Santo el Enmascarado de Plata. Propuesta para su Análisis" (bachelor's thesis, Universidad del Valle de México, 1994); Carlos Monsiváis, *Los rituales del caos* (Mexico City: Biblioteca Era, 1995).

52. "Otra pelicula de Santo en el Cine Maya," *La Opinión*, January 21, 1968, microfilm. Translation from Spanish: "No hay figura más dinámica en el cinema mexicano que la de Santo, 'El Enmascarado de Plata,' quien se presenta nuevamente en una película intitulada 'Santo vs El Estrangulador,' donde el luchador y flamante astro de la pantalla alterna los papeles centrales con el cantante Alberto Vázquez y la bella María Duval."

53. Carro, *Cine de luchadores*, 47.

54. In the same year, the Mayan Theater programmed *El tesoro de Moctezuma* (*The Treasure of Moctezuma*; René Cardona, 1966) in April with El Santo and *Las diabólicas* (*The Diabolical Women*; Chano Urueta, 1966) in November with the second-biggest luchador in Mexico, Blue Demon, who starred in twenty-five movies, of which nine are with El Santo. "El tesoro de Moctezuma," advertisement, *La Opinión*, April, 28 1968, microfilm; "Las diabolicas," advertisement, *La Opinión*, November 17, 1968, microfilm.

55. "El tesoro de Moctezuma," Filmaffinity, accessed November 20, 2017, https://www.filmaffinity.com/mx/reviews/1/992493.html.

56. Texcoco was a natural lake within the Anáhuac, or Valley of Mexico. It is best known as the place where the Mexicans built the city of Tenochtitlán, which was located on an island within the lake. During Spanish colonization, efforts to control flooding led to most of the lake being drained.

57. The Penacho—allegedly from one of the last Mexica leaders, Moctezuma Xocoyotzin— has been part of the collection of the Weltmuseum in Vienna since 1878 despite ongoing requests to return it to Mexico. In 2014, a team of experts from the Institute of Aesthetic Studies/UNAM, the National Institute of Anthropology and History (INAH), in Mexico and the Weltmuseum in Austria argued that the Penacho is too fragile to be transported. For more, see Khadija von Zinnenburg, "The Inbetweenness of the Vitrine: Three Parerga of a Feather Headdress," in *The Inbetweenness of Things: Materializing Mediation and Movement between Worlds*, ed. Paul Basu (New York: Bloomsbury, 2017), 23–36.

58. Particularly revealing in this regard is the role that some films found in the cine de luchadores, Mexican horror, or Mexploitation subgenres play in a greater narrative, one that seems to be able to clearly identify what is to be rescued from the past and highlight and fight off the supernatural, superstitious, traditional, or debauched evils and dangers of this very same past and/or foreign, imperialist, neocolonial aggressions threatening the modernization of Mexico.
For more, see Doyle Green, *Mexploitation Cinema: A Critical History of Mexican Vampire, Wrestler, Ape-Man and Similar Films, 1957–1977* (Jefferson, N.C.: McFarland, 2005); Andrew Syder and Dolores Tierney, "Importation/Mexploitation; Or, How a Crime-Fighting, Vampire-Slaying Mexican Wrestler Almost Found Himself in an Italian Sword-and-Sandals

Epic," in *Horror International*, ed. Steven Jay Schneider and Tony Williams (Detroit, Mich.: Wayne State University Press, 2005), 33–55.

59. Syder and Tierney, "Importation/Mexploitation," 33.

60. These clips are specially produced by the Lucha VaVoom crew in relation to its theme nights—Valentine's Day, Cinco de Mayo (May 5), summertime, and Halloween.

61. Tony Kay, "Sexo y Violencia Come to the Showbox SoDo Sunday: Lucha VaVoom!," *SunBreak*, May 13, 2010, http://thesunbreak.com/2010/05/13/sexo-y-violencia-come-to-the -showbox-sodo-sunday-lucha-vavoom/.

62. Kay.

63. Kay.

64. Stephanie Nolasco, "Q&A Sessions: Lucha VaVoom," NocheLatina, June 15, 2010, http://www.nochelatina.com/Articles/6656/Interview-with-Lucha-VaVooms-Rita-D-Albert -Cassandro-and-Liz-Fairbairn.

65. Hoechtl, "Teatro Maya como travestismo cultural," 122; Nina Hoechtl, "Wrestling with Burlesque, Burlesquing Lucha Libre," in *Performance and Professional Wrestling*, ed. Broderick Chow, Eero Laine, and Claire Warden (New York: Routledge, 2016), 70–82.

66. Hoechtl, "Wrestling with Burlesque," 73.

67. Hoechtl, 73.

68. Jack Citrin and David O. Sears, *American Identity and the Politics of Multiculturalism* (New York: Cambridge University Press, 2014), 47.

69. "Racial/Ethnic Composition, Los Angeles County, 1990–2010 Census," Los Angeles Almanac, accessed January 4, 2016, http://www.laalmanac.com/population/po13.htm.

70. Tina Norris, Paula L. Vines, and Elizabeth M. Hoeffel, "The American Indian and Alaska Native Population: 2010," United States Census Bureau, accessed November 4, 2017, https://www.census.gov/prod/cen2010/briefs/c2010br-10.pdf.

71. Arroyo, *Travestismos culturales*, 5.

72. Arroyo, 5. Translation from Spanish: "La integración del cuerpo del otro en el discurso nacional plantea los problemas de la representación-racial, sexual y de género-de ese cuerpo y las distintas máscaras a las que tiene que recurrir el sujeto."

73. Hoechtl, "Wrestling with Burlesque," 73.

74. In the following movies, luchadorxs protect Mexico's precolonial heritage: *El tesoro de Moctezuma* (René Cardona and René Cardona Jr., 1966) and *Lucha a muerte* (Fernando Pérez Gavilán, 1992). They often fight against Aztec or Mayan mummies who are resurrected through the negligence or ignorance of archaeologists, who are often foreigners and malevolent: *La momia azteca* (*The Aztec Mummy*; Rafael Portillo, 1957), *La maldición de la momia azteca* (*The Curse of the Aztec Mummy*; Rafael Portillo, 1957), *La momia Azteca contra el robot humano* (*The Aztec Mummy against the Humanoid Robot*; Rafael Portillo, 1958), *Santo en la venganza de la momia* (*Santo and the Vengeance of the Mummy*; René Cardona, 1970), and *Las luchadoras contra la momia* (*Wrestling Women versus the Aztec Mummy*; René Cardona, 1964).

75. Barriendos, "Colonialidad del ver," 16. Translation from Spanish: "Consiste en una serie de superposiciones, derivaciones y recombinaciones heterárquicas, las cuales interconectan, en su discontinuidad, el siglo XV con el Siglo XXI."

76. This genre would try to visualize fragments of what Gayatri Chakravorty Spivak proposes as the end of the ghost dance in order "to make a common multinational figured past return through the ghostly agency of haunting so that a future can dictate actions as if already there as a 'before.'" Spivak, "From Ghostwriting," in *The Spectralities Reader*, ed. María del Pilar Blanco and Esther Peeren (New York: Bloomsbury, 2013), 323.

77. Dina Gilio-Whitaker, "Native Americans in L.A. Almost Saw Their Culture Erased—Now They're Getting It Back," *LA Weekly*, November 21, 2016, http://www.laweekly.com/ content/printView/7627340.

At UCLA's American Indian Studies Center, the project "Mapping Indigenous Los Angeles"—with direct participation of all indigenous communities who call Los Angeles

home—intends, among other things, to reclaim the city's names before settler colonialism. See the project home page at https://mila.ss.ucla.edu.

78. José M. Alamillo, *Making Lemonade out of Lemons: Mexican American Labor and Leisure in a California Town, 1880–1960* (Urbana: University of Illinois Press, 2006), 89.

79. Hoechtl, "Wrestling with Burlesque," 78.

ACKNOWLEDGMENTS

This book grew out of research for the UCLA Film & Television Archive's program "Recuerdos de un cine en español: Latin American Cinema in Los Angeles 1930–1960," a forty-film retrospective in Los Angeles curated by Alejandra Espasande Bouza, María Elena de las Carreras, Colin Gunckel, and Jan-Christopher Horak. The exhibition was part of "Pacific Standard Time II: Latin America / Los Angeles," funded by the Getty Foundation and Bank of America. We would also like to thank the UCLA Film & Television Archive staff who made "Recuerdos" possible: Roberto Green Quintana, Kelly Graml, Jennifer Rhee, Paul Malcolm, K. J. Relth, and Mark Quigley.

There are a number of people who contributed specifically to the production of this anthology. We would first like to thank Paulina Suárez-Hesketh for her contributions to an earlier version of this manuscript. We are also grateful to Laura Isabel Serna for serving as a respondent on our panel at the 2016 Society for Cinema and Media Studies conference that focused on this anthology and featured several of our contributors. We also appreciate the insightful comments and questions from the audience that helped shape and refine this effort. While the curators and archive staff associated with "Recuerdos" and this anthology all contributed to the considerable research the project entailed, we also owe a debt of gratitude to Viviana García Besné and Alistar Tremps at the Permanencia Voluntaria in Tepoztlán, Mexico, for providing us access to their archival materials and offering generous assistance throughout the process.

Colin Gunckel and Lisa Jarvinen would also like to thank their respective institutions—the University of Michigan and La Salle University—for generous leaves that allowed time for the research that made this anthology possible. There are also many individuals whose feedback, input, and support were indispensable: Ernesto Chávez, Liaa Raquel Cruz, Robert Dickson at the

Academy of Motion Pictures Arts and Sciences Margaret Herrick Library, Rielle Navitski, Nicolas Poppe, Dolores Tierney, and the anonymous reader for Rutgers University Press. Lastly, we are eternally grateful to Leslie Mitchner for her unflagging dedication to this project and for moving this book to completion. Thank you!

BIBLIOGRAPHY

Abel, Richard. "History Can Work for You, If You Know How to Use It." *Cinema Journal* 44, no. 1 (2004): 107–112.

Agrasánchez, Rogelio, Jr. *Mexican Movies in the United States: A History of the Films, Theatres, and Audiences, 1920–1960.* Jefferson, N.C.: McFarland, 2006.

Alamillo, José M. *Making Lemonade out of Lemons: Mexican American Labor and Leisure in a California Town, 1880–1960.* Urbana: University of Illinois Press, 2006.

Alaniz, Yolanda, and Megan Cornish. *Viva la Raza: A History of Chicano/a Identity and Resistance.* Seattle: Red Letter Press, 2008.

Alcerreca, Rafael. *Una mirada a los Estudios Churubusco. Un regard sur les Studios Churubusco.* Mexico City: Estudios Churubusco Azteca, 2002.

Alonso, Enrique. *María Conesa.* Mexico City: Océano, 1987.

Alonzo, Juan J. *Badmen, Bandits, and Folk Heroes: The Ambivalence of Mexican American Identity in Literature and Film.* Tucson: University of Arizona Press, 2009.

Alvarado, Manuel, Ana M. López, and John King, eds. *Mediating Two Worlds: Cinematic Encounter in the Americas.* London: Verso, 1993.

Amábilis, Manuel. *La arquitectura precolombina de México.* Mexico City: Orion, 1956.

Amaya, Hector. *Citizenship Excess: Latino/as, Media, and the Nation.* New York: New York University Press, 2013.

Andrews, David. *Theorizing Art Cinemas: Foreign, Cult, Avant-Garde and Beyond.* Austin: University of Texas Press, 2013.

Antonio Paranaguá, Paulo, ed. *Mexican Cinema.* London: British Film Institute, 1995.

Arroyo, Jossianna. *Travestismos culturales: Literatura y etnografía en Cuba y Brasil.* Pittsburgh: Instituto Internacional de Literatura Iberoamericana, 2003.

Avila, Jacqueline. "Arcady Boytler: *La mujer del puerto* (1933)." In *Clásicos del cine mexicano,* edited by Christian Wehr, 57–70. Frankfurt: Editorial Vervuert Verlag, 2015.

———. "Juxtaposing *teatro de revista* and *cine*: Music in the 1930s *comedia ranchera.*" *Journal of Film Music* 5, no. 1–2 (2012): 119–124.

———. "*México de mis inventos*: Salon Music, Lyric Theater, and Nostalgia in *Cine de añoranza porfiriana.*" *Latin American Music Review* 38, no. 1 (Spring 2017): 1–27.

———. "Los sonidos del cine: Cinematic Music in Mexican Film, 1930–1950." PhD diss., University of California, Riverside, 2011.

Aviña, Rafael. *Aquí está su pachucote . . . ¡Noooo! Biografía narrative de Germán Valdés*. Mexico City: Consejo Nacional para la Cultura y las Artes, 2009.

Barnard, Tim, ed. *Argentine Cinema*. Toronto: Nightwood Editions, 1986.

Barriendos, Joaquín. "La colonialidad del ver: Hacia un nuevo diálogo visual interepistémico." *Nómadas* 35 (October 2011): 13–29.

Beezley, William H. *Judas at the Jockey Club and Other Episodes of Porfirian Mexico*. Lincoln: University of Nebraska Press, 2004.

Beltrán, Mary C. *Latina/o Stars in U.S. Eyes: The Making and Meanings of Film and TV Stardom*. Champaign: University of Illinois Press, 2009.

Berg, Charles Ramírez. *The Classical Mexican Cinema: The Poetics of the Exceptional Golden Age Films*. Austin: University of Texas Press, 2015.

———. *Latino Images in Film: Stereotypes, Subversion, and Resistance*. Austin: University of Texas Press, 2002.

Bergfelder, Tim. *International Adventures: German Popular Cinema and European Co-productions in the 1960s*. New York: Berghahn, 2004.

Bossom, Alfred C., and E. H. Ries. "New Styles in American Architecture: And What We Might Learn from the Mayas." *World's Work* 56, no. 2 (1928): 189–195.

Botey, Mariana. "The Enigma of Ichcateopan: The Messianic Archive of the Nation." In *Frozen Tears III: Gay Prophecy of the Demonically Social*, edited by John Russel, 299–336. Birmingham: ARTicle Press, 2005.

———. *Zonas de disturbio: Espectros del México indígena en la modernidad*. Mexico City: Siglo veintiuno editores, 2014.

Braun, Barbara. *Pre-Columbian Art and the Post-Columbian World: Ancient American Sources of Modern Art*. New York: Harry N. Abrams, 1993.

Braun, Marta, Charlie Keil, Rob King, Paul Moore, and Louis Pelletier. *Beyond the Screen: Institutions, Networks, and Publics of Early Cinemas*. Bloomington: Indiana University Press, 2016.

Brégent-Heald, Dominique. *Borderland Films: American Cinema, Mexico, and Canada during the Progressive Era*. Lincoln: University of Nebraska Press, 2015.

Bunker, Steve. *Creating Mexican Consumer Culture in the Age of Porfirio Díaz*. Albuquerque: University of New Mexico Press, 2012.

Bustillo Oro, Juan. *Vida cinematográfica*. Mexico City: Cineteca Nacional, 1984.

Calderón Brothers Estate Collection. Papers. Permanencia Voluntaria, Tepoztlán, Mexico.

Carro, Nelson. *El cine de luchadores*. Mexico City: Filmoteca de la UNAM, 1984.

Castillo, Luciano, and Édgar Soberón Torchia. "Cine hispano en Hollywood." In *Los cines de América Latina y el Caribe*, vol. 1, *1890–1969*, edited by Édgar Soberón Torchia, 58–62. San Antonio de los Baños: Ediciones EICTV, 2012.

Chanan, Michael. *The Cuban Image*. London: British Film Institute, 1985.

Citrin, Jack, and David O. Sears. *American Identity and the Politics of Multiculturalism*. New York: Cambridge University Press, 2014.

Contreras Torres, Miguel. *El libro negro del cine mexicano*. Mexico City: Edición del Autor, 1960.

Criollo, Raúl, José Xavier Nava, and Rafael Aviña. *¡Quiero ver sangre! Historia ilustrada del cine de luchadores*. Mexico City: UNAM, 2012.

Curtin, Michael. "Media Capital: Towards the Study of Spatial Flows." *International Journal of Cultural Studies* 6, no. 2 (June 2003): 202–228.

Dávila, Arlene. *Latinos, Inc.: The Making and Marketing of a People and a Culture.* Berkeley: University of California Press, 2001.

De Groof, Matthias. "Intriguing African Storytelling: On *Aristotle's Plot* by Jean-Pierre Bekolo." In *Storytelling in World Cinemas*, vol. 1, *Forms*, edited by Lina Khatib, 115–134. London: Wallflower Press, 2012.

Del Amo Estate Company Collection. Papers. Archives and Special Collections, California State University Dominguez Hills, Carson, Calif.

de la Mora, Sergio. *Cinemachismo: Masculinities and Sexuality in Mexican Cinema.* Austin: University of Texas Press, 2006.

de la Vega, Eduardo. "José Bohr en Hollywood." *Dicine: Revista de Diffusion e Investigacion Cinematograficas* 45 (May 1992): 18–19.

———. "Origins, Development and Crisis of the Sound Cinema (1929–64)." In *Mexican Cinema*, edited by Paulo Antonio Paranaguá, 79–93. London: British Film Institute, 1995.

———. *Pioneros del cine sonoro.* Vol. 1, *Gabriel Soria 1903–1971.* Guadalajara: Universidad de Guadalajara, 1992.

———. *Pioneros del cine sonoro.* Vol. 2, *Arcady Boytler 1863–1965.* Guadalajara: Universidad de Guadalajara, 1992.

Deleyto, Celestino. *From Tinseltown to Bordertown: Los Angeles on Film.* Detroit, Mich.: Wayne State University Press, 2017.

Delgado, Ulíses, and Hugo Ocampo. "El Cine de Luchadores: Santo el Enmascarado de Plata. Propuesta para su Análisis." Bachelor's thesis, Universidad del Valle de México, 1994.

de los Reyes, Aurelio. *Con Villa en México: Testimonios sobre camarógrafos norteamericanos en la revolución.* Mexico City: Universidad Autónoma de México, 1985.

———. *Medio siglo de cine mexicano (1896–1947).* Mexico City: Editorial Trillas, 1987.

del Valle, José. "US Latinos, *la hispanofonía*, and the Language Ideologies of High Modernity." In *Globalization and Language in the Spanish-Speaking World: Macro and Micro Perspectives*, edited by Clare Mar-Molinero and Miranda Stewart, 27–46. New York: Palgrave, 2006.

DeLyser, Dydia. *Ramona Memories: Tourism and the Shaping of Southern California.* Minneapolis: University of Minnesota Press, 2005.

de María y Campos, Armando. *El teatro de género chico en la Revolución Mexicana.* Mexico City: Biblioteca del Instituto Nacional de Estudios Históricos de la Revolución Mexicana, 1956.

Dennison, Stephanie, and Lisa Shaw. *Popular Cinema in Brazil, 1930–2001.* New York: Manchester University Press, 2004.

de Orellana, Margarita. *Filming Pancho Villa: How Hollywood Shaped the Mexican Revolution.* New York: Verso, 2004.

de Usabel, Gaizka S. "American Films in Latin American: The Case History of United Artists Corporation, 1919–1951." PhD diss., University of Wisconsin–Madison, 1975.

———. *The High Noon of American Films in Latin America.* Ann Arbor, Mich.: UMI Research Press, 1982.

Dever, Susan. *Celluloid Nationalism and Other Melodramas: From Post-revolutionary Mexico to fin de siglo Mexamérica.* Albany: State University of New York Press, 2003.

Deverell, William. *Whitewashed Adobe: The Rise of Los Angeles and the Remaking of Its Mexican Past.* Berkeley: University of California Press, 2004.

Dueñas, Pablo. *Las divas en el teatro de revista mexicano*. Mexico City: Asociación mexicana de estudios fonográficos, 1994.

Durovicová, Nataša. "The Hollywood Multilinguals." In *Sound Theory, Sound Practice*, edited by Rick Altman, 38–53. New York: Routledge, 1992.

Ehrenberg, Ilya. *Die Traumfabrik: Kronik des Films*. Berlin: Malik-Verlag, 1931.

Eleftheriotis, Dmitris. *Popular Cinemas of Europe: Texts, Contexts and Frameworks*. New York: Continuum, 2001.

España-Maram, Linda. *Creating Masculinity in Los Angeles's Little Manila: Working-Class Filipinos and Popular Culture, 1920s–1950s*. New York: Columbia University Press, 2006.

Esterrich, Carmelo, and Angel M. Santiago-Reyes. "De la carpa a la pantalla: Las mascaras de Cantinflas." *Archivos de la Filmoteca* 31 (February 1999): 48–59.

Evans, R. Tripp. *Romancing the Maya*. Austin: University of Texas Press, 2004.

Fein, Seth. "Myth of Cultural Imperialism and Nationalism in Golden Age Mexican Cinema." In *Fragments of a Golden Age: The Politics of Culture in Mexico since 1940*, edited by Gilbert Joseph, Anne Rubenstein, and Eric Zolov, 159–198. Durham, N.C.: Duke University Press, 2001.

Field, Allyson Nadia, Jan-Christopher Horak, and Jacqueline Najuma Stewart, eds. *L.A. Rebellion: Creating a New Black Cinema*. Berkeley: University of California Press, 2015.

Film Daily. *1938 Film Daily Yearbook*. New York: Film Daily, 1938.

———. *1941 Film Daily Yearbook*. New York: Film Daily, 1941.

Fregoso, Rosa Linda. *The Bronze Screen: Chicano and Chicana Film Culture*. Minneapolis: University of Minnesota Press, 1993.

Fuller, Kathryn H. *At the Movie Show: Small-Town Audiences and the Creation of Movie Fan Culture*. Washington, D.C.: Smithsonian Institution Press, 2001.

Fuller-Seeley, Kathryn H., ed. *Hollywood in the Neighborhood: Historical Case Studies of Local Moviegoing*. Berkeley: University of California Press, 2008.

Garcia, Desirée J. *The Migration of Musical Film: From Ethnic Margins to American Mainstream*. New Brunswick, N.J.: Rutgers University Press, 2014.

———. "'The Soul of a People': Mexican Spectatorship and the Transnational *Comedia Ranchera*." *Journal of American Ethnic History* 30, no. 1 (Fall 2010): 72–98.

García Canclini, Néstor. *Hybrid Cultures: Strategies for Entering and Leaving Modernity*. Minneapolis: University of Minnesota Press, 1995.

García Riera, Emilio. *Breve historia del cine mexicano. Primer siglo 1897–1997*. Mexico City: Ediciones Mapa, 1998.

———. "Cine Hispano." In *Historia documental del cine mexicano*, vol. 1, *1929–1937*, 38–44. Mexico City: Ediciones Era, 1969.

———. *Historia documental del cine mexicano*. Vols. 1–18. Mexico City: Consejo Nacional para la Cultural y las Artes, 1992.

Gaudreault, André, and Philippe Marion. *The End of Cinema? A Medium in Crisis in the Digital Age*. Translated by Timothy Barnard. New York: Columbia University Press, 2015.

Gerow, Aaron. *Visions of Japanese Modernity: Articulations of Cinema, Nation, and Spectatorship, 1895–1925*. Berkeley: University of California Press, 2010.

Girbal, Florentino Hernández. *Los que pasaron por Hollywood*. Madrid: Editorial Verdoux, 1992.

González, Reynaldo. "Introducción: Primeros tropezones del español en el cine." In *La lingua española y los medios de comunicación*, vol. 2, ed. Luis Cortés Bargalló, 735–743. Mexico City: Siglo XXI Editores, 1998.

Green, Doyle. *Mexploitation Cinema: A Critical History of Mexican Vampire, Wrestler, Ape-Man and Similar Films, 1957–1977.* Jefferson, N.C.: McFarland, 2005.

Gunckel, Colin. "Ambivalent Si(gh)tings: Stardom and Silent Film in Mexican America." *Film History* 27, no. 1 (Spring 2017): 110–139.

———. *Mexico on Main Street: Transnational Film Culture in Los Angeles before World War II.* New Brunswick, N.J.: Rutgers University Press, 2015.

———. "The War of the Accents: Spanish Language Hollywood Films in Mexican Los Angeles." *Film History* 20, no. 3 (2008): 325–343.

Gutiérrez, Laura G. *Performing Mexicanidad: Vendidas and Cabareteras on the Transnational Stage.* Austin: University of Texas Press, 2010.

Hall, Stuart. "Culture, the Media and the Ideological Effect." In *Mass Communication and Society,* edited by James Curran, Michael Gurevitch, and Jane Woollacott, 52–86. London: Edward Arnold, 1977.

Harland, Robert. "Quiero chupar tu sangre: A Comparison of the Spanish- and English-Language Versions of Universal Studios' *Dracula* (1931)." *Journal of Dracula Studies* 9 (2007). https://kutztownenglish.files.wordpress.com/2015/09/jds_v9_2007_harland.pdf.

Havens, Timothy. *Black Television Travels: African American Media around the Globe.* New York: New York University Press, 2013.

Heinink, Juan B., and Robert Dickson. *Cita en Hollywood: Antología de las películas norteamericanas habladas en español.* Bilbao: Ediciones Mensajero, 1990.

Henderson, Rose. "A Primitive Basis for Modern Architecture." *Architectural Record* 54, no. 2 (1923): 189–196.

Hershfield, Joanne. *The Invention of Dolores del Río.* Minneapolis: University of Minnesota Press, 2000.

Hershfield, Joanne, and David R. Maciel, eds. *Mexico's Cinema: A Century of Film and Filmmakers.* Wilmington, Del.: Scholarly Resources, 1999.

Hoechtl, Nina. "If Only for the Length of a Lucha: Queer/ing, Mask/ing, Gender/ing and Gesture in Lucha Libre." PhD diss., Goldsmiths, University of London, 2012.

———. "El Teatro Maya como travestismo cultural: Una lectura performativa y descolonizadora de su arquitectura." *Extravío. Revista electrónica de literatura comparada* 7 (2015). https://www.academia.edu/16896750/El_Teatro_Maya_como_travestismo_cultural._Una_lectura_performativa_y_descolonizadora_de_su_arquitectura.

———. "Wrestling with Burlesque, Burlesquing Lucha Libre." In *Performance and Professional Wrestling,* edited by Broderick Chow, Eero Laine, and Claire Warden, 70–82. New York: Routledge, 2016.

Huhndorf, Shari M. *Going Native: Indians in the American Cultural Imagination.* Ithaca: Cornell University Press, 2001.

Ingle, Marjorie. *The Mayan Revival Style: Art Deco Mayan Fantasy.* Salt Lake City: Gibbs M. Smith and Peregrine Smith Books, 1984.

Irwin, Robert, and Maricruz Ricalde, eds. *Global Mexican Cinema: Its Golden Age.* London: British Film Institute, 2013.

Jarvinen, Lisa. *The Rise of Spanish-Language Filmmaking: Out from Hollywood's Shadow, 1929–1939.* New Brunswick, N.J.: Rutgers University Press, 2012.

Johns, Michael. *The City of Mexico in the Age of Díaz.* Austin: University of Texas Press, 1997.

Johnson, Randal, and Robert Stam. *Brazilian Cinema.* New York: Columbia University Press, 1995.

Kanellos, Nicolás. *A History of Hispanic Theatre in the United States: Origins to 1940*. Austin: University of Texas Press, 1990.

Karush, Matthew B. *Culture of Class: Radio and Cinema in the Making of a Divided Argentina, 1920–1946*. Durham, N.C.: Duke University Press, 2012.

Khor, Denise. "Asian Americans at the Movies: Race, Labor, and Migration in the Transpacific West, 1900–1945." PhD diss., University of California, San Diego, 2008.

King, John, and Nissa Torrents. *Garden of Forking Paths: Argentine Cinema*. London: British Film Institute, 1988.

King, Rob. "Introduction: Early Hollywood and the Archive." *Film History* 26, no. 2 (2014): vii–xiv.

Kirby, Lynne. *Parallel Tracks: The Railroad and Silent Cinema*. Durham, N.C.: Duke University Press, 1997.

Koegel, John. "Mexican Immigrant Musical Theater in Los Angeles, circa 1910–1940." Paper read at the national meeting for the American Musicological Society, Louisville, Ky., 2015.

———. "Mexican Musical Theater and Movie Palaces in Downtown Los Angeles before 1950." In *The Tide Was Always High: The Music of Latin American in Los Angeles*, edited by Josh Kun, 46–75. Berkeley: University of California Press, 2017.

Kropp, Phoebe S. "Citizens of the Past? Olvera Street and the Construction of Race and Memory in 1930s Los Angeles." *Radical History Review* 81 (Fall 2001): 35–60.

Lerner, Jesse. *The Maya of Modernism: Art, Architecture, and Film*. Albuquerque: University of New Mexico Press, 2011.

Lev, Peter. *The Euro-American Cinema*. Austin: University of Texas Press, 1993.

Levi, Heather. *The World of Lucha Libre: Secrets, Revelations, and Mexican National Identity*. Durham, N.C.: Duke University Press, 2008.

López, Ana M. "Are All Latins from Manhattan? Hollywood, Ethnography, and Cultural Colonialism." In *Unspeakable Images: Ethnicity and the American Cinema*, edited by Lester D. Friedberg, 404–424. Urbana: University of Illinois Press, 1991.

———. "Before Exploitation: Three Men of Cinema in Mexico." In *Latsploitation, Exploitation Cinemas, and Latin America*, edited by Victoria Ruétalo and Dolores Tierney, 13–33. New York: Routledge, 2009.

———. "A Cinema for the Continent." In *The Mexican Cinema Project*, edited by Chon A. Noriega and Steven Ricci, 7–12. Los Angeles: UCLA Film & Television Archive, 1994.

———. "Crossing Nations and Genres: Traveling Filmmakers." In *Visible Nations: Latin American Cinema and Video*, edited by Chon A. Noriega, 33–50. Minneapolis: University of Minnesota Press, 2000.

———. "Early Cinema and Modernity in Latin America." *Cinema Journal* 40, no. 1 (2000): 48–78.

———. "From Hollywood and Back: Dolores Del Rio, a Trans(national) Star." *Studies in Latin American popular Culture* 17, no. 5 (1998): 5–33.

———. "Tears and Desire: Women and Melodrama in the 'Old' Mexican Cinema." In *The Latin American Cultural Studies Reader*, edited by Ana del Sarto, Alicia Ríos, and Abril Trigo, 441–458. Durham, N.C.: Duke University Press, 2004.

Lorenzen, Mark. "Creativity at Work: On the Globalization of the Film Industry." Creative Encounters Working Papers 8, Copenhagen Business School, February 2008. http://www.cbs.dk/creativeencounters.

Lott, Eric. *Love and Theft: Blackface Minstrelsy and the American Working Class*. New York: Oxford University Press, 1995.

Maltby, Richard, Melvyn Stokes, and Robert C. Allen, eds. *Going to the Movies: Hollywood and the Social Experience of Cinema*. Exeter: University of Exeter Press, 2007.

Mañón, Manuel. *Historia del teatro principal de México, 1753–1931*. Mexico City: Editorial Cultural, 2009.

McWilliams, Carey. *Southern California Country: An Island on the Land*. 2nd ed. Salt Lake City: Gibbs-Smith, 1973.

Miranda, Jorge, ed. *Del rancho al Bataclán: Cancionero de teatro de revista 1900–1940*. Mexico City: Museo Nacional de Culturas Populares, 1984.

Miró, César. *Hollywood, la ciudad imaginaria*. Los Angeles: Imprenta de la Revista México, 1939.

Möbius, Janina. *Und unter der Maske . . . das Volk. LUCHA LIBRE—Ein mexikanisches Volksspektakel zwischen Tradition und Moderne*. Frankfurt/Main: Vervuert Verlag, 2004.

Molina, Natalia. *Fit to Be Citizens? Public Health and Race in Los Angeles, 1879–1939*. Berkeley: University of California Press, 2006.

Monroy, Douglas. *Rebirth: Mexican Los Angeles from the Great Migration to the Great Depression*. Berkeley: University of California Press, 1999.

Monsiváis, Carlos. *Mexican Postcards*. London: Verso, 1997.

———. *Los rituales del caos*. Mexico City: Biblioteca Era, 1995.

Mora, Carl J. *Mexican Cinema: Reflections of a Society, 1896–1980*. 3rd ed. Jefferson, N.C.: McFarland, 2012.

———. *Mexican Cinema: Reflections of a Society, 1896–2004*. 2nd ed. Jefferson, N.C.: McFarland, 2005.

Moreno Rivas, Yolanda. *Historia de la música popular mexicana*. Mexico City: Océano, 2008.

Museo Nacional de Culturas Populares. *El país de las tandas: Teatro de revistas 1900–1940*. Mexico City: Museo Nacional de Culturas Populares, 2005.

Stewart, Jacqueline Najuma. *Migrating to the Movies: Cinema and Black Urban Modernity*. Berkeley: University of California Press, 2005.

Navitski, Rielle, and Nicolas Poppe, eds. *Cosmopolitan Film Culture in Latin America, 1896–1960*. Bloomington: Indiana University Press, 2017.

Noble, Andrea. *Mexican National Cinema*. New York: Routledge, 2005.

Nomland, John. *Teatro mexicano contemporáneo 1900–1950*. Mexico City: Ediciones del Instituto Nacional de Bellas Artes, Departamento de Literatura, 1967.

Noriega, Chon A. "Birth of the Southwest: Social Protest, Tourism, and D. W. Griffith's *Ramona*." In *The Birth of Whiteness: Race and the Emergence of U.S. Cinema*, edited by Daniel Bernardi, 203–226. New Brunswick, N.J.: Rutgers University Press, 1996.

———. *Chicanos and Film: Representation and Resistance*. Minneapolis: University of Minnesota Press, 1992.

———. ed. *Visible Nations: Latin American Cinema and Video*. Minneapolis: University of Minnesota Press, 2000.

Noriega, Chon A., and Steven Ricci, eds. *The Mexican Cinema Project*. Los Angeles: UCLA Film & Television Archive, 1994.

Olsson, Jan. *Los Angeles before Hollywood: Journalism and American Culture, 1905–1915*. Stockholm: National Library of Sweden, 2008.

O'Neil, Brian. "The Demands of Authenticity: Addison Durland and Hollywood's Latin Images during World War II." In *Classic Hollywood, Classic Whiteness*, edited by Daniel Bernardi, 359–385. Minneapolis: University of Minnesota Press, 2001.

————. "Yankee Invasion of Mexico, or Mexican Invasion of Hollywood? Hollywood's Renewed Spanish-Language Production of 1938–1939." *Studies in Latin American Popular Culture* 17 (1998): 79–105.

Ortiz Bullé Goyri, Alejandro. "Orígenes y desarollo del teatro de revista en México (1869–1953)." In *Un siglo de teatro en México*, edited by David Olguín, 40–53. Mexico City: Consejo Nacional para la Cultura y las Artes, 2011.

Osorio, Fernando. "The Case of the Cineteca Nacional Fire: Notes and Facts in Perspective." In *This Film Is Dangerous: A Celebration of Nitrate Film*, edited by Roger Smither, 140–143. Brussels: FIAF, 2002.

Pagán, Eduardo Obregón. *Murder at the Sleepy Lagoon: Zoot Suits, Race, and Riot in Wartime L.A.* Chapel Hill: University of North Carolina Press, 2004.

Paranaguá, Paulo Antonio, ed. *Mexican Cinema.* London: British Film Institute, 1995.

Paz, Octavio. *The Labyrinth of Solitude.* 1961. Reprint, New York: Grove Press, 1985.

Peredo Castro, Francisco. *Cine y propaganda para Latinoamérica. México y Estados Unidos en la encrucijada de los años cuarenta.* Mexico City: UNAM, 2011.

Phillips, Ruth Anne. "'Pre-Columbian Revival': Defining and Exploring a U.S. Architectural Style, 1910–1940." PhD diss., City University of New York, 2007.

Pilcher, Jeffrey M. *Cantinflas and the Chaos of Mexican Modernity.* Wilmington, Del.: Scholarly Resources, 2001.

————. "Cantinfladas of the PRI: (Mis)representations of Mexican Society in the Films of Mario Moreno." *Film-Historia* 9, no. 2 (1999): 189–206.

Price, Victoria. *Vincent Price: A Daughter's Biography.* New York: St. Martin's Press, 1999.

Production Code Administration Records. Papers. Academy of Motion Picture Arts and Sciences, Margaret Herrick Library, Los Angeles, Calif.

Pulido Llano, Gabriela. "Empresarias y tandas." *Bicentenario: El ayer y hoy de México* 2, no. 6 (2009): 14–21.

Ramos, Samuel. *Profile of Man and Culture in Mexico.* Austin: University of Texas Press, 1962.

Ramsaye, Terry, ed. *1937–38 International Motion Picture Almanac.* New York: Quigley, 1938.

————, ed. *1940–41 International Motion Picture Almanac.* New York: Quigley, 1941.

Reyes de la Maza, Luis. *El cine sonoro en México.* Mexico City: Universidad Nacional Autónoma de México, 1973.

Rogoff, Irit. "Studying Visual Culture." In *The Visual Culture Reader*, edited by Nicholas Mirzoeff, 24–36. London: Routledge, 1998.

Romo, David Dorado. *Ringside Seat to a Revolution: An Underground Cultural History of El Paso and Juárez: 1893–1923.* El Paso, Tex.: Cinco Puntos Press, 2005.

Rosenblum, Marc R. *Mexican Migration to the United States: Policy and Trends.* Washington, D.C.: Congressional Research Service, 2012. https://www.fas.org/sgp/crs/row/R42560.pdf.

Rotha, Paul. *The Film till Now: The Film since Then.* London: Spring Books, 1970.

Ruiz, Vicki L. "'Star Struck': Acculturation, Adolescence, and the Mexican American Woman, 1920–1950." In *Building with Our Hands: New Directions in Chicana Studies*, edited by Adela de la Torre and Beatríz M. Pesquera, 109–129. Berkeley: University of California Press, 1993.

Saavedra, Leonora. "Urban Music in the Mexican Revolution." Paper read at the national meeting for the Society for Ethnomusicology, Columbus, Ohio, 2007.

Sadlier, Darlene J., ed. *Latin American Melodrama: Passion, Pathos, and Entertainment.* Urbana: University of Illinois Press, 2009.

Sadoul, George. *Histoire d'un art: Le cinéma des origines à nos jours.* Paris: Flammarion, 1964.

Sanchez, Carlos. "The 'Golden Age' of Spanish-Language Theaters in Los Angeles: The Formation of a Transnational Cinema Audience." *Film Matters* 6, no. 1 (March 2015): 38–44.

Sánchez, George J. *Becoming Mexican American: Ethnicity, Culture, and Identity in Chicano Los Angeles, 1900–1945.* New York: Oxford University Press, 1993.

Sandi, Luis. "The Story Retold: Chronicle of the Theater in Mexico." *Theater Arts Monthly* 21, no. 8 (1938): 611–623.

Schaefer, Eric. *"Bold! Daring! Shocking! True!" A History of Exploitation Films, 1919–1959.* Durham, N.C.: Duke University Press, 1999.

Schaffer, R. Murray. *The Soundscape: Our Sonic Environment and the Tuning of the World.* Rochester, N.Y.: Destiny Books, 1994.

Schatz, Thomas. *Boom and Bust: American Cinema in the 1940s.* Berkeley: University of California Press, 1997.

Schroeder Rodríguez, Paul A. *Latin American Cinema: A Comparative History.* Berkeley: University of California Press, 2016.

Serna, Laura Isabel. "'As a Mexican I Feel It's My Duty': Citizenship, Censorship, and the Campaign against Derogatory Films in Mexico, 1922–1930." *Americas* 63, no. 2 (2006): 225–244.

———. *Making Cinelandia: American Films and Mexican Film Culture before the Golden Age.* Durham, N.C.: Duke University Press, 2014.

Shaw, Lisa, and Stephanie Dennison. *Brazilian National Cinema.* New York: Routledge, 2007.

Shiel, Mark. *Hollywood Cinema and the Real Los Angeles.* London: Reaktion, 2012.

Sinclair, John. "From Latin Americans to Latinos: Spanish-Language Television in the United States and Its Audiences." *Revista Fronteiras: Estudios Mediaticos* 1, no. 1 (January–June 2004): 7–20.

Slide, Anthony. *Nitrate Won't Wait: A History of Film Preservation in the United States.* Metuchen, N.J.: Scarecrow Press, 1992.

Smoodin, Eric. "'Compulsory' Viewing for Every Citizen: 'Mr. Smith' and the Rhetoric of Reception." *Cinema Journal* 35, no. 2 (1996): 3–21.

Soares, André. *Beyond Paradise: The Life of Ramón Novarro.* New York: St. Martin's Press, 2002.

Spivak, Gayatri Chakravorty. *"From* Ghostwriting." In *The Spectralities Reader,* edited by María del Pilar Blanco and Esther Peeren, 317–334. New York: Bloomsbury, 2013.

Starr, Kevin. *Inventing the Dream: California through the Progressive Era.* New York: Oxford University Press, 1985.

Sturman, Janet L. *Zarzuela: Spanish Operetta, American Stage.* Chicago: University of Illinois Press, 2000.

Syder, Andrew, and Dolores Tierney. "Importation/Mexploitation; Or, How a Crime-Fighting, Vampire-Slaying Mexican Wrestler Almost Found Himself in an Italian Sword-and-Sandals Epic." In *Horror International,* edited by Steven Jay Schneider and Tony Williams, 33–54. Detroit, Mich.: Wayne State University Press, 2005.

Tenorio Trillo, Mauricio. *Historia y celebración: México y sus centenarios.* Mexico City: Tusquets Editores México, 2009.

Thomas, Susan. *Cuban Zarzuela: Performing Race and Gender on Havana's Lyric Stage.* Chicago: University of Illinois Press, 2008.

Tierney, Dolores. "Emilio Fernández 'in Hollywood': Hollywood's Postwar Inter-American Cinema, *La perla/The Pearl* (1946) and *The Fugitive* (1948)." *Studies in Hispanic Cinemas* 7, no. 2 (December 2010): 81–100.

———. "Latino Acting on Screen: Pedro Armendáriz Performs Mexicanness in Three John Ford Films." *Revista Cadaniense de Estudios Hispánicos* 37, no. 1 (Fall 2012): 111–133.

Tovar y de Teresa, Rafael. *El último brindis de Don Porfirio 1910: Los festejos del centenario.* Mexico City: Santillana Ediciones Generales, 2012.

Vasey, Ruth. *The World According to Hollywood, 1918–1939.* Exeter: University of Exeter Press, 1997.

Vincendeau, Ginette. "Hollywood Babel: The Coming of Sound and the Multiple-Language Version." In *"Film Europe" and "Film America": Cinema, Commerce and Cultural Exchange, 1920–1939,* edited by Andrew Higson and Richard Maltby, 211–213. Exeter: University of Exeter Press, 1999.

———. "Hollywood Babel: The Multiple Language Version." *Screen* 29, no. 2 (1988): 24–39.

von Zinnenburg, Khadija. "The Inbetweenness of the Vitrine: Three Parerga of a Feather Headdress." In *The Inbetweenness of Things: Materializing Mediation and Movement between Worlds,* edited by Paul Basu, 23–38. New York: Bloomsbury, 2017.

Walsh, Michael D. "The Internationalism of the American Cinema: The Establishment of United Artists' Foreign Distribution Operations." PhD diss., University of Wisconsin–Madison, 1998.

Warf, Barney. "Introduction: Fusing Economic and Cultural Geography." In *Encounters and Engagements between Economic and Cultural Geography,* edited by Barney Warf, 1–17. Berlin: Springer, 2012.

Wilinsky, Barbara. *Sure Seaters: The Emergence of Art House Cinema.* Minneapolis: University of Minnesota Press, 2001.

Ybarra-Fausto, Tomás. "Aún se oye el aplauso, la farándula chicana: Carpas y tandas de variedad." *Revista de Humanidades* 1, no. 2 (1989): 4–20.

Young, Clinton. *Music Theater and Popular Nationalism in Spain 1880–1930.* Baton Rouge: Louisiana State University Press, 2016.

Zielinski, Siegfried. *Audiovisions: Cinema and Television as Entr'actes in History.* Amsterdam: University of Amsterdam Press, 1999.

NOTES ON CONTRIBUTORS

Jacqueline Avila is an assistant professor in musicology at the University of Tennessee. Her research focuses on film music and sound practice from the silent film era to the present and the intersections of identity, tradition, and modernity in the Hollywood and Mexican film industries. She is currently writing her book manuscript titled *Cinesonidos: Cinematic Music and Identity in Early Mexican Film (1896–1952)*, which is an examination of the function and cultural representation of music in the Mexican film industry.

Desirée J. Garcia is an associate professor of Latin American, Latino, and Caribbean studies at Dartmouth College and the author of *The Migration of Musical Film: From Ethnic Margins to American Mainstream* (2014). Formerly a producer for the PBS documentary series *American Experience*, she has published numerous articles and book chapters on film spectatorship and the American musical.

Viviana García Besné is a filmmaker, editor, and historian based in Tepoztlán, Morelos. She is the founder and director of Permanencia Voluntaria, Archivio Fílmico, a project that seeks to provide a home for popular cinema and orphan works in Mexico.

Colin Gunckel is an associate professor of film, television, and media; American culture; and Latino Studies at the University of Michigan and the author of *Mexico on Main Street: Transnational Film Culture in Los Angeles before World War II* (2015). He has published essays in a number of scholarly journals, including *American Quarterly*, *Aztlán: A Journal of Chicano Studies*, *Film History*, *Journal of Popular Music Studies*, *Social Justice*, and *Velvet Light Trap* in addition to essays in multiple art exhibition catalogs and edited anthologies. He also serves as the associate editor of the *A Ver: Revisioning Art History* monograph series on individual Latino artists.

NINA HOECHTL is an artist and researcher in the field of art and popular and visual culture. She was a postdoctoral research fellow at the Institute of Aesthetic Research, National Autonomous University of Mexico (UNAM), from 2014 to 2016.

JAN-CHRISTOPHER HORAK is the director of the UCLA Film & Television Archive and a professor of cinema and media studies at UCLA. He is the former director of the Munich Filmmuseum, a senior curator at the George Eastman House, and a professor at the University of Rochester; Hochschule für Film und Fernsehen, Munich. He received his PhD from Westfälische Wilhelms-Universität, Münster, Germany. His publications include *Saul Bass: Anatomy of Film Design* (2014), *Making Images Move: Photographers and Avant-Garde Cinema* (1997), *Lovers of Cinema: The First American Film Avant-Garde 1919–1945* (1995), and *The Dream Merchants: Making and Selling Films in Hollywood's Golden Age* (1989). He has written more than 250 articles and reviews in English, German, French, Italian, Dutch, Spanish, Hungarian, Czech, Swedish, and Hebrew publications.

LISA JARVINEN is an associate professor of history at La Salle University in Philadelphia. She holds a master's degree in cinema studies from New York University and a PhD in history from Syracuse University. She is the author of *The Rise of Spanish-Language Filmmaking: Out from Hollywood's Shadow, 1929–1939* (2012). Her work has also appeared in *Cinema and the Swastika: The International Expansion of Third Reich Cinema* and *The Wiley-Blackwell History of American Film*.

ALISTAIR TREMPS studied Spanish at the University of Sheffield and the University of St. Andrews. He is a translator and political analyst. For the past twelve years, he has specialized in the Calderón family's history with cinema. He was the producer of the documentary *Perdida*, which premiered at the Telluride Film Festival in 2011. Currently, he is producing a film about film collectors. He lives in Tepoztlán, Mexico, where he collaborates with the archive Permanencia Voluntaria and is an invited programmer at the Baticine.

INDEX